A New Way
of Seeing

KELLY GROVIER

A New Way of Seeing

The History of Art in 57 Works

200+ illustrations

Thames & Hudson

For Caspar and Sinéad

p. 2: Detail of the eye from Albrecht Dürer, *Self-Portrait*, 1500 (p. 110)

A New Way of Seeing. The History of Art in 57 Works
© 2018 Thames & Hudson Ltd, London
Text © 2018 Kelly Grovier

Page design by Lisa Ifsits

First published in 2019 in the United States by
Thames & Hudson Inc., 500 Fifth Avenue, New York,
New York 10110

www.thamesandhudsonusa.com

Reprinted 2019

Library of Congress Control Number 2018945298

ISBN 978-0-500-23963-6

Printed and bound in Slovenia by DZS-Grafik d.o.o

Contents

A Touch of Strangeness

What elevates a work of art to the level of masterpiece? What keeps it suspended in popular imagination, generation after generation, century after century? What makes great art great? The answer to each of these questions, invariably, is strangeness. 'It is a characteristic of great painting,' the art critic Robert Hughes concluded after encountering Vincent van Gogh's *The Starry Night* at an exhibition in New York in 1984, 'that no matter how many times it has been cloned, reproduced and postcarded, it can restore itself as an immediate utterance with the force of strangeness when seen in the original.' But what exactly accounts for this 'force of strangeness' that never weakens, however many times it is confronted? Can such power be isolated or quantified – tracked down to a single detail, quality, or feature: a shadow, a shimmer, a flick of the wrist?

Van Gogh himself believed it could be. The year before he painted *The Starry Night*, 'with its oceanic rush of whorling energy through the dark sky', as Hughes described it, Van Gogh pinpointed precisely what it is about the Romantic artist Eugène Delacroix's soulfully somnambulant painting *Christ Asleep During the Tempest* (*c*. 1853) that nudges it into a work of the very highest order. 'Delacroix paints a Christ', Van Gogh observed of the turbulent seascape in a letter to fellow Post-Impressionist Émile Bernard in July 1888, 'using an unexpected light lemon note, this colourful and luminous note in the painting being what the ineffable strangeness and charm of a star is in a corner of the firmament.' The 'light lemon note' to which Van Gogh refers invigorates the slender serrated halo that cradles Christ's sleeping head. It's a detail over which Van Gogh had been obsessing for weeks. In a letter to his brother Theo the previous month, Van Gogh alludes to the hypnotizing quality of that 'little lemon yellow for the halo, the aureole', which, he says, 'speaks a symbolic language through colour itself'.

But what, exactly, is the symbolic meaning that the work's yellow aureole communicates? Delacroix was already famous for his politically rousing *Liberty Leading the People* (1830) when he began working on *Christ Asleep During the Tempest* two decades later. Given the contemporaneity of the subsequent work with Napoleon III of France's decision to crown himself Emperor of the Second French Empire in 1852, it is tempting to polish the painting's vibrant 'aureole' (or crown) into a more elastic emblem, glinting with cultural allusion – one capable of sparking a meditation on the nature of worldly power. Remove the slight citrine halo that coronates Christ – however relatively minor that ethereal detail might measurably seem in the work – and suddenly the light, the magic, and perhaps even a richness of strangely unexpected meaning, goes out of Delacroix's painting.

Bereft of this modest element, Delacroix's canvas would be aesthetically marooned – moored along that infinite berth of commendable, but not outstanding, visual statements. Stripped of its halo, the painting would lose that levitating dimension that enables a work to float forever on the surface

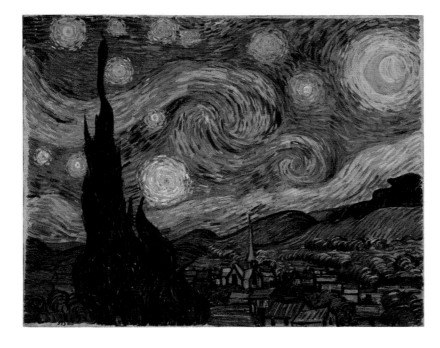

Vincent van Gogh, *The Starry Night*, 1889, oil on canvas, 73.7 × 92.1 cm (29 × 36¼ in.)

Eugène Delacroix, *Christ Asleep During the Tempest*, c. 1853, oil on canvas, 50.8 × 61 cm (20 × 24 in.)

of cultural consciousness, and keeps it from acclimatizing or sinking into familiarity. Key to that buoyancy, in both Van Gogh's and Hughes's estimation, is the ineffable force of 'strangeness'. Van Gogh's insight into Delacroix's painting is pithy, penetrating and unforgettable. Once identified, the singular aspect of that 'luminous note' becomes the 'unexpected' detail around which the entire painting scrambles to organize itself. Suddenly, the 'ineffable strangeness' of Delacroix's work, detected by Van Gogh, which vibrates like 'a star … in the corner of the firmament', anticipates the 'force of strangeness', detected by Hughes, that will echo forever from Van Gogh's own subsequent achievement of *The Starry Night*, created in June of the following year.

Strangeness invisibly binds Delacroix's and Van Gogh's works, and strangeness pulsates forwards and backwards in time to establish a glittering genealogy of greatness in art history. 'Beauty', Charles Baudelaire wrote in 1859, a generation before Van Gogh painted his swirling work, 'always contains a touch of strangeness, of simple, unpremeditated and unconscious strangeness.' 'It is this touch of strangeness', the poet goes on to explain, 'that gives it its peculiar quality of beauty.' 'This dash of strangeness', Baudelaire insists,

'constitutes and defines individuality (without which there can be no beauty).' Observation by observation, a consensus of sentiment begins to ricochet across centuries: greatness is strangeness.

Every great work invariably possesses an element, detail or quality to which its inexhaustible strangeness can be traced and without which it would cease to reverberate, age after age in perpetuity. A relatively recent archaeological discovery has proved that such a propensity is fundamental to the very urge to create art, and is evident from the earliest examples of image-making. In September 2008, the history of art was turned on its head. Or, to put it more accurately, the head was lopped off entirely. A team of scientists from the University of Tübingen brought to light six fragments of whittled tusk from nearly 3 metres (9 ft) below the floor of a cave in southwestern Germany's Swabian forest. Puzzled together, the timeworn chunks of jagged ivory comprise not merely a headless statuette of a voluptuous woman, but the oldest example of figurative sculpture ever discovered.

Fashioned 40,000 years ago from a woolly mammoth tusk, the 6-centimetre-tall (2½ in.) carving caricatures the female form into a tight clump of bulging breasts, buttocks and inflamed genitalia. That the sculpture's physical exaggerations,

which anticipate subsequent depictions of women 10,000 years later in France, were intended to constitute a totem of fertility and abundance is the leading supposition of anthropologists who have studied the object. Given the primitivity of the stone tools likely available to the artist who created the statuette, it has been estimated that hundreds of hours may have been spent scraping the dense dentine into shape.

However long one spends contemplating the curious grooves that run rib-like across the figurine's abdomen, or ponders the truncated Tyrannosaurus-like arms that enfeeble the imagined reach of the depicted woman, or marvels at the gravity-defying buoyancy of the overinflated breasts, what ultimately exercises the imagination most is the utter strangeness of the piece, epitomized in what is not there: the head. The prehistoric craftsman responsible for this little sculpture has nothing to learn from the ensuing millennia of artists who will seize on the presence of absence as the centre of interest in their works. By inserting an eye-hook where the subject's neck and face and cranium should be (thereby allowing the statuette to be worn as an amulet around the neck), the artist has suggestively ground the strange lens through which every subsequent work of art must be assessed.

If we accept the implication of the statuette's strange and estranging eye-hook, the artwork is only conceptually completed when the object is worn, when the head of the amulet's wearer is positioned above it: when art and life merge. The figurine's eye-hook is what bridges the divide between the aesthetic and the real. The presence of the eye-hook makes clear that this, the earliest known example of figurative art, was not merely a bauble to behold but a talisman to become. It is the eye-hook that invests an artwork with palpable strangeness, elevating its value beyond the visual to the vital. Only through the narrow aperture of an artwork's eye-hook can we perceive its truest meanings.

This book offers a new genealogy of art history and introduces an innovative way of perceiving artistic greatness. By locating an 'eye-hook' (indicated throughout the book by the ☉ symbol) within each of the definitive masterpieces featured here, the book endeavours to demonstrate the abiding strangeness of those aesthetic objects that have managed to propel themselves beyond the historical moment of their creation. These eye-hooks are what enable viewers to connect with a work – to bring it into their lives. They also serve as crucial keys to understanding how the power of great works is handed down, undiminished, from age to age. Spanning some 40,000 years of artistic imagination, the works collected here have been chosen for their ability to demonstrate the evolution of the eye-hook as a tool that sculpts our seeing and shapes our understanding of who we are and what it means to be alive in the world.

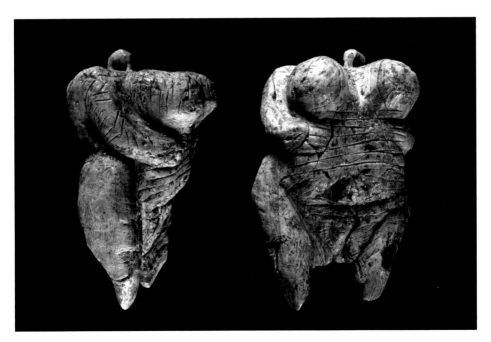

Venus of Hohle Fels,
38,000–33,000 BC,
mammoth tusk ivory,
6 cm (2½ in.)

57
Works

↓ 'Ashurbanipal Hunting Lions',
c. 645–635 BC, relief from the
North Palace, Nineveh

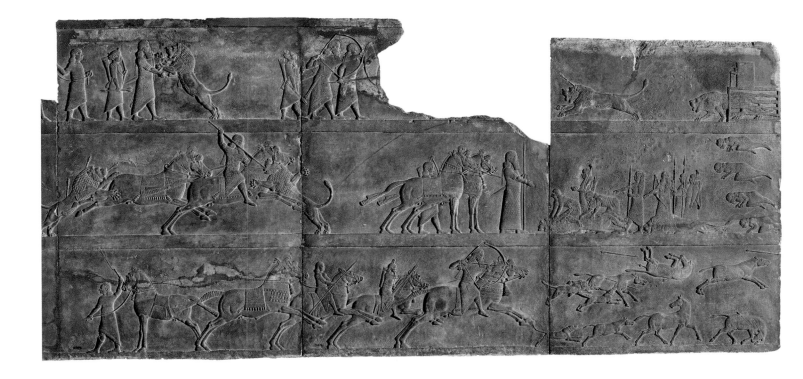

At once groundbreaking and subversive, these ancient stone reliefs from the royal palaces of Nineveh teach us that, in great art, nothing is as it seems.

What strikes the eye first are the arrows. Released by the Assyrian ruler Ashurbanipal in scene after sculpted scene, the arrows soar through the stony air of the work infallibly towards their ferocious target: a snarl of lions whose primal energy appears to threaten the very existence of the kingdom. The arrows, whether drawn back and frozen in their bows, already snapped, or forever piercing the flesh of their hopeless prey, accentuate the narrative thrust of the seventh-century BC reliefs that once adorned the royal palaces of ancient Nineveh, driving the action forward in time – a groundbreaking innovation in the history of image-making which many scholars trace back to these very sculptures.

 The imagined trajectory of the arrows establishes a concurrent spectrum of past-and-present that enables Ashurbanipal simultaneously to appear charioted in one scene, while he rides horseback in another. In addition to the linearity of storyline for which the reliefs are admired, an exquisiteness of chiselled detail that captures the flex and flinch of the stricken animals proved revelatory in the unfolding story of art. 'See!', the twentieth-century American writer William Carlos Williams will exclaim in a poem that recalls the reliefs he had encountered as a young man in

the British Museum, 'Ashur-ban-i-pal / the archer-king on horse-back'. Williams cleverly uses hyphens to thin the Assyrian king's name into the whizz of the soaring arrows, translating into the flow of writing the stasis of the 'archer-king' we see, frozen in stone:

> with drawn bow -- facing lions
> standing on their hind legs,
> fangs bared! his shafts
> bristling in their necks!

Though the artist responsible for creating the reliefs is forgotten, there is little doubt that the surface message he intended is the vivid illustration of the remarkable physical prowess of Ashurbanipal, who alone could be trusted with protecting the kingdom. But locked behind the façade of every great work is an irony that invigorates and unsettles its ostensible meaning. In the case of the seventh-century BC lion hunt of Nineveh, the eye-hook through which crucial visual tension is unleashed is located just above the cage from which a lion is endlessly on the verge of being released. Easily overlooked amid the frozen orgy of violence is the

small enclosure out from which a man can be seen leaning, gingerly lifting the door of the trapped beast's corral.

However mighty Ashurbanipal may appear, in truth his machismo is a choreographed act controlled by the anonymous and half-concealed figure who manipulates the artificial threat-level of the work one manicured mane at a time. He's the wizard behind the curtain to whom Ashurbanipal would rather we paid no attention. The partially obscured figure ensures that the king's safety is never truly in jeopardy and that, in effect, he is shooting fish in a barrel. The lions that the ruler appears heroically to be hunting, thus protecting his kingdom from fearsome predators, were in fact captured beforehand by his minions and held in pens.

Ashurbanipal is said famously to have once roared, 'I held the bow, caused the arrow to fly, the ornament of my prowess.' What he didn't say is that his legendary hunts weren't hunts at all, but staged entertainment – a fact subversively exposed by the sculptor with this incriminating detail. Without the opening of the pen, there is no hunt and there are no arrows suspended in mid-flight forever sculpting the stone into legend. The relief is a farce whose deeper meaning complicates our first impressions. What it ultimately symbolizes is not the might of the king, but the power of art to encapsulate the complexities of life. The king may hold the bow, but the arrow of art always points in one direction: it's the artist who pulls the strings.

More modern and meta than the year of its creation might suggest, the sculpted lion hunt of Nineveh presciently limbers our eyes for appreciating the elaborate textures of every work of art that will follow. Though there is no way of proving it, I imagine that the half-hidden figure with his hand on the lever of the relief's pulse, who alone decides when to inject another surge of aesthetic electricity rippling through the veins of his relief, is a self-portrait of the artist himself, whose identity the whirring feathers of time have slowly erased.

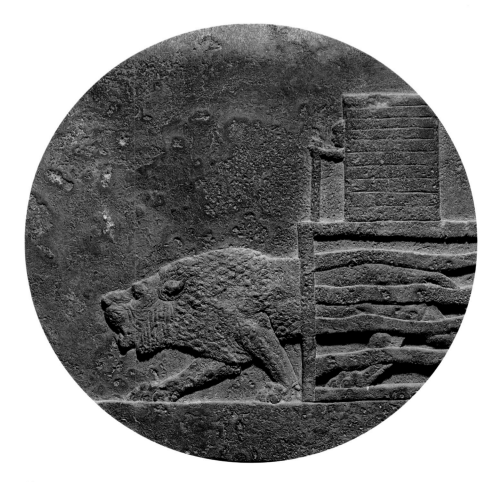

👁 Detail of the opening of the lions' pen, 'Ashurbanipal Hunting Lions', c. 645–635 BC

→ Cai Guo-Qiang, *Inopportune: Stage Two*, 2004, detail of installation consisting of nine life-sized tiger replicas (papier-mâché, plaster, fibreglass, resin and painted hide), arrows (brass, threaded bamboo shafts and feathers) and a mountain stage prop (Styrofoam, wood, canvas and acrylic paint: not shown)

The brutal storytelling of contemporary Chinese artist Cai Guo-Qiang's fierce *Inopportune: Stage Two* echoes the ingenious narrative arrows invented by the nameless, forgotten sculptor of 'Ashurbanipal Hunting Lions' twenty-six centuries earlier.

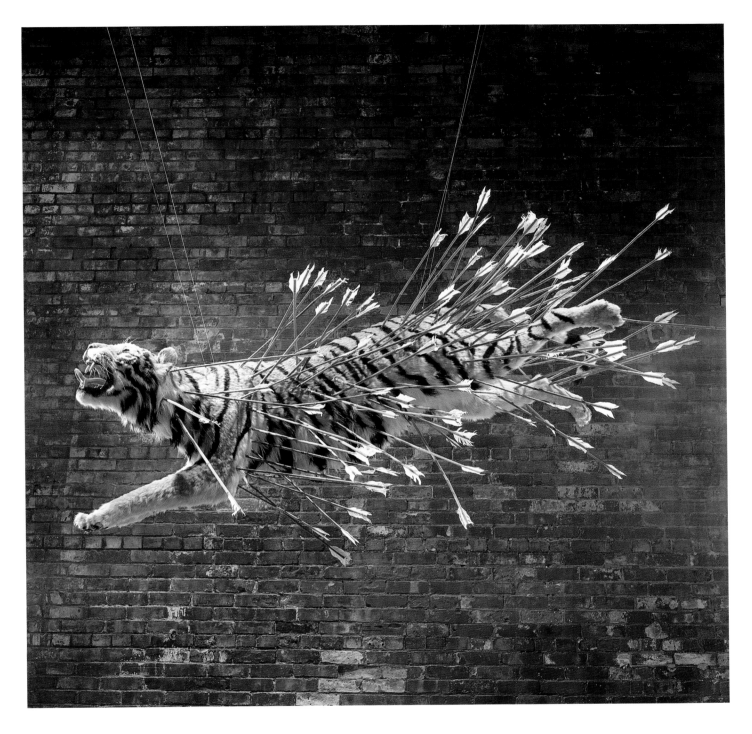

The Romantic poet John Keats said that the 'Grecian grandeur' of the Elgin Marbles had stirred in his heart 'a most dizzy pain'. Hidden deep inside their inscrutable stony folds is a dark mystery.

In September 1802, the *Mentor* – a small two-masted ship commanded by Captain William Eglen and owned by Thomas Bruce, the 7th Earl of Elgin – suddenly found itself in heavy weather on its way to Malta from Athens and crashed on rocks off the coast of the island of Kythira. There is little wonder that the vessel, laden with some seventeen containers crammed with marble sculpture, sank instantly in the Aegean Sea. There was no time for the eighteen passengers to salvage anything more than their own lives. Notified of the disaster and the loss of his cargo, Lord Elgin appealed to the British consul in Kythira for assistance in recovering from the seafloor what he described as 'cases of no great value in themselves'.

Elgin's depreciatory estimation of the worth of the *Mentor*'s haul, which included antique torsos, fragments of a 160-metre (524 ft) bas-relief frieze, and a stone throne, is somewhat at odds with the opinion of the Greek statesman Pericles, who commissioned those objects' creation in the fifth century BC. The sunken marbles Elgin dismissed as possessing 'no great value' once featured as decoration for the Acropolis's Athenian temple, the Parthenon, and represented an artistic achievement that, Pericles believed,

would be 'the marvel of the present day and of ages yet to come'. In the end, it took two years to recover the submerged treasures and, in the centuries since their cumbersome retrieval, conventional wisdom regarding the quality of the Parthenon Marbles has sided emphatically with Pericles. 'A man must be senseless as a clod,' the Romantic poet William Wordsworth insisted, 'or as perverse as a fiend, not to be enraptured with them.' Wordsworth's younger contemporary, John Keats, was likewise enthralled by their majesty. 'He went again and again to see the Elgin Marbles,' his friend Joseph Severn attested after the poet's death, 'and would sit for an hour or more at a time beside them rapt in reverie … with eyes shining so brightly and face so lit up by some visionary rapture.' Keats's famous sonnet 'On Seeing the Elgin Marbles' would help keep the objects buoyed in popular consciousness throughout the nineteenth century.

Considered by many to embody some of the finest achievements of antiquity, the fragments Lord Elgin had ripped from the temple in 1801 and 1802 are a miracle of delicate muscularity – of gusto and grace. Particularly astonishing is the bas-relief frieze of Pentelic marble that

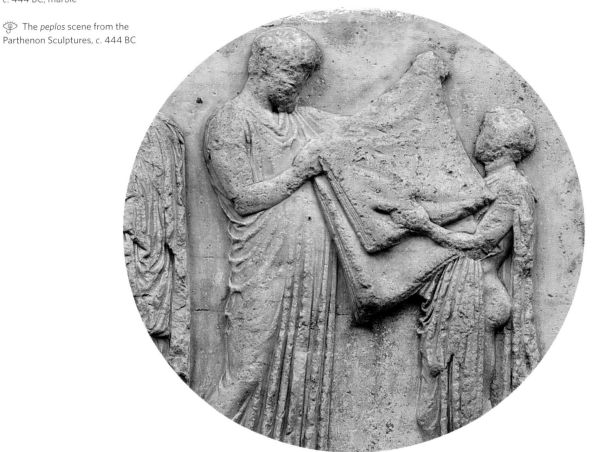

once wrapped itself around the temple, featuring a frozen procession of galloping equestrians and sacrificial cattle, chiselled charioteers and the eternal elegance of levitating maidens. Pursuing the petrified prance, the eye of the observer eventually snags on an enigmatic vignette that would have hovered directly over the entranceway to the temple: this is what art historians refer to as the 'peplos scene'. Since the middle of the eighteenth century, conventional wisdom has held that the scene portrays the bestowal of a newly woven *peplos* (or robe) to be draped over the statue of Athena inside the temple – the culminating ritual in the festival of the Panathenaia, celebrated every four years.

According to a competing theory, however, the exchange depicts something rather darker: the handing over of a burial shroud to the daughter of King Erechtheus, who was alarmed by an oracle that portended the invasion of Athens unless he sacrificed his offspring. Tucked ambivalently between the pleats of joyous tribute and horrifying infanticide, the eye-hook of the stony garment is emblematic of history's un-unravelable tease.

Since 1816, the cryptic *peplos* scene has resided, along with the majority of the Parthenon Marbles, in the British Museum, London, following their transportation to England in the years after the collapse of the *Mentor*. Repeated demands by Greece for the restitution of their national treasure and the mysteries it holds have consistently been rebuffed.

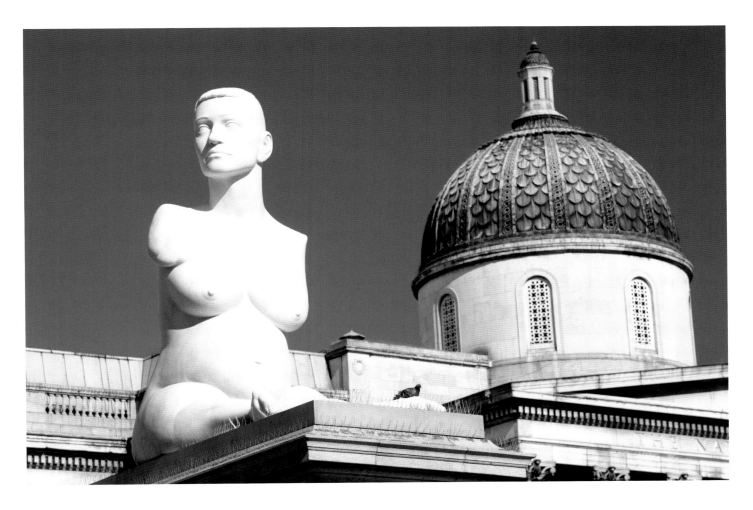

↑ Marc Quinn, *Alison Lapper Pregnant*,
2005, marble, 355 × 180.5 × 260 cm
(139¾ × 71 × 102⅜ in.); Fourth Plinth
Commission, Trafalgar Square, London
(2005–7)

The mystery of fragmented form
concealing undiminished beauty
and truth is a theme that continues
to invigorate sculptors' minds.
Marc Quinn's *Alison Lapper Pregnant*
is evidence of how contemporary
a fascination it remains.

*A miracle of detail and variation,
the Emperor's eternal artilleries mount
a full-frontal assault on our comprehension
of artistic craftsmanship. This is a work
to which our eyes must listen closely.*

'It is not the voice that commands the story,' the twentieth-century Italian writer Italo Calvino once wrote, 'it is the ear.' Scientists investigating one of the strangest and most ambitious artistic projects ever undertaken have come to the same conclusion. In order fully to appreciate the achievement of the ancient artisans who sculpted the thousands of earthenware effigies that comprise China's third-century Terracotta Army, we must listen to their ears.

In 1974, farmers working near the northwestern Chinese city of Xi'an (which once served as the starting point of the legendary Silk Road trade route) began digging a well. Heeling his spade into the fertile ground, one of the farmers suddenly hit something solid. When he reached down to brush away the soil, his incredulous stare was met by that of a life-sized clay head – a pair of fossilized eyes that hadn't seen the light of day in over twenty-two centuries. When a team of archaeologists descended on the site, what it found was truly astonishing: a series of vast subterranean pits populated by over 7,000 terracotta infantrymen, warriors, charioteers, cavalrymen, archers and low-ranking soldiers standing in military formation, as if awaiting war.

Ensuing research revealed that the petrified army is standing sentry before the burial tomb of Qin Shi Huang, founder of the Qin dynasty and, from the age of 38, the First Emperor of China. Construction of the ruler's elaborate city of the dead is thought to have begun in 246 BC, when Qin Shi Huang was just 13 years old. Credited, in life, with expanding China's territory by uniting seven warring kingdoms, instituting wide-ranging economic and social reforms (including the end of feudalism), and initiating a vast defensive barrier that would eventually swell into the Great Wall of China, the emperor, we now know, was no less ambitious when it came to setting his agenda for the afterlife.

Rather than accepting the inevitability of death, Qin became obsessed with the prospect of securing an elixir of life that would give him immortality. In order to obtain such a tonic, he summoned to his many palaces (he is said to have had over two hundred) reclusive sages and alchemists, who were duly executed when they failed to produce a viable recipe. Convinced that such a concoction existed somewhere, Qin despatched exploration parties of hundreds of men and women to comb the remotest

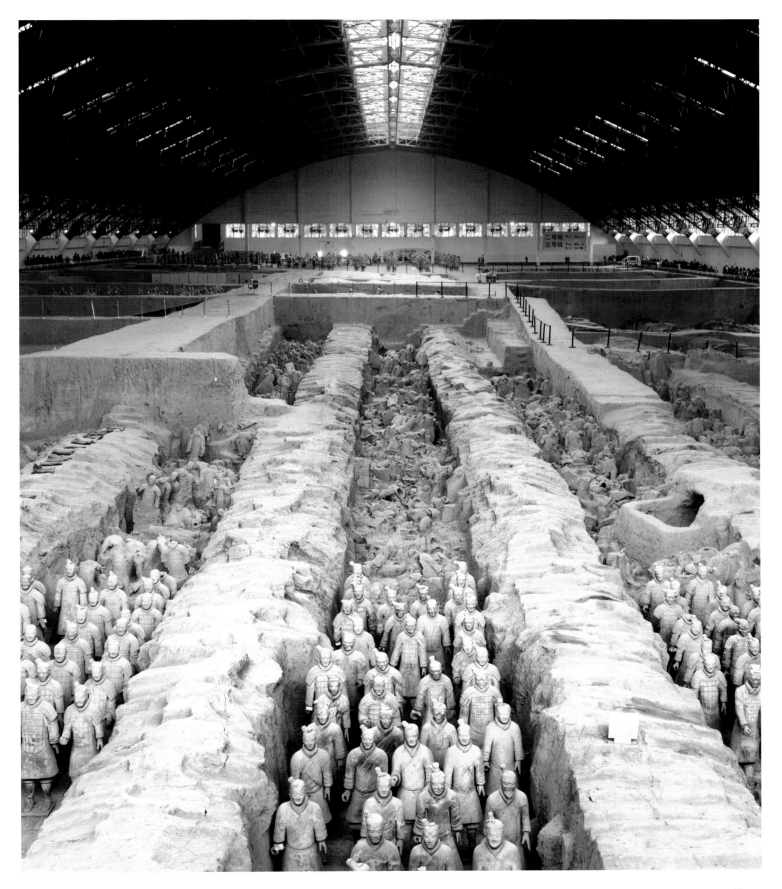

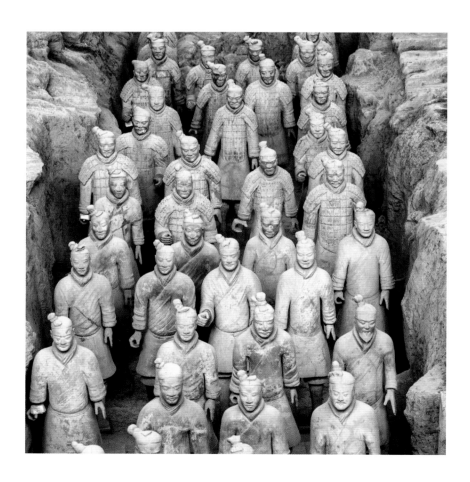

↖ Main view of the Terracotta Army in the Qin Shi Huang Mausoleum of the First Emperor of China, Xi'an, Shaanxi Province, *c.* 210 BC

← Antony Gormley, *Amazonian Field* (detail), 1992, dimensions variable, approx. 24,000 terracotta figures, each between 4 and 40 cm high (1½–15¾ in.)

↓ Terracotta infantrymen of the Terracotta Army, *c.* 210 BC

→ 👁 Detail showing ears of soldiers, Terracotta Army of the First Qin Emperor, *c.* 210 BC

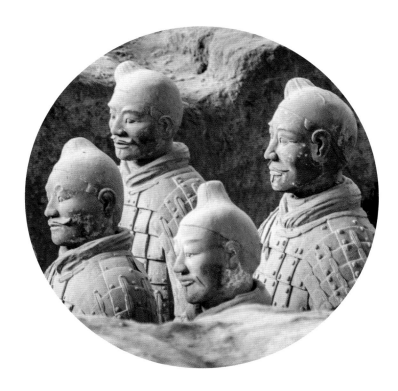

have long speculated that constructing the sculptures must have entailed a mass assembly line and the use of interchangeable parts, as if snapping together mannequins for a department store's display window. But research conducted by a team of archaeologists at the University of London in 2014 discovered something remarkable – something that, far from demystifying the process of creation, invested the army with greater mystery still.

In order to determine how many stock variants of any one physical feature the craftsmen relied upon in assembling the 7,000 sculptures, the soldiers' earthenware ears were subjected to intense analysis by sophisticated imaging technology. Rather than finding similarities, however, the study concluded that no two ears of the Terracotta soldiers were the same, and that their shapes and contours were as unique as any within a population sample of the same size. In living beings, the ears are as individual to one's identity as fingerprints.

The lack of any discernible pattern of repetition in the moulding of the statues' ears makes it likely that, by extrapolation, the sculptures themselves are not generic snap-together dummies or anonymous oversized G.I. Joe dolls – not mass-produced models for a hypothetical battalion, or even the abstract simulacra of a fragile toy army, as British sculptor Antony Gormley would create over two millennia later with *Field*. The implication of such mind-boggling variation is that the statues are either meticulous replicas of actual people after whom they were modelled, or painstaking inventions of the human that refuse to concede the integrity of even the slightest fictionalized detail. Whether they are fossilized ghosts of the forgotten dead or dusty shadows of an imagined people that never were, the Terracotta Army still stands forever at attention on the border between two worlds, not whispering a word.

islands where, according to myth, the secret behind the elusive potion was kept. The voyagers never returned. While Qin desperately scrabbled to locate a means by which he could avoid ever having to confront death directly, hundreds of thousands of conscripted craftsmen were busy, at his decree, preparing for an eventual battle in the hereafter, should it come to that.

Qin's Plan B, if immortality eluded him, was to engage the forces of death head-on following his own physical demise by commanding an immortal army. For such an audacious campaign to succeed, an intimidating fighting corps would need to be marshalled. The result of Qin's macabre mania was the forging from clay of a make-believe militia the likes of which had never before been dreamt of, let alone seen. In addition to crafting stand-ins for every conceivable military role, the now-forgotten craftsmen responsible for magicking from dust the mythic soldiery also sculpted ceramic surrogates for acrobats, musicians and strongmen to keep the emperor entertained during his post-life battle.

Confronted with such overwhelming aesthetic achievement, an observer's eye scrambles for traction – a hook on which its awe can hang. In order to make some sense of the effort required to forge from scratch such a formidable battalion, scholars and casual admirers

↓ Mural, Villa of the Mysteries,
Pompeii, c. 60–50 BC

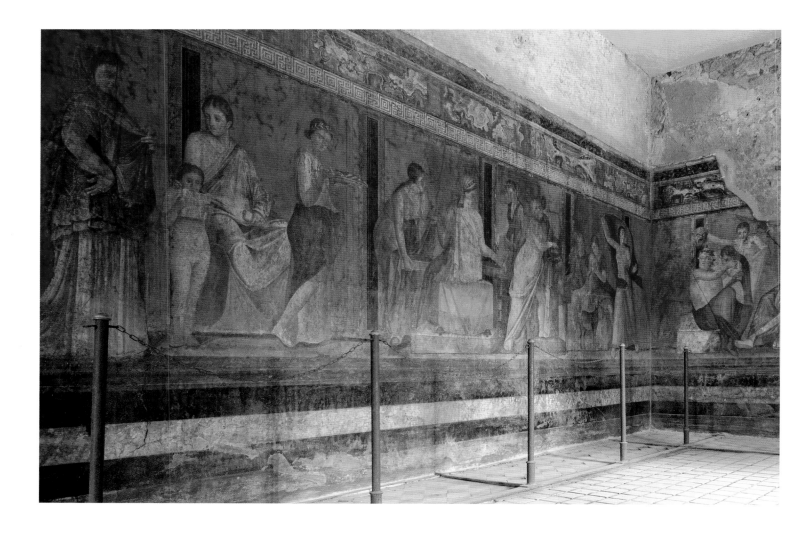

*A keyhole into the secret rituals
of an ancient mystery cult, this is
a work that plies our eyes with its heady
perspectives and has its wicked way
with our imagination.*

Great art is intoxicating. It inebriates the eye. To be under the influence of a great work is to be initiated into its secret rite of seeing – to perceive the world woozily anew, as if reflected in a warping mirror. No artist understood this dizzying power of art better than the first-century BC Roman artist responsible for a series of frescoes that adorn the walls of an ancient Pompeiian villa that was left remarkably unscathed when Mount Vesuvius erupted in AD 79. Though the artist's identity has since evaporated into the fog of history, the extraordinary frescoes in the Villa dei Misteri, widely regarded as the finest example of classical mural painting to have survived antiquity intact, have seeped deep into cultural consciousness.

What, precisely, unfolds across the frescoes' ten interconnected scenes, which encircle a dining room, or *triclinium*, and feature life-sized figures glorified against a sumptuous crimson background, has long been the subject of spirited scholarly debate. Most historians now agree, however, that the paintings portray the initiation of a young woman into a Dionysian mystery cult – a secretive religious order that celebrated uninhibited sensual abandon. Beyond that, our modern eye struggles to unravel a coherent storyline from the clues given, as if the narrative were intentionally hallucinatory in its tipsy telling.

Read from left to right as a guest's gaze spins clockwise around the room, the frescoes appear principally to trace the movements and emotions of the young initiate and the priestess who guides her as they participate in a series of pagan rituals while mythological figures, satyrs and nymphs, frolic around them. In one scene we see the initiate weaving a gift basket for Dionysus while a silenus (an older satyr) plucks a lyre. In another scene she seems startled after catching a glimpse of what awaits her: the *katabasis*, or descent into the underworld. Further along, we catch sight of the initiate as she is whipped by a winged figure before receiving a giant staff topped with a pinecone – a gesture that signifies, some believe, that the ceremony is over.

Squinting to piece together a narrative from the disjointed dreaminess, our eyes begin to suspect that what is being conveyed is anything but a straightforward story. Sometimes the young initiate is present. Sometimes she's vanished. Sometimes her body appears to double, occupying

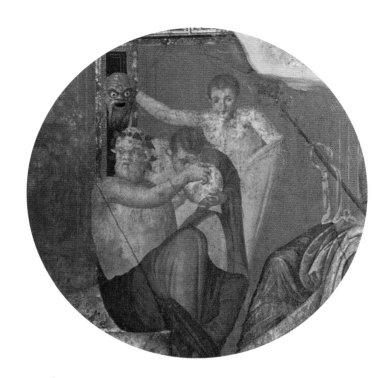

👁 Detail of the three satyrs with theatre mask, Villa of the Mysteries, *c.* 60–50 BC

the same space twice. It's all as clear as a drunken stupor. The only thing we know for certain is that the young woman who begins the ceremony seems to have undergone a dramatic transformation by the time it ends – a butterfly-like metamorphosis from tentative girl into self-possessed woman.

The artist who painted the frescoes seems fully aware that it is one thing merely to illustrate the young woman's induction into the cult of Dionysus, the god of wine and fertility, and another thing entirely to make observers of his work feel as if they're there, intimately involved in the intoxicating ceremony – to inebriate their eyes and knock them off balance. The blurring of boundaries between the real-world space that guests inhabit and the mythic space depicted on the walls is partly achieved through the painterly technique of *trompe l'œil* (or 'trick of the eye'), which makes the figures in the frescoes appear to be occupying actual architectural space, as if elevated onto a stage that guests too could ascend.

To further amplify the illusory effect, the artist has slyly inserted, mid-way in the visual narrative, a telling tableau that forces observers to question not just their own sobriety but the stability of everything unfolding around them. On the main focal wall of the decorated room, a trio of pointy-eared satyrs are seen entangled in a most curious

pantomime. Here, a bearded silenus is shown tilting a silver drinking vessel so that a younger satyr, standing beside him, can look deep into the bowl's reflective concavity. Meanwhile, standing behind the figure who stares into the bowl, another satyr can be seen positioning, with outstretched arm, a frightening theatre mask, adjusting it to precisely the angle necessary to create a reflection of its contorted face in the metallic bowl. As the mischievous satyr manipulates the optical illusion of a warped face howling from the bottom of the vessel – a vision that would be all the more disturbing to a guest already drunk – he gazes out eerily from the fresco with an enigmatic stare.

Is the satyr looking directly at us, breaking the aesthetic barrier of the work in order to tip us a knowing wink that everything we see around us is nothing more than high-spirited hijinks – the passing illusion of a Dionysian trance? The direction of his right eye would appear so. Or is he instead looking past us, as if we are no more substantial than the fleeting phantasms he casts into the cup? Such indeed is the trajectory of his left eye. So inscrutable is the satyr and his cockeyed eye-hook gaze, one cannot help wondering if his wonky proto-Cubistic depiction is really a quasi self-portrait of the forgotten artist himself – the Bacchanalian host who serves inebriating visions to his guests.

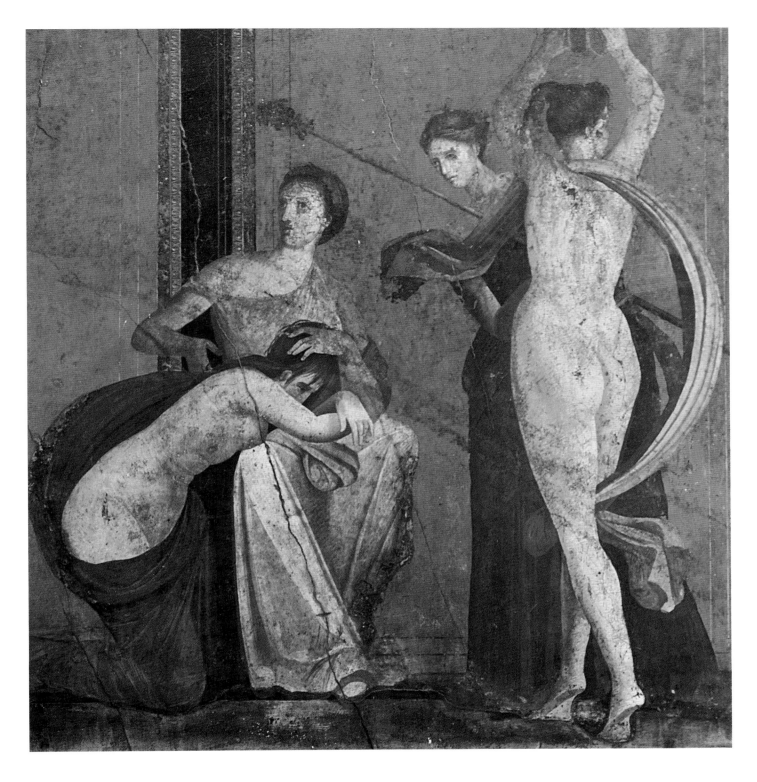

↑　Detail of mural, Villa of
the Mysteries, *c.* 60–50 BC

Described by the Roman scholar Pliny the Elder as 'a work to be preferred to all others', this ancient sculpture implicates our gaze in the torture it portrays.

What grabs the eye is what crushes the subject: the serpents wrapping their lethal scales around *Laocoön and his Sons*. The ancient sculpture was unearthed in Rome in the spring of 1506. Michelangelo, who had just arrived in the city to begin work on Pope Julius II's tomb, was suddenly summoned to a hole in the ground near the Colosseum, where a twisting slither of marble had been discovered. Helping oversee the excavation, Michelangelo quickly realized what was slowly writhing to the surface: the single most legendary artwork of all antiquity, praised by the first-century Roman writer Pliny the Elder as 'a work to be preferred to all others, either in painting or sculpture'.

Though the precise date of the creation of *Laocoön and his Sons* has been debated since Michelangelo supervised its excavation (the Romantic poet William Blake insisted it was a crude forgery of a lost Hebraic work representing Jehovah and his sons), historians now believe the sculpture was likely made during Pliny's lifetime, in the century that spans 30 BC to AD 70, and displayed in the palace of the Roman emperor Titus. The statue, which Pliny says was the collaborative work of 'three most eminent artists, Agesander, Polydorus, and Athenodorus', depicts the intense physical suffering of a tormented trio from Greek mythology – the Trojan seer, Laocoön, and his two sons – who struggle to free themselves from the lethal squeeze of muscular sea serpents.

According to Virgil, Laocoön became suspicious that a gift of an enormous wooden horse offered by Ulysses might stealthily be inhabited by Greek soldiers in a ruse to infiltrate Troy. To punish Laocoön for his ingratitude (on its surface, the Trojan Horse was an offering to the goddess Athena), Poseidon and Athena coax a pair of vicious sea monsters to torture and kill the priest and his two sons. The ancient sculpture captures the slithery assault in mid-clench, suspending the triple execution at the moment when one of the venomous serpents is about to tighten its fangs on Laocoön's side.

Few sculptures have agitated the imaginations of cultural critics more than *Laocoön and his Sons*. Crucial to the work's perpetual fascination has been the conundrum it presents to writers desperate to distill from its static pulse of stone a single abiding emotion. For some, such as the eighteenth-century archaeologist and historian Johann Joachim Winckelmann, the sculpture is an emblem of stoic heroism,

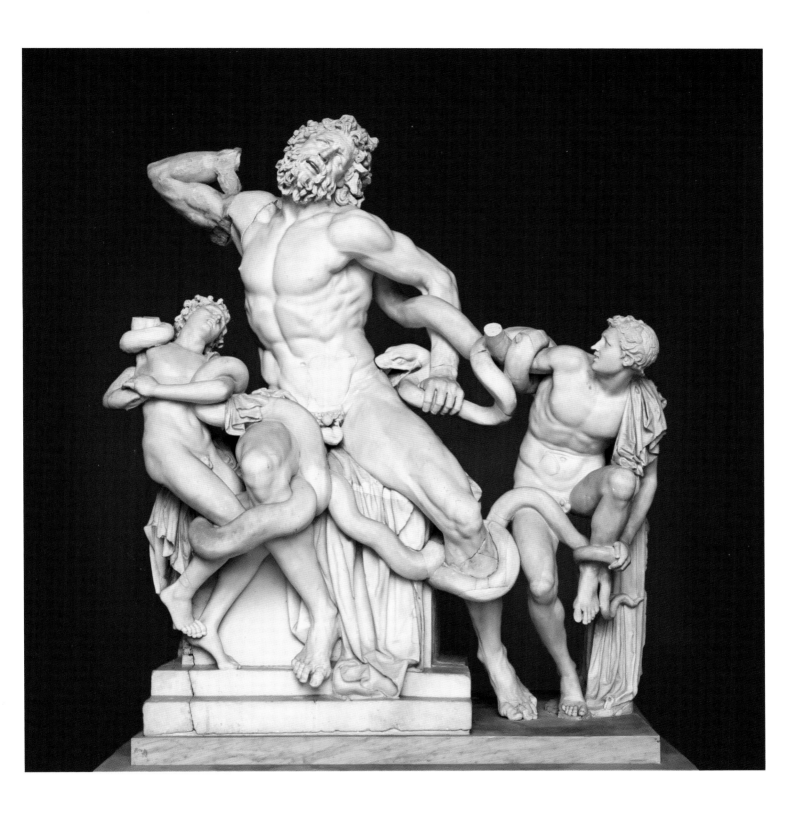

↑ *Laocoön and his Sons,*
c. 27 BC–AD 68, marble,
208 × 163 × 112 cm
(81⅞ × 64⅛ × 44 in.)

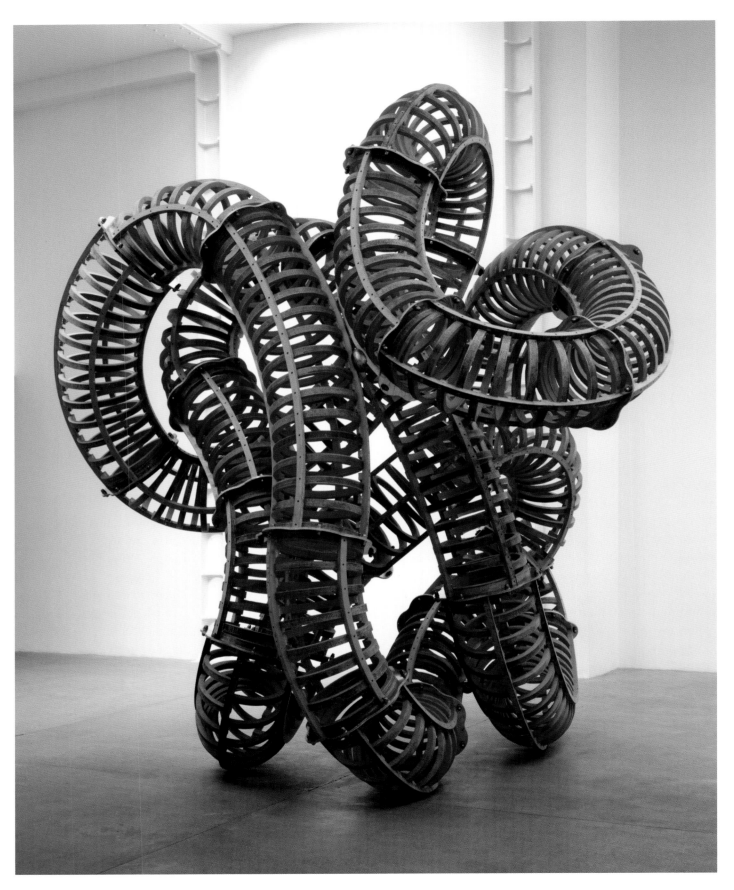

← Richard Deacon, *Laocoön*, 1996, steamed beechwood, aluminium and steel bolts, 430 × 364 × 357 cm (169¼ × 143⅜ × 140½ in.)

Two millennia since its creation, *Laocoön* continues to wriggle in cultural imagination. British artist Richard Deacon's abstract sculpture, inspired by the classical masterpiece, captures the mirroring writhe of inner turmoil and outward form.

👁 Detail of the head of Laocoön, *Laocoön and his Sons, c.* 27 BC–AD 68

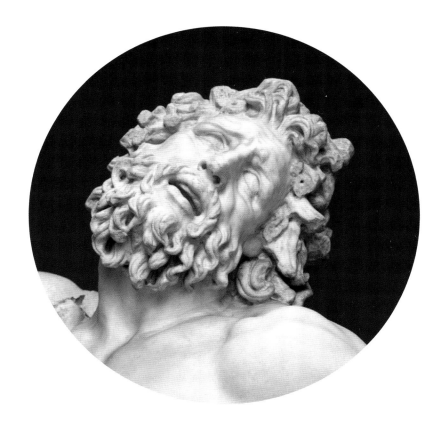

as Laocoön, in Winckelmann's view, philosophically endures the serpents' assault without a whimper. For others, such as the eighteenth-century polymath Gotthold Ephraim Lessing, the work embodies instead a latent rage building silently between the clenched teeth of its tortured subject. The discrepancy in response, even among learned contemporaries such as Winckelmann and Lessing, is evidence of an abiding ambiguity in the work's portrayal.

Key to the work's enduring indeterminacy of emotion is the rendering of the lines that furrow Laocoön's brow. In 1862, the French scientist Guillaume-Benjamin Duchenne published an influential treatise, *The Mechanism of Human Facial Expression*, that took issue with the neurological verisimilitude of Laocoön's portrayal, noting, in particular, a confusion between the handling of the Trojan's eyebrows and that of the muscles above them, which rumple the forehead. Rather than constituting a defect, however, as Duchenne regarded the inconsistency of emotion (and Charles Darwin after him), the clash of emotion between agony and endurance twitching between the tilt of Laocoön's eyebrows and the furrows of his forehead may be precisely that to which millennia of observers have subliminally

responded. The impossible simultaneity of muscular flex captured by *Laocoön and his Sons* creates a ceaseless tension in the stony sculpture that troubles our attention, rendering the work as animate and inscrutable as ourselves.

In my own mind, the unpredictable writhe and snap of the snakes and the indeterminate rumple of Laocoön's brow mirror one another's movements like parallel undulations of inner and outer torment. It is impossible to disentangle our fascination with the emotional tensions experienced by Laocoön's psyche from our fixation on the physical distress suffered by his body. The work's inexhaustible intensity relies no less on the ceaseless slip-and-slide of the viewer's eye along the swirling length of a serpent's body than on the horrified flex of the Trojan's muscles. Ineluctably, our gaze swivels between his afflicted countenance and the determination of the serpent, swerving insidiously between the victims' legs, around their powerless biceps until it reaches Laocoön's effete fingers, inches from the serpent's still unsnapped jaw. The sinuous movement of our eyes, which further ensnares the imperilled forms, makes us complicit in the eternal torture we're witnessing.

Comprised of hundreds of scenes and figures that were, by and large, never intended to be seen up close, Trajan's Column is a masterpiece of invisible intricacies – a silent symphony that doesn't blow its own horn.

According to myth, around the turn of the sixteenth century, Jacopo Ripanda, a Renaissance frescoist from Bologna, dangled himself precariously in a basket from a rope tied to the top of Trajan's Column in Rome, in order to study up close the intricate, 200-metre-long (655 ft) frieze that winds around the 38-metre-tall (125 ft), second-century marble monument. In fact, Ripanda had rather less daringly erected a scaffold upon which he perched so that he could see more clearly what was otherwise impossible to decipher from ground-level: the 155 separate scenes that rotate around the shaft, commemorating the two triumphant campaigns against the Dacians that had been led by Emperor Trajan, a statue of whom stood atop the structure.

Whatever apparatus enabled Ripanda to gain a better vantage on the famous frieze, the extraordinary lengths required to observe the visual narrative – which begins to blur into illegibility only a few twists along its twenty-three rotations around the column – raise a key question regarding the design and achievement of the formidable object: why create a work that is almost impossible to appreciate? Why sculpt scene after painstaking scene of highly wrought narrative if no one will be able to admire them? The truth is,

no one really knows how, exactly, the architect Apollodorus of Damascus (who designed the column shortly after completing the impressive Forum of Trajan nearby), or the anonymous team of forgotten craftsmen who sculpted the frieze that wraps around it, expected the monument would be received by observers – how it would be experienced as an aesthetic object, a work of art. That mystery remains for us to muse upon, if not solve.

No scholarly evidence has yet come to light to corroborate the existence, posited by some historians, of viewing platforms. We must therefore assume that, for the most part, this was a work of breathtaking complexity that was never intended to be scrutinized in any real detail by ordinary observers – that it was deliberately to be experienced as a rather grandiose blur of nearly 2,700 figures, carefully kitted in authentic costumes and wielding weapons against an eternal onslaught of doomed Dacian soldiers. We must assume, in other words, that this was a work whose visual music was deliberately one of exquisite white static meant to blare far, not be parsed for nuanced notes or meticulous melodies.

One might suspect that in such a context, where subtlety is overshadowed by formidable might, it would be difficult to

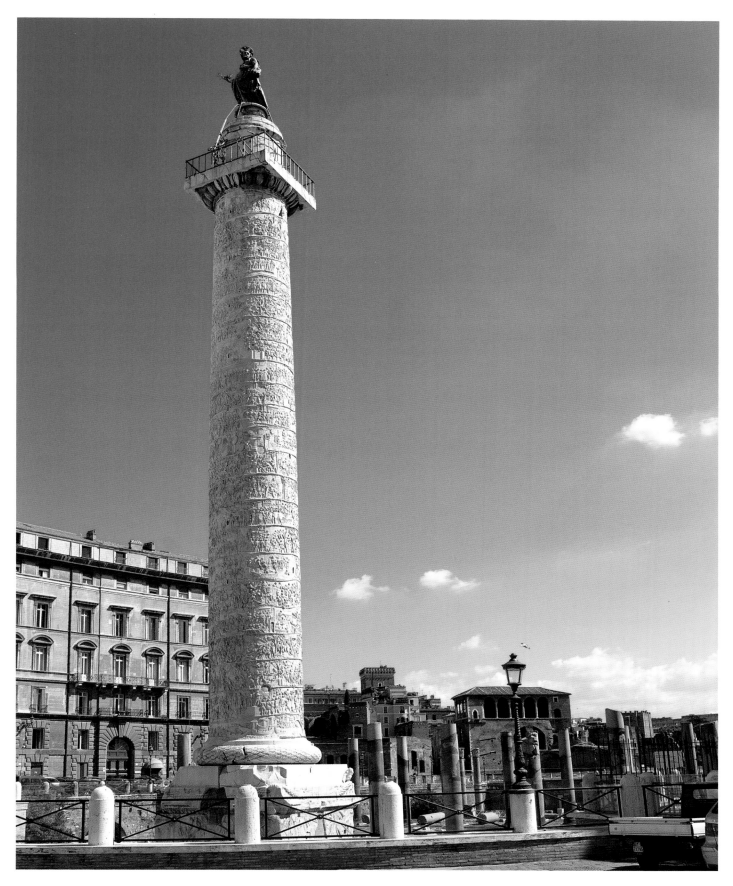

↖ Trajan's Column, Rome, designed
by Apollodorus of Damascus, AD 113

👁 Detail showing the carnyx,
Trajan's Column, AD 113

→ Detail of Trajan's Column, AD 113

isolate a single eye-hook through which our gaze can glimpse the object's aesthetic essence. But Trajan's Column does feature on its sculpted and inscribed base – the one level that observers of the soaring object would be expected to contemplate up close – an easily overlooked detail that may unlock how its harsh harmonies should be heard. Like the cylindrical column that rests upon it, the structure's heavy cubical base (consisting of eight blocks of multi-ton marble) is surrounded by a highly detailed frieze. Here, the confiscated armour and regalia of the crushed Dacians is shown heaped up in a dense and dishevelled mound. Amid the cacophonous pile of shields and swords, helmets and spears, one strange item stands out: the howling head and distended neck of what appears to be some kind of stylized mythological beast.

The object – in fact, a type of ancient trumpet known as a carnyx – would have played a crucial role in asserting the Dacians' presence on the battlefield. Shaped not unlike a modern periscope, the carnyx was an elongated bronze tube fitted, on one end, with a mouthpiece, and, on the other, with the opened-mouth roar of a fearsome creature such as a serpent or boar. Blown discordantly as a rallying screech to rouse one's troops, the carnyx was hoisted vertically above the head of the soldier who played it, as if channelling the will and power of the gods. Symbolically staking claim to the air space in which it was raised, the carnyx stood straight like a shining column, fixing a focal point around which the Dacian's muscle was mustered.

The eventual erection of Trajan's Column, which commemorated the vanquishment of the Dacians and the silencing of the carnyx's 'dreadful din' (as the Greek historian Polybius described the instrument's jarring notes), signalled a supplantation of one kind of instrument with another. Comprised of twenty-nine blocks of solid marble that have been hollowed out to accommodate a winding staircase, Trajan's Column – like a carnyx – is an empty phallic tube thrust into the air trumpeting valour. Both the carnyx and Trajan's Column serve the symbolic function of a fluted conduit capable of connecting the breath and struggles of this world with the realms of deity above. In 1587, Pope Sixtus V ordered that the statue of Trajan that had blared boldly from atop the column for a millennium and a half be replaced by a bronze likeness of St Peter, amplifying the impression that the column is not so much to be appreciated as a chronicle of skirmishes in this world than as a holy instrument heralding the soul's whispered whoosh to one beyond.

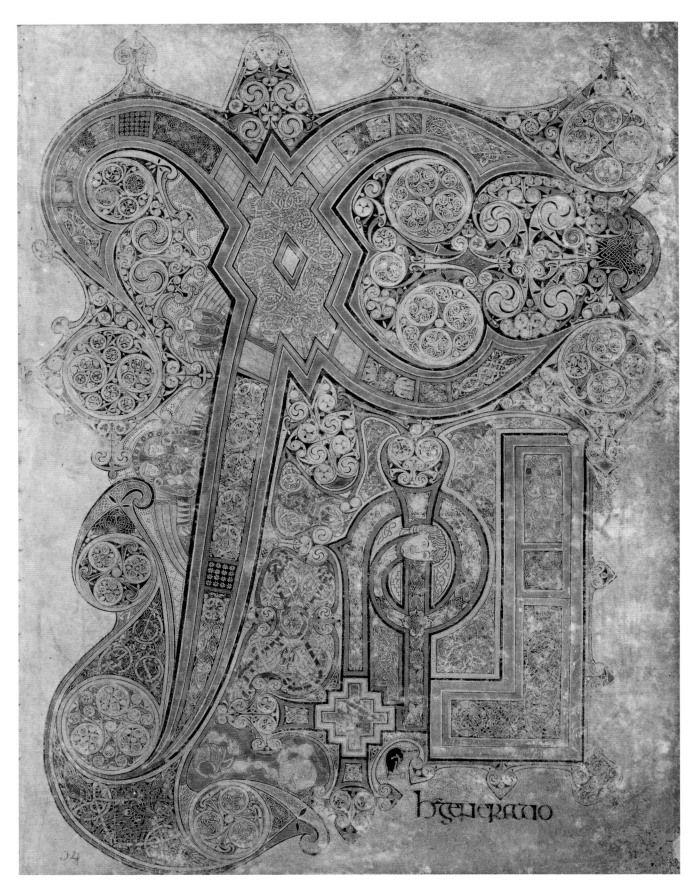

hGENERATIO

The twelfth-century historian Gerald of Wales concluded it was 'the work of an angel and not of a man'. But what makes this carefully calibrated engine of soulful symbolism tick?

Art is a knot. The most intense and enduring works are a braid of personal and universal expression interwoven so intricately and cinched so tightly that it is difficult, if not impossible, to detect where the intimate ends and the infinite begins. No work demonstrates the entanglement of the personal and the shared more impressively than the 340 surviving folios of the illuminated manuscript known as *The Book of Kells*. Created around AD 800 by Columban monks on Iona (a small island in the Inner Hebrides off the western coast of Scotland), the book is composed in Latin calligraphy and features the four gospels of the New Testament preceded by a variety of texts and elaborate tables.

Consisting of four separate volumes made from calfskin vellum, *The Book of Kells* knits into its sumptuous surfaces an elaborate combination of competing visual systems: verbal and non-verbal, representational and abstract, geometric and free-flowing. The result is a text that isn't a text – a drawing that isn't a drawing. As letters and creatures, spirals and doodles, angels and symbols merge and diverge before our very eyes in a labyrinth of language – now tugging together, now pulling apart in an endless flux of pliable forms – we find ourselves flailing for legibility, struggling for visual survival.

Like a lava lamp of shifting shapes, the universe and everything in it appears on the verge of melting into words, while every syllable is suddenly a chrysalis capable of sprouting wings and flying off: an incarnation of the very thing for which it previously stood.

Psychedelic hybrids on which word and image are entangled, the book's pages appear to rustle mystically between two worlds: the real and the unreal, heaven and earth, what is there and what is not. To study the book carefully, the twelfth-century historian Gerald of Wales insisted, is to 'make out intricacies, so delicate and so subtle, so full of knots and links, with colours so fresh and vivid, that you might say that all this were the work of an angel and not of a man'.

But what were the angelic creators of *The Book of Kells* trying to express? A recurring motif, and one into which the reader's eye is repeatedly impelled, is that of the Celtic 'triskelion', improvised versions of which spin spellbindingly throughout the medieval pages. Comprised of three twisting Archimedean spirals whirled curvaciously into a single sign of simultaneous triple rotation, the triskelion is ancient in origin and long pre-dates Christianity.

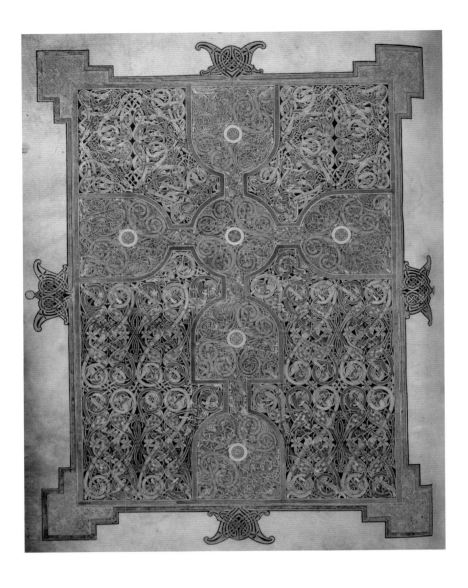

↖ Chi-Rho page, *The Book of Kells*, *c.* AD 800

← Page from the *Lindisfarne Gospels*, *c.* AD 700

The insular illumination of the *Lindisfarne Gospels*, created off the coast of Northumberland nearly a century before *The Book of Kells*, is likewise obsessed with reconciling the immutable mathematics of geometric patterns with the fleeting flesh of this world.

↓ Matthew Barney, preparatory sketch for *Cremaster 4*, 1994

The ancient motif of the three-legged triskelion continues to whirl in artistic imagination to this day. It features in multimedia American artist Matthew Barney's creation myth, *Cremaster 4*, as a symbol of eternal energy.

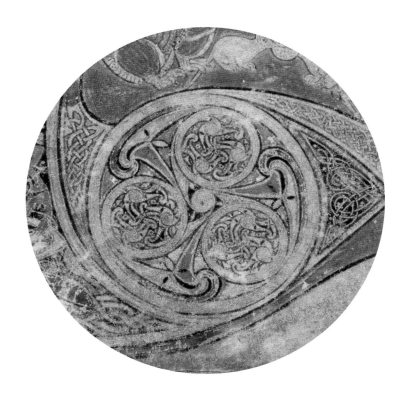

Detail of a triskelion from the Chi-Rho page, *The Book of Kells*, *c*. AD 800

Believed by anthropologists to represent the cyclical intertwinement of human and elemental energies (fire and blood, wind and breath, water and tears), the pagan pattern famously features in carvings found at the prehistoric tomb of Newgrange in County Meath, Ireland – a neolithic monument older than the pyramids of Egypt. The triple-pupils of the enthralling triskelion gaze out from the surface of the colossal stones into which they've been etched, transforming their countenance into a mien of weightless fluidity. To linger meditatively on the interlocking lace of their curvilinear paths is to risk falling under the spell of a mystic's deepening stare and the impulsion of his third eye. Though 'triskelion' literally means 'three-legged', the design is less leggy and far more optical in its penetrating urgency – like three irises spinning hypnotically. The dynamic of a third eye calls to mind the pupillary node Hindi masters refer to as the 'brow chakra': an invisible organ capable of spiritual perception located in the centre of the forehead above the anatomical eyes.

Twisting sinuously in Celtic imagination for centuries, the triskelion was easily adapted by Columban monks into a symbol signifying the mysteries of the Christian trinity: the undisentanglableness of God and man and spirit. Stylized versions of the triskelion that feature, for instance, on the so-called 'Chi-Rho' page of the illuminated masterpiece,

succeed in transforming the folio from a static artifact into the jewel-like gears of an ancient kinetic engine, whose whirring wheels-within-wheels mesmerize the eyes. On its face, the page is merely an obsessive glorification of the first three letters of Christ's name in the Greek alphabet – the Chi (an 'X'), the Rho (a 'P') and Iota (an 'I') – into which the now-forgotten illustrator stitched a mythic menagerie of beguiling beasts and bodies, tokens and motifs.

But stare long enough into the triple-gaze of the triskelions that whirligig across the page – from between the pinching pincers of the 'X', to the lower right-hand corner of the 'I' – and one is soon lulled into a spiritual trance necessary for feeling, if not consciously comprehending, the book's enticingly entangled message. Far from frivolous flourishes, the treble pirouettes of the triskelion provide counterweights to the charming, though studied, vignettes stitched into the folio's complex tapestry. While the sight of an otter catching a fish (the symbol for Christ), elsewhere on the Chi-Rho page, or the vision of butterflies resurrected from their silken tombs, can all be deciphered with scholarly footnotes, the monks who illustrated *The Book of Kells* were ultimately undertaking a far more profound illumination. The result is a divine lexicon that takes the reader from words read and interpreted intellectually to the very language of the soul.

Arguably the most important work to be created during the Song period, Fan K'uan's spiritualizing scroll offers a visual masterclass in the existential art of locating oneself in the eternal entanglements of nature.

Some eye-hooks are conspicuous. Others conceal themselves in the dense brush of an object's aesthetic landscape, apprehensive of apprehension. Such is the case with the only known surviving work of a reclusive, mountain-dwelling, Daoist poet and artist from China's Song dynasty. Here, the eye-hook that unlocks the mystery of the work managed slyly to dodge detection for nearly a millennium.

Fan K'uan's long, hanging scroll *Travellers among Mountains and Streams*, created sometime around the turn of the eleventh century, is the most sublime and influential work of the Song period, an era that stretched from 960 (the estimated year, coincidentally, of the artist's birth) to 1279. The over 2-metre-tall (6 ft) silk work is a marvel of misty perspective and calligraphic brushstroke. In it, the artist has articulated, out of a mizzle of often small and painstakingly precise gestures, a majestic landscape scene in which a ghostly mule train, loping its gauzy way leftwards across the upper foreground of the work, is shadowed into material insignificance by the looming scale of a brooding mountain rising behind it.

Fan K'uan's steep, cascading vision, which invested with mystical energy an existing tradition in Eastern art

of meditating on the forces of nature, antedates by many centuries any comparable inclination in Western art to regard the landscape as a subject worthy of scrutiny and representation in its own right. Art historians endeavouring to characterize Fan K'uan's achievement in his soulful scroll have tended to locate its poetic temperament within the context of what little we know of the artist's own life. Attention is typically drawn to his ascetic retreat from society, in a time of political and social turbulence following a tempestuous stretch of Chinese history known as the Five Dynasties and Ten Kingdoms period (an era of intense upheaval that saw the rapid succession of Chinese states). Alone in the mountains, Fan K'uan searched for enlightenment.

Seen as a visual echo of Fan K'uan's own journey, *Travellers among Mountains and Streams* is widely interpreted as a spiritual statement on man's position in the cosmic order of the universe. Focus is typically drawn to the three distinctive planes of existence that the scroll articulates, each demarcated by a horizontal hiatus in detail where the landscape appears briefly to dissolve into the empty silk background of the work. Moving from bottom to top,

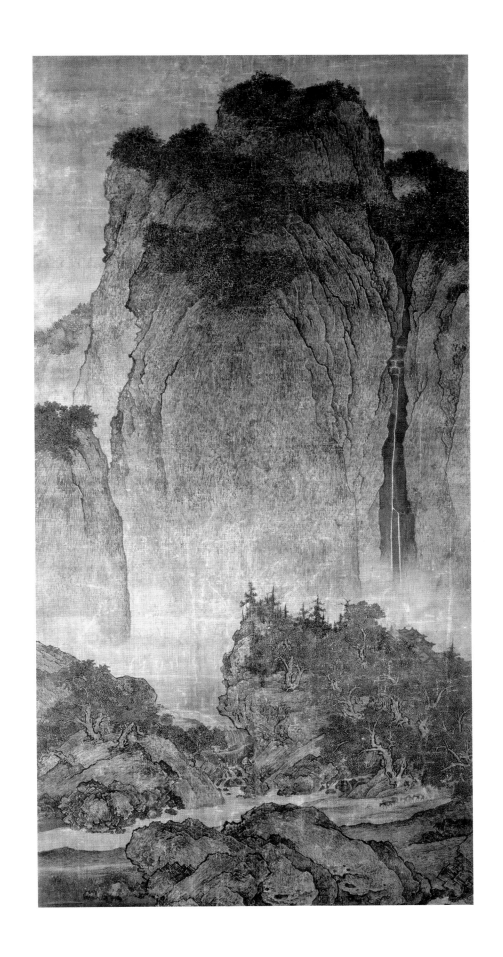

→ Fan K'uan, *Travellers among*
Mountains and Streams, c. 1000,
ink on silk hanging scroll,
206.3 × 103.3 cm (81¼ × 40⅝ in.)

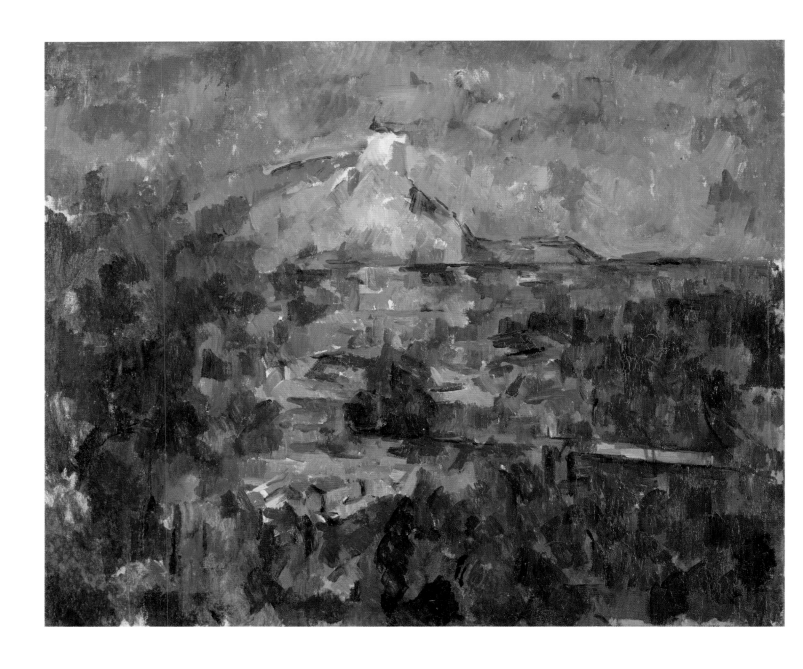

↑ Paul Cézanne, *Mont Sainte-Victoire seen from Les Lauves*, 1904–6, oil on canvas, 60 × 72 cm (23⅝ × 28⅜ in.)

Fan K'uan's inclination to translate the mountain into a symbol of self, and to break his gestures down into philosophical statements, anticipates the perspective of Paul Cézanne, who would measure his existence against the changing aspects of Mont Sainte-Victoire in southern France.

Detail showing the artist's signature (three Chinese characters stacked vertically, below the white mark among the leaves at centre right) in *Travellers among Mountains and Streams*, c. 1000

the eye levitates from the lowest sphere, a rocky foreground, upwards through the gap created by the path along which the mule train advances, to the second sphere, a hillocky middleground of contorted trunks and leafy limbs that half-conceals a temple. From there, the eye climbs precipitously, with no diminishment in perceptible detail along the way, through the highest sphere, which dominates the scroll, until it reaches a craggy eminence that the mind cannot avoid equating with the abode of eternal power.

A dark and narrow fissure in the mountain, bisected by a contrasting lightning-flash of falling water, brings our vision hurtling back to the lower spheres from which an endless cycle of ascent and descent begins again. Because the work's perspective never privileges the vantage of any one plane of existence, the scroll appears to offer itself as a stark manifesto on the ceaselessly intertwining and evaporative structure of nature's patterns, as movement is constant between darkness and light, presence and absence, positivity and negativity, lowness and highness. To stare into the gnarled rise and plunge of *Travellers among Mountains and Streams* is to ruminate on the dissolution of one's individual worldly self into the universe's energies and processes – to find oneself subsumed into something greater.

Profoundly philosophical in its vision, the work risks appearing unflinchingly austere, indifferent and aloof. But an ensconced eye-hook camouflaged in the scroll's heavy foliage, and discernible only after intense inspection and introspection, reveals just how intimately the artist himself comprehended the endless dispersals of being that his scroll mystically maps. Shadowing the emergence of the mule train as it materializes, on the right-hand margin of the scroll, from a jigsaw of dense leaves, Fan K'uan has secreted a ghostly vestige of his own dissipating identity in the form of the three stacked characters that comprise his name.

Caught mid-way between the abstract tessellation of strokes that the artist uses to denote the branches of trees, on the one hand, and the abbreviated brushwork that delineates the body of the man driving forward his herd, on the other, Fan K'uan has inserted himself symbolically into his vision. Neither literal nor metaphorical, yet both, the artist's name occupies a spiritual threshold between emergent states of existence, hovering forever between word and being, syllable and breath, the spoken-of and the speaking. By entangling an aspect of his own ephemeral self as a frangible component in the endless mutability of nature that his scroll describes, the artist elevates the achievement of his work from something purely philosophical to something deeply personal and poignantly felt. Once spotted, hunching in the hedge, the artist's fragile eye-hook signature – forever composing and decomposing into the universe around it – is the aperture through which we too perceive our endlessly transitory position in the cosmos.

Chronicling the Anglo-Saxon world in rich and compelling detail, this enchanting tapestry, woven by forgotten female hands, shows how the needle is mightier than the sword.

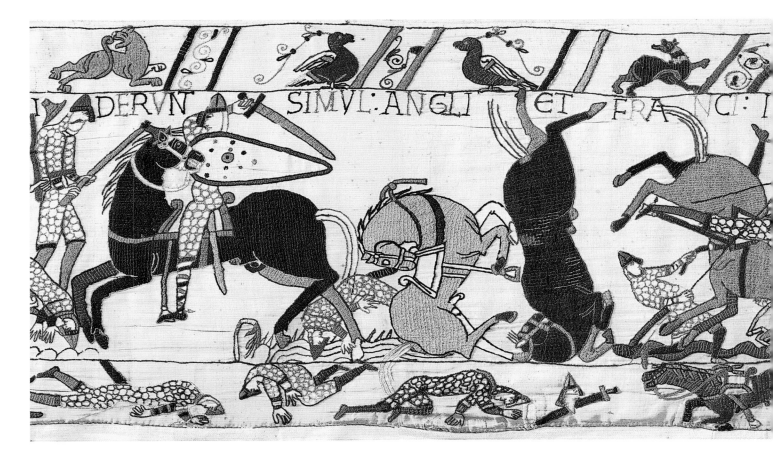

Just as every needle has an eye, so too does every great work of art. The eye is what pulls the thread forward towards meaning. Without the eye, the exercise of creation would be a pointless drag, knitting nothing. Occasionally, the eyes of the seamstress and those of a great artist merge into a single stupefying weave. Such is the case of our next work: the enchanting medieval textile known as the Bayeux Tapestry.

Likely created in the decade following the Battle of Hastings in 1066, in which Duke William II of Normandy defeated the forces of the Anglo-Saxon king Harold Godwinson, the 70-metre-long (230 ft) embroidered cloth unfolds in dizzying detail the events leading up to the Norman conquest of England. Fashioned from woollen yarn (or 'crewel') on tabby-woven linen, the work features over thirty scenes with Latin labels (or *tituli*) and takes observers on a journey from the royal palace of Westminster in 1064, when Harold is dispatched to Normandy by Edward the Confessor, to the retreat of Harold's forces from the battlefield following his death. It's assumed that a now-missing final scene originally concluded the work's visual narrative, and that the last words that now appear on the embroidery – *Et fuga verterunt Angli* ('and the English left fleeing') – are an early nineteenth-century intervention in the work.

More than merely an animated military chronicle, the three parallel furrows ploughed horizontally by the tapestry (the main central avenue of narrative is flanked, above and below, by narrower margins of imagery and comment) teem with vibrant snapshots of the Anglo-Saxon world. Stitched vividly into the fabric are glimpses of contemporary weaponry (swords, spears, bows and axes) as well as a suspended catwalk of battle-garb such as the leather kirtle known as a *hauberk* – a protective full-body tunic comprised of metal plates riveted together like oversized fish scales. Also on parade is a frozen flotilla of ancient ships that has proved indispensable to historians eager to distinguish their *drekars* from their *langskips* (their 'dragons' from their 'longships'). Amid the knotted flow of soldiery is woven, too, chiefly in the bordering friezes, a mingled menagerie of real and

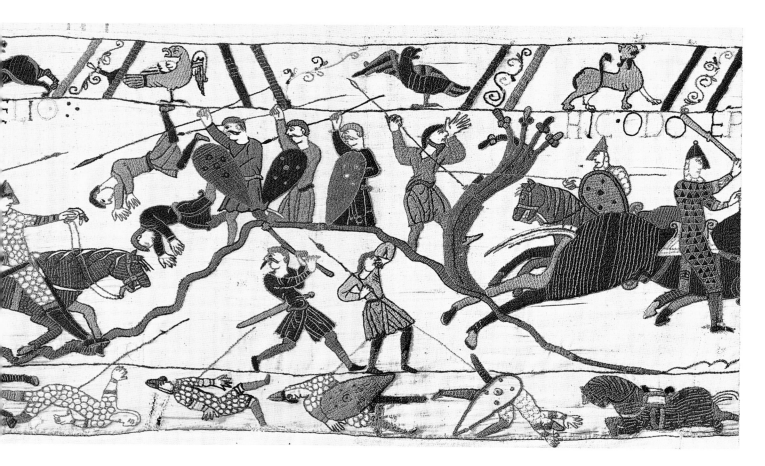

mythical beasts – camels and centaurs, deer and dragons, birds and griffins – integrated fantastically into a composite vision of perceived and imaginary existence.

The tapestry's digressive narrative, where a central story is braided with iconography cluttering contemporary consciousness, would prove extraordinarily influential to the imaginations of artists in the ensuing millennium. In 2009, the British artist Grayson Perry created an ambitious work that arguably updates the eleventh-century masterpiece. Perry's *Walthamstow Tapestry* (named after a northeastern borough of London) reinvents the clamour of signs on the contemporary psyche. In Perry's vision, however, the allure of fables (allusions to Aesop and the Roman poet Phaedrus have been located in the Bayeux Tapestry) is updated to an obsession with consumerism and retail brands. Gone is the legendary tale of conquest, replaced by a squandering of life spent in retail pursuits, while the lyrical imagery of mythical creatures has been supplanted by a crass cacophony of local and multinational brand names, from IKEA to Louis Vuitton.

Since the rediscovery in 1729 of the Bayeux Tapestry, hanging in the Norman-Romanesque cathedral in Bayeux, northwestern France, the precise circumstances surrounding its creation have been the source of much debate. At present,

academic consensus favours the belief that the work was commissioned by William's half-brother, Bishop Odo (who built the Bayeux cathedral where it was discovered), and that the arduous needlework itself was likely carried out by female artisans. The identity of the work's designer or designers remains a mystery.

What is clear, however, is the aim of the artist's eye, which pulls ours across the fabric of time. Caught in the artist's weave, we're drawn into her battle. If there were any doubt that the seamstresses responsible for creating this extraordinary history sought to stitch themselves and those they've seduced by their mastery into the fold of their creation, one needs merely follow the bias of their weave to its crewel end: the eye of King Harold, pierced by an arrow in the penultimate scene of this extraordinary history. Here, the artist's needle becomes, imaginatively, the very weapon that kills the English king and draws the story to its lethal conclusion. By clutching the arrow that pierces his eye, Harold merges at once into the figure of the artist, holding the needle, as well as the observer, whose eye too has been pulled forward by the slowly unfurling vision. With the tug of a single stitch, the eyes of the see-er, the seeing and the seen are hooked.

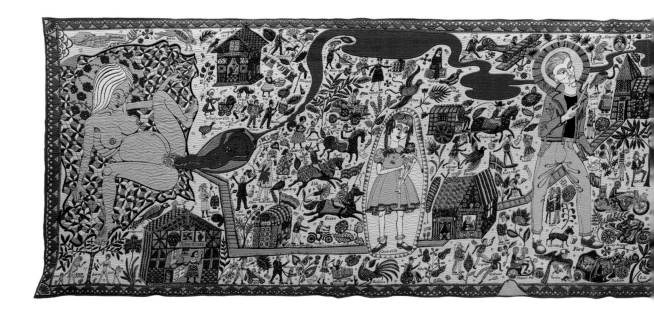

↖ Detail of the Bayeux Tapestry,
c. 1077 or after, crewel embroidery
on linen, total 50 × 700 cm
(19⅝ × 275½ in.)

👁 Detail of King Harold with an
arrow in his eye, Bayeux Tapestry,
c. 1077 or after

↓ Grayson Perry, *The Walthamstow
Tapestry*, 2009, wool and cotton
tapestry, 300 × 1471 cm (118 × 579 in.)

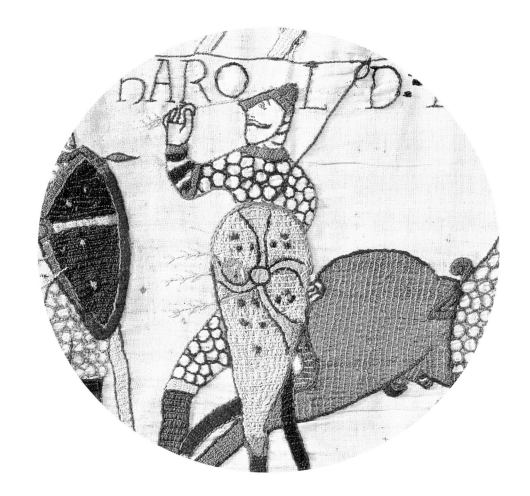

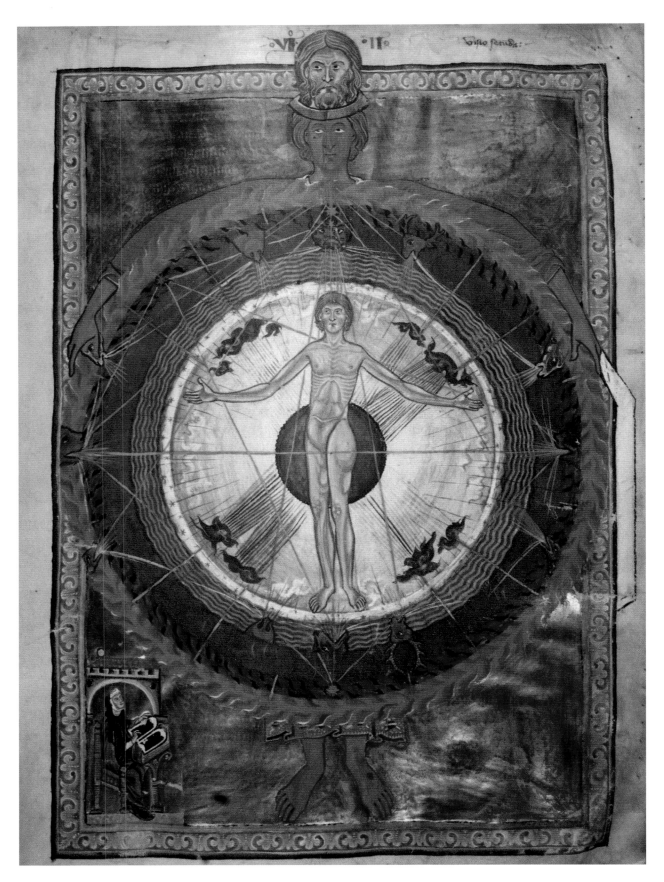

Anticipating one of Leonardo da Vinci's most famous drawings by several centuries, this mesmerizing vision of cosmological harmony and wholeness is music for the eyes.

Eye is in the art of the beholder. If that sentence seems a little inside out, so too are the inverted optics of our next work: a hypnotizing manuscript illumination by the twelfth-century German mystic and polymath Hildegard of Bingen. To lean in close and scrutinize the work for an eye-hook within the rippling concentricity of her illustration *The Universal Man* (sometimes referred to as 'Man as Microcosm') is to lose sight of the work's all-enveloping vision of cosmological wholeness. It is only when we zoom out from the image that we realize it is, itself, a large, stylized eye symbolizing the profound penetrations of mystical sight: a spiritual lens that simultaneously brings into focus the inner and outer universes of our being.

The illumination belongs to a series of ten intense visions that Hildegard experienced and subsequently illustrated for her third volume of theological writings, *Liber divinorum operum* (or 'Book of Divine Works') (*c.* 1165), to which she devoted a decade of her life. In the corner of each image (here, in the lower left), the Benedictine abbess installed a self-portrait depicting the instant when the divine vision occurred. A gifted dramatist (author of the earliest known morality play) and innovative linguist (creator of the first independently invented language), Hildegard was also blessed with a mathematician's eye and a composer's ear for symmetry and proportion. Those intuitions blend symphonically in the eye-music of Hildegard's *The Universal Man*.

The image represents, on one level, the mystic's conviction in the harmonic structure of the Trinity: 'the bearded Creator emerges', according to one scholar's interpretation of the work, 'from the head of the fiery Holy Spirit who embraces, in turn, the circular firmament surrounding the world'. On another level, the image demonstrates the melodic proportions of the human body in relation to those of the universe that surrounds it, cosmologically, and the material that comprises it, microscopically. Millennia before modern-day nuclear physicists would successfully model the orbit of subatomic particles, Hildegard traces a dizzying ricochet of mystical energy trapped within her dimension-defying orb. Amplifying the sense of competing rotations, or spins-within-spins, that invigorate the work is the rivalrous movement of coaxial bands of different elements.

Moving inward from its outermost crust, the work appears to be comprised of distinct layers held in mysterious equilibrium, as an exterior skin of fire envelops a galactic

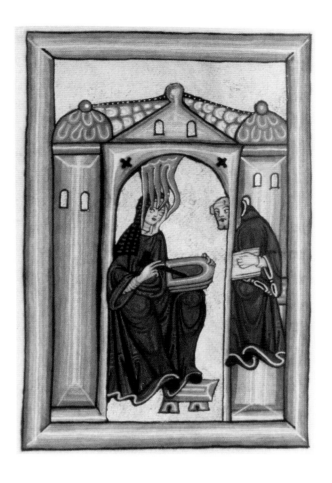

stratum of stars just beneath it, which in turn enshrouds
a band of flowing water, followed by an atmosphere of
implosive winds, and finally a clay-like crux at the very core.
Further complicating the orb's inimitable anatomy is a
mesh of light that webs its surface like blood vessels pulsing
in the white sclera of an eye, thereby turning the image's
unflinching stare back at the observer into something vital
and urgent. The result is an image that doesn't merely mirror
the cosmic structure of the universe it beholds but is itself
a mystical merging of the seeing and the seen, the beholder
and the beheld. In the spiritual language of Hildegard's
vision, being and seeing – the macro- and microscopic
designs of the universe and the design of the eye – are one
and the same.

Three centuries before Leonardo da Vinci would square
the circle of his awe at the body's geometry in his pen-and-
ink drawing from 1490, *The Vitruvian Man*, Hildegard plucked
from the mute chords of the universe a symbol of the
inward and outward perfection of the human physique. Da
Vinci's later work, which corresponds to ideas propounded

by the Roman architect Vitruvius in his first-century BC
treatise *De architectura*, illustrates the classical notion
that the human form establishes the ideal proportions
for all man-made structures. But Hildegard's earlier
vision hypothesizes something galactically grander:
the human body is the indispensable unit against which,
and through which, all of creation must be measured.
Whether one's scrutiny of her illumination moves from
the margins to the core or vice versa, a concentricity
of consciousness – from human perception at the work's
centre to divine omniscience overseeing all from outermost
edge – dominates the image.

The centripetal force of Hildegard's illustration
generates a diffusive blare from the central human frame,
as if the combined mechanism of body and soul were
that of a vibrating lute orchestrating into existence the
unheard music of the spheres that harmonizes all around
it. What ultimately stares back at us is an all-perceiving
work of inward and outward depth that, by seeing,
helps us see.

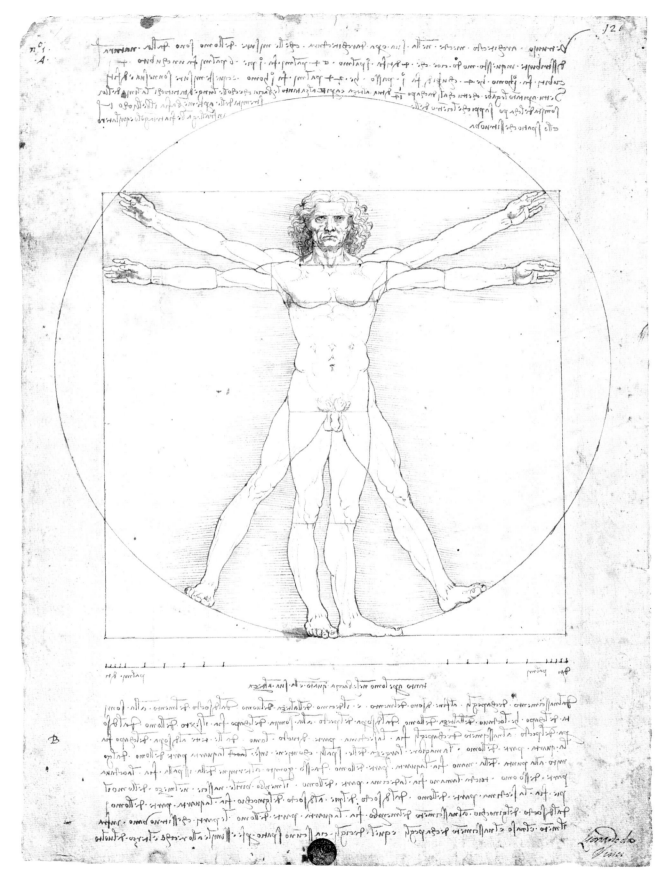

The shadow cast by Masaccio's wrenching depiction of Eve howling as she and Adam exit paradise, among the most excruciating in art history, is stranger than it seems.

'Beware,' the ancient storyteller Aesop once warned, 'lest you lose the substance by grasping at the shadow.' Anyone attempting to apprehend the essence of our next work would do well to keep Aesop's riddling advice in mind. Created by the fifteenth-century Renaissance master, Masaccio (Tommaso di Giovanni), the seemingly simple fresco *The Expulsion from the Garden of Eden*, which has clung to the walls of the Brancacci Chapel in the church of Santa Maria del Carmine in Florence for nearly six hundred years, is a work whose substance is difficult to disentangle from a tease of shadows.

At first glance, the biblical work is as elegantly straightforward in its visual narrative as it is excruciatingly poignant. Sloping, slump-shouldered and ashamed, Adam and Eve, escorted by a sword-wielding angel who floats above them, are portrayed exiting paradise after their crime of indulging in fruit from the tree of knowledge of good and evil has been exposed. Eve, covering herself awkwardly with her arms and hands, wails wretchedly while an inconsolable Adam hides his eyes in humiliation as the full weight of their fallenness sinks in.

An emblem of insufferable sorrow, Masaccio's depiction is deservedly famous and frequently reproduced. Beyond the profundity of its illustration of incalculable loss, the work is often cited by historians as groundbreaking in its insistence on portraying the human body with anatomic exactitude. Though one may niggle with the proportions of the figures' limbs, the artist's determination to create credible bodies that are consistent with those we encounter in the real world is unmistakeable and one that would influence the next generation of Renaissance masters, particularly Michelangelo.

Ultimately, however, it is not the convincing physiques that explains the endless awe the fresco evokes. Six centuries after he created the work, Masaccio's pioneering realism, while significant on an art historical level, is not what makes the image perpetually urgent. Rather, our gaze is transfixed by a tension that the eye hardly registers on a conscious level. To stare into the interminable torment depicted in the fresco is to find oneself caught, subliminally, in the crosshairs of competing sources of light – one physical, the other spiritual. It is this surreal clash of imagined radiance that invigorates the painting's surface – a discordance that complicates the artist's vision and draws us into his soulful conception of man's liminal position in the universe as forever suspended on the threshold between two irreconcilable realities.

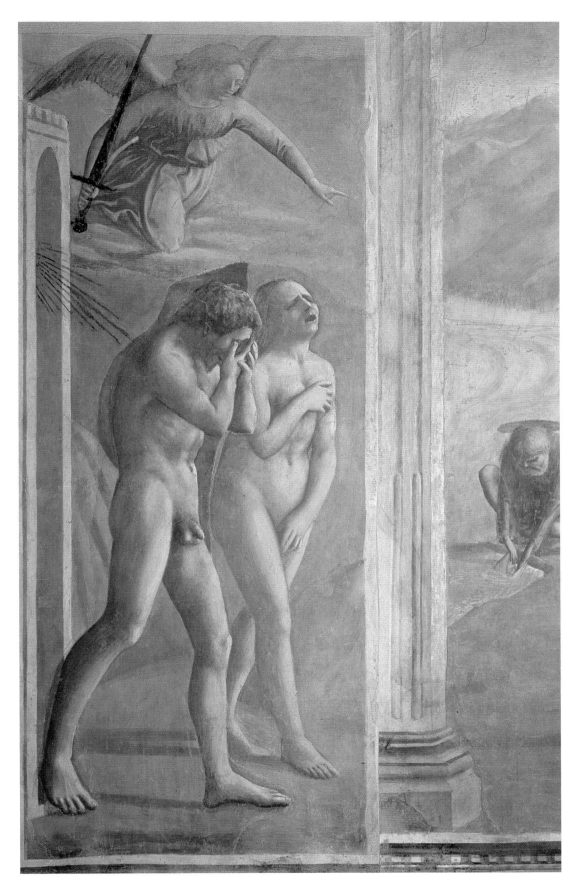

→ Masaccio, *The Expulsion from the Garden of Eden, c.* 1427, fresco, 217 × 90 cm (85 ⅜ × 35 ⅜ in.)

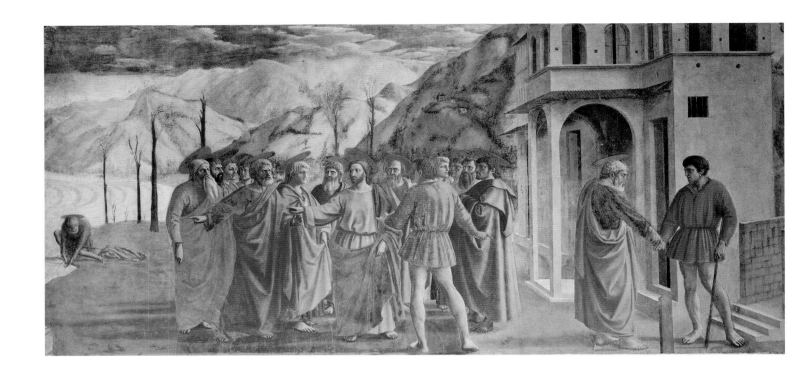

↑ Masaccio, *The Tribute Money*, 1425, fresco, 247 × 597 cm (97¼ × 235 in.)

→ Mark Alexander, *Red Mannheim III*, 2010, oil on canvas, 258 × 190 cm (101½ × 74⅞ in.)

Masaccio's mingling of earthly and spiritual light created a clash of illuminations that would cast a long shadow on art history. The weeping infant figures of Adam and Eve in British artist Mark Alexander's *Red Mannheim* (a huge silkscreen inspired by the fragments of an eighteenth-century altarpiece by the German artist Johann Paul Egell that was shattered in the Second World War) vibrate a haemoglobin glow that also seems simultaneously to flow from the body and the soul.

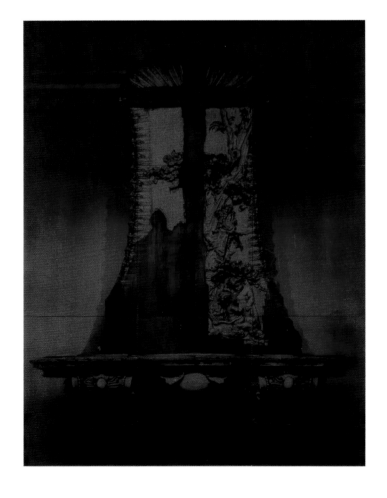

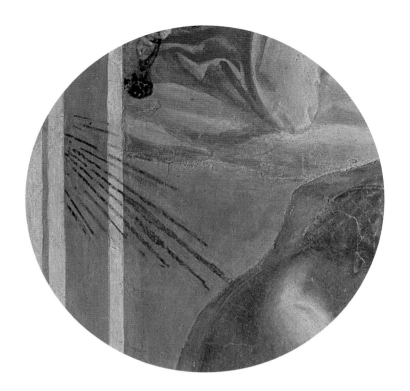

👁 Detail of rays of light in
*The Expulsion from the Garden
of Eden*, c. 1427

To trace the curious collision of conflicting luminosities, merely compare the angle at which the shadows that stretch across the ground from the feet of Adam and Eve are projected, with that of the rays of light we see blaring from left to right through the acutely foreshortened gate from which the pair have just emerged. Brilliantly lustrous when initially painted in the fifteenth century, these thirteen lucent spokes, which flare aggressively towards Adam's back, have slowly tarnished over time. No longer silvery and easily equatable with refulgent gleam, they now appear black and heavy. To the modern eye, these diverging tangents seem more like cartoon gestures for trumpeted sound than a bold burst of light from paradise lost. That this great gust of light surging from Eden fails to generate a single shadow from the expelled figures of Adam and Eve is the most subtly jarring and quietly heartbreaking aspect of the fresco. Only ghosts cast no shadow.

We know from a much larger adjoining fresco, painted by Masaccio around the same time and immediately to the right of his *Expulsion from the Garden of Eden*, that the artist was obsessed by the verisimilitude of shadows in his work – a meticulous fascination that would influence subsequent artists. The light cast across Masaccio's *The Tribute Money*, widely regarded as a masterpiece of perspective and shading, has been carefully calibrated by the artist to appear as if it is streaming into the space from a source to the right of the painting, directly through the windows of the chapel itself. That same light source, located outside the fresco, appears likewise responsible for casting the shadows that fall from the bodies of Adam and Eve, thereby connecting not only the two separate scenes, but the spiritual world of the frescoes and the physical world of reality.

It is Masaccio's uncanny decision to create a mystical clash in sources of light – one flowing from the right and one from the left – that hooks the soul's eye and amplifies the observer's sense of spiritual dislocation from the lost lucency of paradise. Once 'apparelled in celestial light', as the Romantic poet Wordsworth would later describe a similar expulsion in his *Ode: Intimations of Immortality*, 'the light of common day' now dims the prospects of Adam and Eve, who are left to wander the world asking 'whither is fled the visionary gleam? Where is it now, the glory and the dream?'

↓ Jan van Eyck, Ghent Altarpiece
(closed), 1430–32, oil on panel,
350 × 230 cm (137 ¾ × 90 ½ in.)

Though oil painting was only just coming into vogue in the fifteenth century, Van Eyck demonstrates a mastery that has yet to be surpassed. His altarpiece conjures textures that are mesmerizing in their zesty detail.

Art is a lemon. It must be squeezed into meaning. Take the fifteenth-century altarpiece that resides in St Bavo's Cathedral in Ghent, Belgium – the multi-panel masterwork known as the *Adoration of the Mystic Lamb*. Painted between 1430 and 1432 by the Flemish artist Jan van Eyck and designed by Jan's brother Hubert, the so-called Ghent Altarpiece is comprised of twenty-four oil-on-wood-panel devotional scenes, twelve of which are visible when the altarpiece is closed, twelve when opened. The polyptych is a milestone in the history of image-making, demonstrating how oil paint (only recently introduced into Western art) could make figures and objects appear more realistic than ever before.

The vibrancy of scenes from the Annunciation of Mary and sculptural portraits of St John the Baptist and St John the Evangelist (observable when the altarpiece is shut) is surpassed when the work opens along its two sets of hinges to reveal what's hidden inside: the outrageous opulence of an enthroned Christ, flanked by a bejewelled Virgin Mary on one side and a regal John the Baptist on the other. The swanky triumvirate, clad flamboyantly in swish velvet robes trimmed with sparkly stones, are surrounded by musical angels – some singing, some playing instruments – all of whom preside over a gathering of congregations, descending from every angle, that have come to witness the Lamb of God being sacrificed. Never before has the portrayal of flesh seemed so believably supple, have jewels popped so resplendently, has foliage flourished so perishably, or has fabric rumpled so lyrically.

Amid the avalanche of sumptuous detail, a single small object stands out and seems strangely at odds with the luxuriance that glitters all around. As the observer's eye slips from texture to texture – from Christ's crystalline sceptre in the top middle panel to the suspended swing of pewter censers in the scene below him, from the pursed-lipped petals of the lily-fluted crown worn by Mary to the soft trickle of weightless water that spurts from the fountain of life in the panel beneath her – the gaze suddenly snags on the small rugged sphere that rests between Eve's delicate fingers in the top right corner of the work. By balancing in her gentle grip not a waxen-skinned apple (as most artists portraying the forbidden fruit previously had) but instead a now rarely encountered cousin of the lemon known as a 'citron', Van Eyck stitches into the fabric of his painting a curious cipher that unlocks much of the visual energy that ties his complex work together.

↓ Jan van Eyck, Ghent Altarpiece
(open), 1430–32, oil on panel,
350 × 460 cm (137¾ × 181⅛ in.)

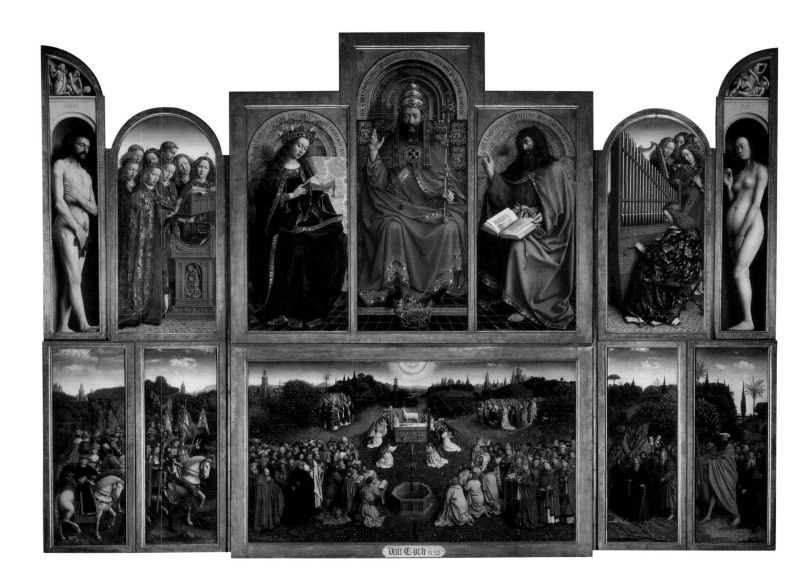

Knobbly and sullen in colour, the citron (which was known to Van Eyck's contemporaries by the suggestive nickname the 'Adam's Apple') is rich in secret symbolism and teeters on Eve's lips as a subtle rebuke to the egregious extravagance glittering all around. Rarely enjoyed as a food, due to the bitterness of its flesh, the citron has been prized since antiquity for the alleged healing power of its sweet scent. So treasured was citron oil in Roman times that it was thought its fragrance could open up one's senses to spiritual enlightenment. Jewish tradition added a deeper layer of religious significance still. Embellishing Roman attitudes towards the fruit, Jews began regarding the citron (or what they call the *etrog*) as a symbol of their own endurance in the face of persecution and went to great lengths to procure for ceremonial adoration pristine pieces of the fruit from distant tropical climates. Once acquired, the gnarled *etrog* was placed on a small flax pillow in an ornately engineered cradle, like a swaddling child.

A well-travelled diplomat, Van Eyck would have had many opportunities to learn of the citron's spiritually rich history on his journeys throughout the Mediterranean. By intertwining contradictory connotations of both innocence (a swaddled infant) and experience (the fruit of original sin), the citron enshrines within its fragrant rind paradoxical allusions to the Fall of Mankind and to its eventual salvation with the arrival of the Christ Child. Everything depicted in Van Eyck's altarpiece, in other words, is symbolically contained in and flows from the strange fruit that Eve holds. To amplify the point, Van Eyck appears to cut the citron open and squeeze spiritual light on those who have come to witness the sacrifice of the Lamb in the altarpiece's central panel. The concentric rings of the orb that vibrates at the apex of that panel bear a remarkable resemblance to the cross-section of a citron, which is characterized by a bumpy rind and thick albedo. To stand before the Ghent Altarpiece is to souse one's soul in the secret citron light of a fragrant masterpiece.

At first glance, Rogier's work traces a downward movement from tortured elevation to emotional despair. Look closer, and the painting's true trajectory is charted on another plane entirely.

The greatest works of art take aim at the eye and pierce the soul. Consider Rogier van der Weyden's Early Flemish masterpiece *The Descent from the Cross*, painted around 1435. It used to be asserted that the work owes its extraordinary power principally to Rogier's agility with the newly introduced medium of oil painting. (Giorgio Vasari, the legendary Renaissance biographer erroneously, although influentially, attributed the invention of oil painting to Rogier's contemporary Jan van Eyck.) While it is true that no painter before or since has alchemized from those same modest ingredients of pigment, linseed and wood panel a more lilting lyricism than glistens from the trembling tears that bejewel the faces of the devastated mourners in *The Descent from the Cross*, it isn't merely Rogier's prodigious proficiency with his materials that makes the work so pressingly poignant.

To appreciate what truly makes the painting thrust itself with unprecedented urgency in the viewer's direction one must first dispose of the notion that Rogier himself believed that he was constructing merely a static painting rather than a sophisticated contraption of retinal assault. Where earlier portrayals of the New Testament scene, such as the Limbourg brothers' illumination of the same subject in the French Gothic manuscript *Très Riches Heures du Duc de Berry* (*c.* 1410) and the virtuoso tempera-on-panel *Deposition of Christ* (*c.* 1433) by Rogier's Italian contemporary, Fra Angelico, seek to elevate the observer onto a transcendent plane of solemn yet composed grief, Rogier is determined to deliver to those who encounter his work a visceral body blow – one that is as physically and emotionally destabilizing as the anguish suffered by those in attendance at Christ's descent.

How does Rogier orchestrate such a stinging strike? Though the painting in every respect appears, at first glance, to demonstrate the artist's formidable skill in translating reality into art – from its masterful rendering of patterned fabrics, fur and contrasting complexions to the heft and curve of convincing form it sculpts from a flat surface – the intense choreography of its figures is strangely stilted and has, in fact, been distorted into the shape of a weapon being loaded. The work was commissioned by the Great Crossbowmen's Guild for display in the Chapel of Our Lady Outside the Walls at Leuven, which the archers' union had founded a century earlier. Students of the panel have long delighted in the hidden homage Rogier pays his patrons by secreting into the spandrels that lattice the upper leftmost and

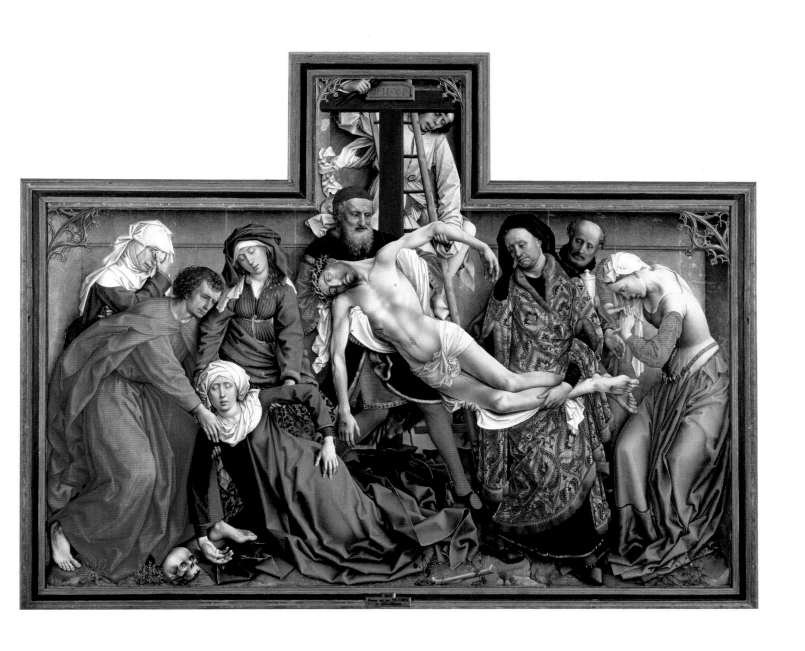

↑ Rogier van der Weyden,
The Descent from the Cross, c. 1435,
oil on panel, 204.5 × 261.5 cm
(80 ½ × 102 ⅞ in.)

Detail showing the spikes in
The Descent from the Cross, c. 1435

← Peter Paul Rubens, *Descent
from the Cross*, 1611–14, oil on panel,
420.5 × 320 cm (165 ½ × 126 in.)

rightmost corners of his painting a pair of tiny crossbows that twist and dangle on the periphery of our vision. It is also widely accepted that the distinctive shape of that armament (which dates back to the sixth century BC) is echoed in the crumpling physiques of three of the key protagonists of the work: the deceased Christ himself, his fainting mother below him, and (to our far right) the collapsing figure of Mary Magdalene, whose bowed limbs rhyme remarkably with the sprung lathes of a cocked crossbow.

But Rogier's invocation of the contours of the crossbow goes well beyond tactical tribute to a powerful benefactor on whose commissions his career relied to the very heart of the work's theological and artistic strategies. Suddenly, the pulling back of Christ's arm by the young attendant assisting in his descent becomes, itself, the drawing of the crossbow's string – as if the weapon were being loaded. In the attendant's other hand, still poised upon the crucifix's horizontal crossbeam (far too short to have ever supported the outstretched arms of the body being deposed), are a pair of long spikes. Historians have always assumed that these horrid skewers are the crucifixion nails that had posted Christ's hands and feet to the cross. Unlike typical crucifixion spikes, however, these

prongs do not have flat heads that could withstand aggressive hammering but rather sharp arrow-like points. In length and design, they far more closely resemble iron crossbow bolts than nails.

Stained with blood, these fearsome spurs are meant, visually, to serve the dual function of representing the literal nails that perpetuated Christ's torture and the metaphorical arrows that will, once released into consciousness, pierce the soul of those who encounter Rogier's poignant panel. The unexpected eye-hooks of his work, these bolts protrude slightly beyond the frame's perimeter in the manner of subtle *trompe l'œil*, breaking the visual plane of the painting – the only objects in the work to do so – in order to begin their soar across centuries. In their long flight through the atmosphere of Renaissance and Baroque masterworks to the sublimated spiritualities of works created in our own age, we'll catch glimpses of these nimble nails again and again: spiking the bloodshot eye of the copper basin at the foot of Peter Paul Rubens's *Descent from the Cross* (1611–14) and transmuted into a sharp syringe that lolls beside a car-crashed corpse in Grayson Perry's 2012 tapestry, *#Lamentation*, inspired by Rogier's panel.

Fra Angelico doesn't want you to look at his painting. He wants your spirit to surge through it.

The most moving works of art are mutually penetrating: we enter them and they enter us. No artist understood that reciprocity more profoundly than the fifteenth-century Early Italian Renaissance painter, Fra Angelico. His depiction of the Annunciation – the moment described in the gospels of Luke and Matthew when the Virgin Mary is informed by the angel Gabriel that she will become the mother of Jesus – is a masterpiece of simultaneous penetration of subject and observer, the see-er and the scene.

Fra Angelico's fresco was part of a suite of decorations commissioned by Cosimo de' Medici between 1437 and 1444 to adorn the walls of the recently refurbished Convent of San Marco in Florence. Unlike earlier treatments of the same subject by medieval and Byzantine predecessors, however, Fra Angelico's work goes well beyond merely illustrating the story of the mystical meeting between angel and mortal; it also plays with the entangled physical and spiritual paradoxes of the event portrayed – the Virgin Mary, conceiving the inconceivable – by manipulating the observer's experience of the graphic space that the fresco constructs. By positioning his work at the top of a set of stairs that lead to a collection of dormitory cells on the north side of the convent, the artist ingeniously exploits the upward trajectory of the monks' movement towards his fresco by creating the illusion that the ascendancy could extend right *through* the fresco.

The principles of geometric perspective had only recently been established by the pioneering Italian designer Filippo Brunelleschi, who demonstrated in 1413 how the orthogonal lines of every scene we look upon converge to a distant vanishing point. Barely a generation later, Fra Angelico is adroitly finessing Brunelleschi's theories in the construction of a work that collapses physics and metaphysics, action and prayer, life and art, into a single imagined plane. Monks climbing the stairs of the convent, their eyes fixed upon Fra Angelico's *Annunciation*, would find themselves contemplating a merging of self and scripture: a penetration of the impenetrable.

Without this kinetic component of the observer rising physically towards the fresco, the work would appear organized on a strangely steep incline. While the figures themselves are described with exquisite contemplative calm, the forward thrust of the viewer upwards towards the fresco gives the experience momentum – an impetus that no *Annunciation* before or since arouses. Intensifying the

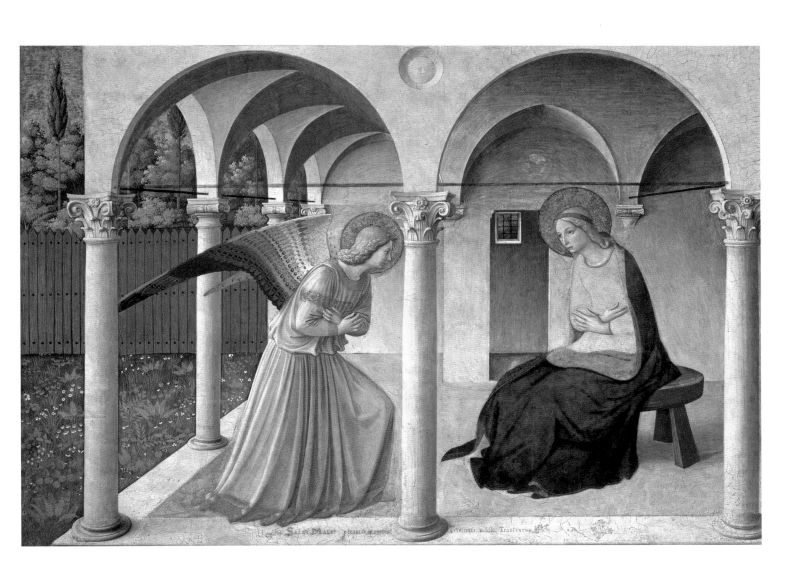

↑ Fra Angelico, *The Annunciation*,
c. 1438–47, fresco, 230 × 321 cm
(90 ½ × 126 ⅜ in.)

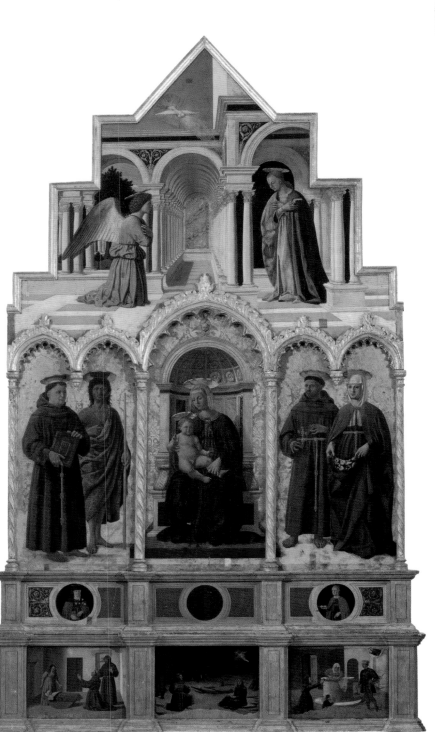

👁 Detail showing the rear window in *The Annunciation*, *c.* 1438–47

← Piero della Francesca, *Polyptych of St Anthony*, *c.* 1470, oil and tempera on panel, 338 × 230 cm (133 × 90½ in.)

The implied penetration of perspective in Fra Angelico's *The Annunciation* is echoed in the architectural regressions of Piero della Francesca's later depiction of the same biblical scene in his *Polyptych of St Anthony*.

effect is Fra Angelico's placement of the vanishing point itself in a spot that lies just beyond the bars of the small window that is punched into the wall of the cramped chamber at the very back of the painting. By leading our eye and spirit through this crude partition to the secret garden that lies just beyond, Fra Angelico is inviting our gaze to perforate the boundaries of one world to access another.

The artist's contemporaries would immediately have equated the hidden garden that sprawls on the other side of the barred window with the tradition of the *hortus conclusus* – a recurring symbol in religious literature of the time. A Latin phrase meaning 'enclosed garden', the *hortus conclusus* is a complex metaphor that simultaneously conjures the lost paradise of Eden (recoverable only through the salvation provided by Christ's birth, death and resurrection) as well as Mary's own impenetrable immaculateness – her sacred virginity. In other words, the invisible garden that lies beyond the back wall of the space in which the Annunciation is unfolding is a spiritual space that symbolizes Mary's unstainable purity. By propelling the observer's eye through his work, beyond the eye-hook of the black bars of the back window, to the fresco's teasingly unreachable vanishing point, Fra Angelico encourages a kind of imagined penetration of Mary's heretofore undefiled garden. By doing so, he has orchestrated an irresistible aesthetic paradox of inevitable, yet impossible, piercing – an ascent of vision that echoes the spiritual assent that Mary gives to the angel Gabriel.

→ Richard Hamilton, *The Annunciation*, 2005, digital print on paper, 95.4 × 68 cm (37½ × 26¾ in.)

A modern retelling of Fra Angelico's famous painting, Richard Hamilton's digital print re-imagines the spiritual dialogue between the Virgin Mary and the angel Gabriel as a relaxed chat on a cordless phone. The eye-hook *hortus conclusus*, magnified into a large window, still beckons the soul.

A triumph of manipulative perspective, this masterpiece from the fifteenth century conceals in plain sight an easily overlooked key that unlocks its profundity.

With every blink, our eyes anoint themselves in tears. Momentarily entombed behind lids, our sight is continually resurrected and our perception of the world ceaselessly born again. To see and to anoint are primal reflexes of being, inextricably linked. Arguably no work in the history of art is more passionately aware of that interdependency than the unflinching depiction by the Italian Renaissance artist Andrea Mantegna of the parched body of the dead Christ awaiting burial. The painting, believed to have been created around 1480, is perhaps most admired by historians and casual observers alike for its groundbreaking vantage on the crucified figure, whom we see in extreme foreshortening, stretched on a marble slab known as the Stone of Anointment. Though not a large work, the painting's optics are disproportionately dramatic as Christ's feet appear almost to jut out of the canvas at us. The result is a body that smashes the visual plane, forcing observers to confront the reality of the tortured figure in an almost palpable way, as if physically present for the gruesome ablutions that immediately precede entombment.

In the context of earlier treatments of the biblical subject, Mantegna's painting is quite simply shocking. Accustomed to seeing the cradling of Christ's flaccid body in the grief-stricken arms and laps of those who knew him most intimately (as we see in such antecedents as Giotto's treatment of the lamentation in Padua's Scrovegni Chapel), observers of Mantegna's work would have found disorientating the brutal isolation of the unheld figure, propped on a comfortless slab, and distressingly callous the estranged posture of Christ's head, which tilts lifelessly away from those mourning beside him. Where Giotto strove to soften the spiritual blow of seeing Christ's crumpled body by surrounding him with mortified devotees with whom observers could emotionally identify, Mantegna strips away any semblance of reassurance that human contact might bring by refusing to depict any touching of the crucified flesh. The constellation of anguished angels that congregate majestically in the blue-frescoed heavens above Giotto's Christ has been swapped by Mantegna for a claustrophobic cropping of the scene as the upper edge of the frame crushes our gaze, forcing our eyes to withdraw by retreating along the length of the body and escaping through the wounds in his feet back into ourselves.

However innovative Mantegna's manipulation of perspective was – and it was – what ultimately piques

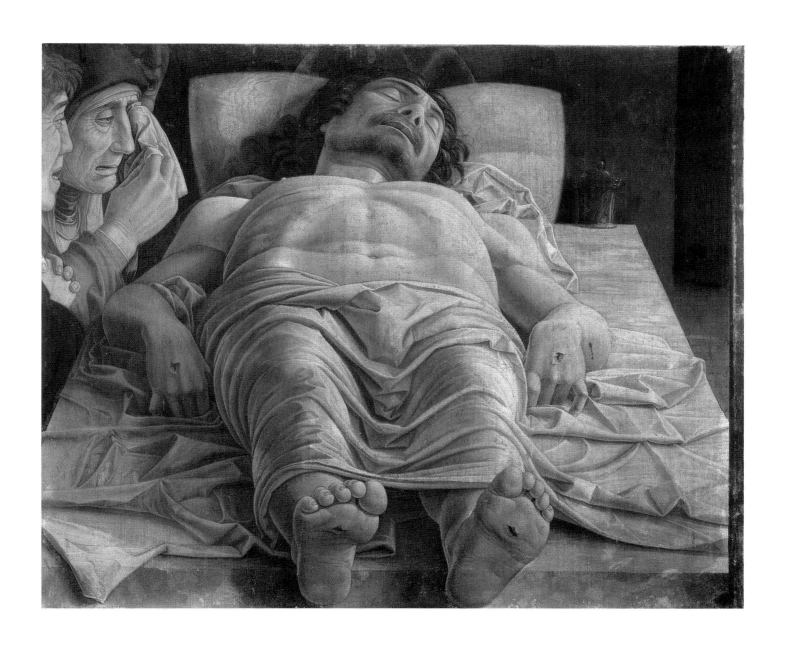

↑ Andrea Mantegna,
*The Lamentation over
the Dead Christ*, c. 1480,
tempera on canvas,
68 × 81 cm (26¾ × 31⅞ in.)

The legacy of Mantegna's pioneering perspective and innovative foreshortening is still being felt today. It can be traced in the eerie manipulations of physique by the Australian artist Ron Mueck, whose otherwise forensically precise sculpture of his deceased father truncated the corpse to three-quarters-life-size scale. The result was a work that blurred the lines between painstaking realism and artificial effigy.

our fascination is not our angle on the subject, but a detail to which the eerie foreshortening cunningly guides the eye: a lidded jar at the back of the work that crouches beside Christ's lolling head. Almost translucent in the darkness of its rendering and nudged by Mantegna so far to the rear edge of the Stone of Anointment that it seems to levitate in space, the object occupies a mystical realm that is at once inside and outside the world of the picture. Yet it is the jar that holds the composition together and intensifies its meaning.

Empty now, the mysterious vessel was once filled with the luxurious perfume known as spikenard, an aromatic amber oil with ancient origins, and it belongs to a figure no less obscurely depicted than the jar itself: Mary Magdalene. We can just barely discern her chin and haunted lips, agape with horror, behind the mournful countenances of the disciple John (nearest to us on the left) and the weeping Virgin Mary (between them). Everything about Christ's

lifeless posture points to the ghostly presence of the gauzy pot – from the gentle tilt of his head to the trajectory of our gaze as it penetrates the desiccated wounds of his left foot through that of his left hand to the spectral jar. We know the container is empty because the gospel stories tell us that Mary has already spent its expensive contents, days earlier, on Christ's body when he was still alive, before mopping the unguent off him with her hair (a gesture that provoked the rebuke of Judas, who said the perfume ought instead to have been sold to raise money for the poor).

The mocking redundance of the oil-less jar throws into poignant absurdity the situation of Christ's body on a surface designed entirely for undertaking the ritual of anointing the corpse. Suddenly, the cracked and moistureless texture of Christ's skin is excruciatingly irredeemable in its physical and spiritual dehydration. The jar is a cruel tease of impossible relief, as wickedly unhelpful to Christ in his suffering as our looking and our tears.

↓ Sandro Botticelli, *The Birth of Venus*,
c. 1482–85, tempera on canvas,
172.5 × 278.9 cm (67⅞ × 109⅞ in.)

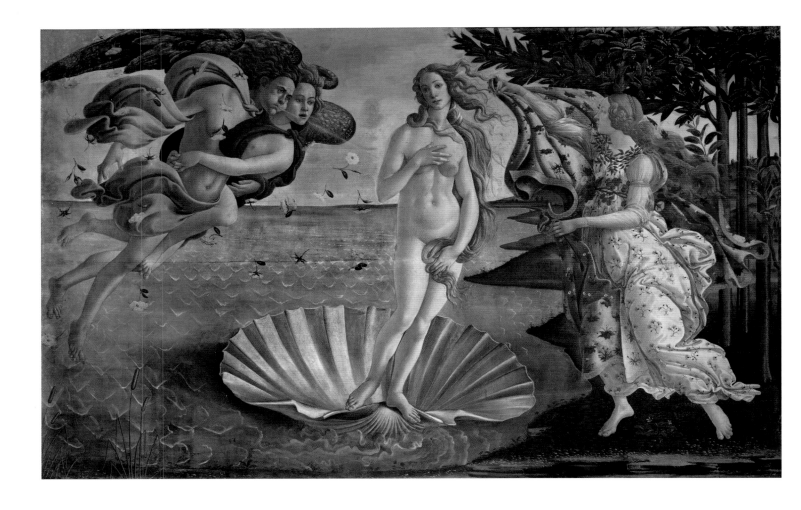

Botticelli's famous depiction of the goddess of love, surfing a scallop shell to the shores of Kythira, has a geometric mystery spinning at its centre.

It is one of those hypnotic flourishes that, once spotted, transfixes the eye: the spiral of golden hair suspended on the goddess's right shoulder in Sandro Botticelli's Renaissance masterpiece *The Birth of Venus*. Poised between a symphony of floating rose sprigs that perfume the air on one side of her, and the embroidered polyphony of daisies and cornflowers that adorn the wind-flapped fabrics to her right, the captivating curl is more than mesmerizing; it is arguably the very engine generating what the British art historian Kenneth Clark once described as 'the ecstatic energy' of the painting. Far too perfect in the precision of its radial spin and in the measure of each hair's widening vector to be an accident of brushwork, the coil has been deliberately installed on the vertical axis of the work as though it were a kind of miniature motor propelling the powerful painting.

If we scrutinize closely what we might call the 'Venus Twist', we soon discover its carefully calibrated whorl conforms perfectly to the contours of a curve that will later come to preoccupy mathematicians – the so-called 'logarithmic spiral'. It will be another century and a half before the French philosopher René Descartes will formally calculate how, mathematically, the curling line that creates the geometric shape travels centrifugally away from its centre, and another half a century after that before Swiss thinker Jacob Bernoulli will, in 1692, give it a more befitting title: *spira mirabilis*, or 'the marvellous spiral'. Putting to one side its winding history, what is this finely tuned twirl doing in a fifteenth-century painting devoted to the maritime emergence of a pagan goddess who hover-crafts to shore on an oversized scallop shell, propelled by the breath of Zephyrus, the god of the west wind, and that of Chloris, the nymph Zephyrus so violently abducted?

The first large-scale work since antiquity to feature a nude woman in a non-religious context (and one of the first to be executed on canvas rather than wood panel), *The Birth of Venus* is deliberately daring in its visual strategy, never mind the spiral spinning mysteriously on Venus's shoulder. Botticelli would have been fully aware that his unrestrained celebration of fleshly beauty risked religious censure. Not taking any chances, he pre-empted objections to his work by ensuring its complex iconography was sufficiently laced with Christian elements. Compare his Venus with a version of the Virgin Mary that the artist would go on to paint only a couple of years later for the St Barnaba altarpiece, and

Detail of the golden spiral in *The Birth of Venus, c.* 1482–85

→ Leonardo da Vinci, studies for the head of Leda, *c.* 1504–6, pen and ink over black chalk, 17.7 × 14.7 cm (7 × 5⅞ in.)

the two representations are remarkably similar. The close physiognomic resemblance of Mary and Venus is augmented by the dominance, in both works, of sprawling scallop shells that control the aesthetic space. Now scooping Venus up, now hovering protectively above the Virgin, the sea shell, as a potent symbol of fertility, swivelled in Botticelli's imagination between decadence and divinity. Believed, since antiquity, to be aphrodisiacs, molluscs were also associated, since at least the Middle Ages, with being immaculately fertilized by dew.

Though symbolically crucial in blurring the identities of Venus and Virgin, the oversized scallop on which the classical goddess windsails to shore in Botticelli's masterpiece is overshadowed, conceptually, by the spellbinding swirl of another kind of conch – the one that has spun itself into mystery from Venus's golden tresses on her right shoulder. Venus gently tilts her head towards the logarithmic spiral as if listening intently to the whispers of a sea shell, waiting for the dark echoes swirling inside it to divulge the secrets of the universe. (To see the hair styled into a shape echoing a spiral sea shell isn't as eccentric as it might at first sound; a contemporary drawing by Leonardo da Vinci, who was Botticelli's peer in the workshop of the Florentine master Andrea del Verrocchio, similarly imagines a woman's coif

braided elaborately into the logarithmic whirl of the extinct cephalopod, the ammonite, whose fossils fascinated da Vinci.)

It is tempting to read into the sinuous curl anything and everything from foreshadows of medical science to esoteric channellings and mystical intentions. After all, one species of the logarithmic spiral, based on the sequence of integers detected by the medieval Italian thinker Fibonacci (what will eventually be known popularly as the 'golden spiral'), is regularly reached for by art critics as a kind of yardstick of beauty against which the intensity and achievement of Old Master paintings can be measured. Is that the spiral's function here? Is it a secret cipher, centuries ahead of its time, one that proves that beauty is an irreducible physical force, a fundamental law of nature that transcends the ephemera of pagan superstition and orthodox religion alike? Or does it, humming silently to Venus's ear, presage the anatomical discovery that our auditory organs are fitted with their own impeccable logarithmic spiral – what will, in the seventeenth century, be christened the 'cochlea' (from Greek *kokhlos*, meaning 'spiral shell')? Or is this seductive twist, this curious question mark, nothing more than a fleeting flourish – an enticing windswept curl whose truest profundities, like art itself, can never really be unravelled?

↑ Sandro Botticelli, *The Virgin and Child with Four Angels and Six Saints*, St Barnaba altarpiece, *c.* 1488, tempera on panel, 268 × 280 cm (105½ × 110¼ in.)

→ Rineke Dijkstra, *Kolobrzeg, Poland, July 26 1992*, 1992, chromogenic print on paper, 168 × 141.5 cm (66⅛ × 55¾ in.)

It was never the intention of contemporary Dutch artist Rineke Dijkstra to echo Botticelli in her famous photograph of a girl who appears to have just emerged from the sea behind her. But the waves created by *The Birth of Venus* continue to crash in our collective psyche, and it is difficult for modern eyes to disentangle the girl's posture and the tilt of her head from the hypnotizing engine of imagery Botticelli set in motion five and half centuries ago.

It is the most famous painting in all of art history, but what is it about da Vinci's portrait that fidgets with our imagination, generation after generation, century after century?

In 1852, so the legend goes, an aspiring French artist by the name of Luc Maspero opened the window of his fourth-storey Paris hotel room and jumped to his death. The note he left behind explained the reason for his despair: 'For years I have grappled desperately with her smile. I prefer to die.' While there are reasons to doubt whether the Mona Lisa ever actually drove artists to take their own lives (the existence of Maspero is trickier to pin down than the expression that allegedly haunted and taunted him), there is no denying the tortuous hold Leonardo da Vinci's preposterously famous painting has exerted on the minds of those who have encountered it. 'The smile is full of attraction,' the nineteenth-century art critic Alfred Dumesnil wrote in 1854, 'but it is the treacherous attraction of a sick soul that renders sickness. This so soft a look, but avid like the sea, devours.' 'Beware!', the French historian Jules Michelet likewise cautioned his readers, 'this dangerous picture' 'acts upon you through a strange magnetism'. 'This work', he goes on to confess, 'calls me, invades me, absorbs me; I go to her in spite of myself, as the bird goes to the serpent.'

But what exactly is it about da Vinci's painting that has so vexed generation after generation? Nearly from the moment that the Renaissance master began work on the portrait of Lisa del Giocondo, the wife of a Florentine silk merchant, she has bewitched her visitor's gaze. From the first, what seems most to enthrall the eye is the subject's uncanny ability to seem at once real and ghostly – convincingly lifelike yet eerily otherworldly. The celebrated Renaissance historian and biographer Giorgio Vasari, from whom most of what we know about the work's commission, creation and reception comes, concludes his comments on the painting in his *Lives of the Most Excellent Painters, Sculptors, and Architects* with the paradoxical observation that 'in this work of Leonardo there was a smile so pleasing, that it was a thing more divine than human to behold, and it was held to be something marvelous, in that it was not other than alive'. Forever vacillating on a liminal threshold between a being 'more divine than human to behold' and yet, at the same time, 'not other than alive', the Mona Lisa embodies a restless magic that agitates the imagination. She's neither here nor there, mortal nor immortal, yet all at once.

By the time, three centuries later, the English essayist Walter Pater turns his own eye to the portrait's elusive allure, the work has lost none of its evasive appeal. 'She is older than

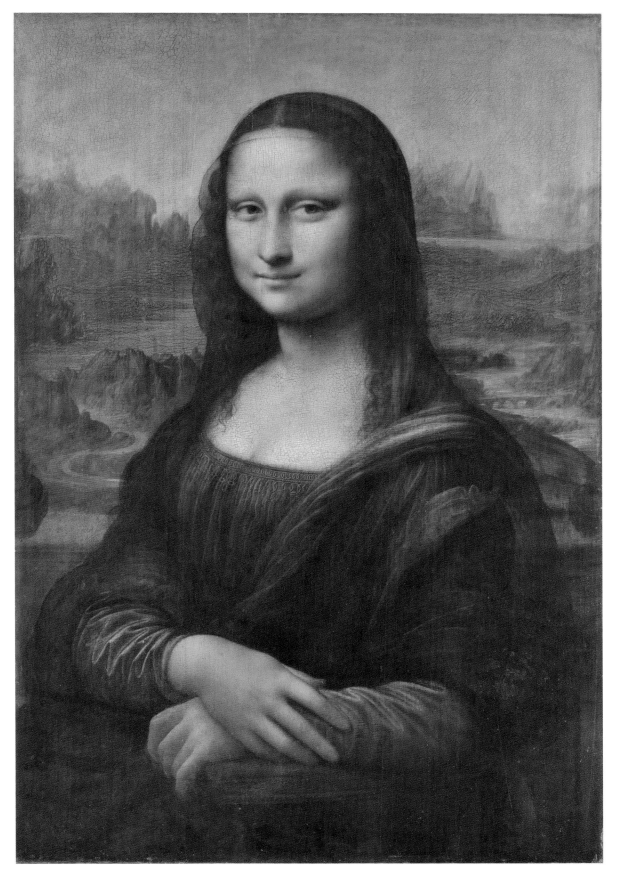

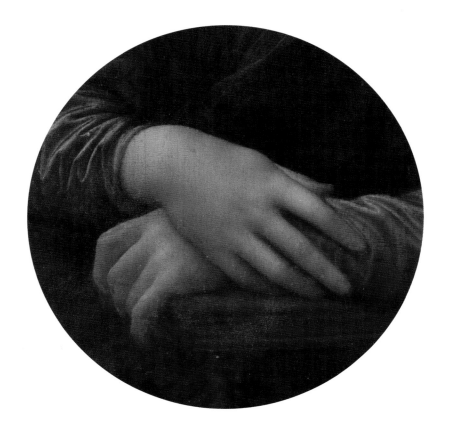

↖ Leonardo da Vinci, *Mona Lisa*,
c. 1503–6, oil on panel, 77 × 53 cm
(30 × 21 in.)

👁 Detail showing the artist's
change to the right index finger
in *Mona Lisa*, *c.* 1503–6

the rocks among which she sits', Pater says; 'like the vampire, she has been dead many times, and learned the secrets of the grave.' Perceiving the Mona Lisa as inhabiting a threshold between the real world in which we encounter her and an invisible one to which she's been and may, at any moment, return, Pater comes closer to identifying the mystical essence of the portrait's dangerous allure than anyone before or since: the work 'lives', he says, 'only in the delicacy with which it has moulded the changing lineaments, and tinged the eyelids and the hands'.

By shifting our focus from that feature on which most looks have lingered, her lips, to the Mona Lisa's hands, Pater nudges us in the direction of the real eye-hook that controls the ambiguous energy of the portrait: the 'changing lineaments' of her right hand. Ghosting her index finger, half visible, is the gauzy outline of another spectral digit – one that twitches up the left arm on which it rests. The phantom finger is regarded by most historians as a mere 'pentimento', or change of direction made by the artist. In fact, this vestigial suggestion of another hand trembling beyond the vanishing point of our perception is crucial to the work's aesthetic success; it worries away at the work's

stability by forcing us constantly to focus and refocus our stare. Its ghostliness accentuates the holographic effect that is created by the diaphanous veil that shadows Lisa's head, creating the impression that her body is ceaselessly shifting against the apparitional background of gloom-soaked mist. The edgy effect, accentuated by the *sfumato* that softens every contour of her countenance, is haunting. She appears at once a part of the world in which she sits and existentially removed from it.

Suddenly, everything about Lisa appears to teeter between states of being – time-bound and unending; particle and wave; a universe we can see and one we can't. The round chair from which the Mona Lisa enigmatically stares out at us in three-quarter profile (an innovative posture in da Vinci's day) would have been known by the artist's contemporaries as a 'pozzetto'. Meaning 'little well', the pozzetto subliminally reinforces the sense that the Mona Lisa is seated tentatively between the phenomenal world of the here-and-now in which we encounter her and utterly unfathomable depths into which she could disappear at any moment.

→ Marcel Duchamp, *L.H.O.O.Q.*, 1919, reproduction of Leonardo da Vinci's *Mona Lisa* with added moustache, goatee and title in pencil, 19.4 × 12.4 cm (7⅝ × 4⅞ in.)

By drawing a moustache and beard on a postcard reproduction of Mona Lisa and attaching to the piece initials that, when pronounced in French, resemble the vulgar phrase 'she's hot in the arse', Marcel Duchamp mischievously illustrates how even the greatest works of art are not safe from crass consumerism.

← Robert Rauschenberg, *Untitled (Mona Lisa)*, c. 1952, collage (engravings, printed paper, fabric, paper, pencil, foil paper, and glue on paper), 24.1 × 19.1 cm (9½ × 7½ in.)

Created a generation after Duchamp's iconoclastic *L.H.O.O.Q.*, Robert Rauschenberg's distressed collage, which summons Mona Lisa as merely another cultural document to be reproduced and sampled, reveals a work on the verge of aesthetic saturation.

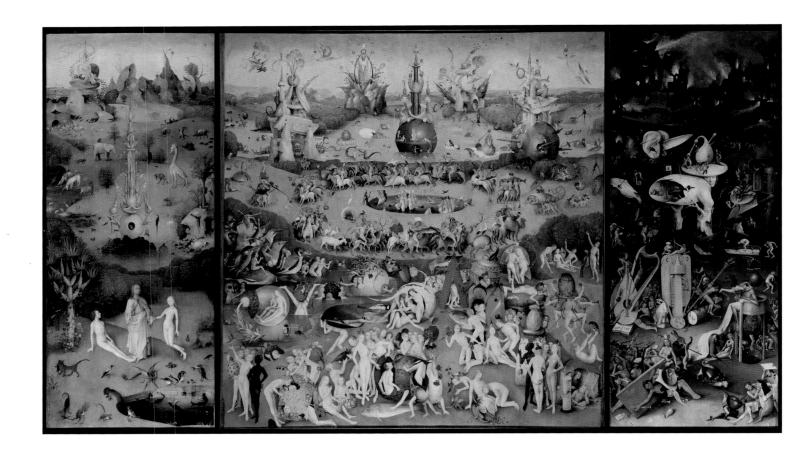

Though Bosch's iconic vision of heaven, hell and everything in between is best known for its rampant grotesqueries, the medieval triptych's meaning hinges on the most commonplace of objects placed boldly at its very centre.

If trying to crack the code of a great work of art has left you scrambling, look for the egg. No painting in the history of art is more teasing or offers a more rewarding landscape for embarking on an egg hunt than Hieronymus Bosch's complex triptych, *The Garden of Earthly Delights*. Hinged like a window fitted with shutters, the wood-panelled work, when open, is comprised of three spectacles representing, in turn, the blisses of Eden (left), a realm of fleshly temptation (centre) and the torments of Hell (right).

When closed, the left and right panels creak into the centre of the triptych to reveal, painted in shades of grey (or 'grisaille') on the back, an image of the universe suspended in the process of creation. The result is a restlessly kinetic work – forever hatching and unhatching itself – implying the endless birth and rebirth of being. The nascent world portrayed when the triptych is shut is ghostly in its monochromatic rendering, like an ultrasound of a cosmic womb. The planetary orb it imagines is that of a translucent ovum whose inner life is still taking shape. To unlatch the triptych's wings and swing them against their hinges is to crack the work and the world wide open.

Once unfastened, the triptych reveals to us the physical and spiritual trajectories of untempered decadence, as observers are left to meander from the innocence of paradise, through a dimension of carnal diversions, to a plane of eternal comeuppance. With so much dizzying detail to range over – from mythic flora and fauna to grotesque gymnastics – the eye struggles to gain narrative traction. Sensing that our gaze needs a way into (and out of) the intensity of his all-enveloping vision, Bosch has secreted an eye-hook amid the relentless romp of fleshly shenanigans.

To find the secret cipher, one needs merely draw an imaginary cross from the four corners of the triptych (or even from just those of the central panel itself). Voilà: 'egg' marks the spot, in the dead-centre of Bosch's work, providing a focal point of unsullied purity at the triptych's core. A safe haven into which our eyes can quickly retreat, the unhatched egg offers the continual promise of redemption – as if the carnal chaos that whirls centripetally all around it, at any instant, might implode back into the sinlessness of pre-existence: the soul before sin. Almost eye-shaped, the egg is a wink in our direction that hooks us with its pupil-less stare. Once spotted, the pivot-point of the egg in Bosch's garden becomes the epicentre around which his entire vision spins, flinging us on a hunt for the many cracked shells that

Detail showing the central unhatched egg in *The Garden of Earthly Delights*, 1505–10

↓ Follower of Hieronymus Bosch, *The Concert in the Egg*, 1561, oil on canvas, 108 × 126.5 cm (42½ × 49⅞ in.)

Bosch's fascination with the egg as the space from which creation sings itself into being long pre-dates his hiding of eggs in *The Garden of Earthly Delights*. *The Concert in the Egg*, created by a follower of Bosch a generation after the famous triptych, is thought to be based on a *c.* 1475 drawing by the Netherlandish artist.

litter the landscape and from which much monstrousness has crawled.

If there is any doubting how crucially the egg figured in Bosch's imagination when formulating the design of his enthralling universe, consider the strange shape crouched awkwardly in the middle of the Hell panel, to the right. Christened the 'Tree Man' by art historians, the figure is widely considered a gnarled composite of the Tree of Life (from the paradise panel) and a self-portrait of the artist, looking back at us over his shoulder. Bizarrely, Bosch's body in this surreal depiction is neither born nor unborn, but constructed instead out of a discarded egg shell – that fragile membrane that separates becoming from being – suggesting that, even in the oblivion of damnation, we carry with us the very vehicle of redemption.

The aesthetic rewards awaiting artists capable of spotting Bosch's egg and cracking its symbolic code were recognized by many subsequent painters who proceeded to tuck into their works hidden allusions to the fragile cipher. Half a century after *The Garden of Earthly Delights* was completed, Pieter Bruegel the Elder's depiction of Mad Meg (a peasant woman from Flemish folklore who commanded a mob of female

marauders through Hell) owes much to the outlandishness of Bosch's vision, and in particular to the strange scattering of egg-like capsules across its turbid surface. Yolking itself visually to the right-most panel of Bosch's triptych, Bruegel's *Dull Gret* (*c.* 1562) foregoes any hint of salvation offered by Bosch by providing instead only the damaged goods of broken shells out of which fresh grotesqueries endlessly spawn.

Passed down from one generation to the next, Bosch's enigmatic egg would eventually find itself incubating in the mischievous palm of the Spanish artist Salvador Dalí, who magnified its inscrutable significance in his 1937 painting, *Metamorphosis of Narcissus*. Admired by Surrealists such as André Breton, Joan Miró and Max Ernst for its anxious penetration of the subconscious mind, Bosch's *Garden* proved fertile ground for the imaginations of artists seeking to prune the hedge that separated the realms of reality from myth, allegory from dream. In Dalí's strange, moustache-twiddling hands, the egg at the centre of his painting (which mirrors the downcast head of the Greek youth who perished admiring his own reflection in a pool) appears to crack the mysterious barrier between conscious awareness of who we are and a fledgling knowledge that wriggles just beneath the surface.

→ Hieronymus Bosch, *The Garden of Earthly Delights* (triptych closed: the grisaille panels reveal the universe suspended in the process of creation and enable us to gaze through its transparent shell), 1505–10

↓ Pieter Bruegel the Elder,
Dull Gret, c. 1562, oil on panel,
115 × 161 cm (45¼ × 63⅜ in.)

↓ Salvador Dalí, *Metamorphosis of Narcissus*, 1937, oil on canvas, 51.1 × 78.1 cm (20⅛ × 30¾ in.)

Michelangelo's masterpiece is a rambunctious jungle-gym of visual detail. In order to perceive the divine ratios that harmonize it, you must close your eyes and listen.

The ear sees what the eye echoes. Nothing illustrates the interdependence of the senses in comprehending a great work more profoundly than the sumptuous frescoes with which the Renaissance master Michelangelo reluctantly adorned the ceiling of the Vatican's Sistine Chapel. Whether one has stood staring with strained neck beneath the muscular montage of scriptural subjects commissioned by Pope Julius II, or merely has experienced the frescoes' grandeur from reproductions, what first flashes in the mind's eye when recalling the elaborate work is a disjointed shuffle of fragmented images: God reaching out to galvanize Adam into life with an electric touch, say, or the glistening biceps of the wingless angels who pose athletically around the ceiling like Olympic swimmers around a pool.

However stupendous the achievement of the work may appear, there is little doubting that the optical effect of so much detail is overwhelming. The eye struggles for a firm foothold amid the cosmological crush of religious intensity. After all, Michelangelo's scheme consists not merely of the nine Old Testament scenes that famously tingle the ceiling's spine (the creation of Adam being the most renowned); it is a rambunctious jungle-gym swinging with scores of

clambering figures – thirty ancestors of Christ, a dozen prophets and sibyls, the drama of eight intricate family scenes, and a legion of lounging nudes. To contemporaries of the artist who could still recall the serene expanse of blue and the few twinkling gold stars with which his predecessor, the Umbrian painter Piero Matteo d'Amelia, had modestly adorned the ceiling of the Pope's private chapel, Michelangelo's vision must have seemed like an ever-impending avalanche of muscle and colour.

To isolate a single eye-hook amid the dizzying dynamism that surges through the frescoes – a discrete detail capable of crystallizing such unwieldy sublimity – would surely seem an exercise in futility. But completion by Michelangelo of his masterwork was quickly followed with the composition in 1518 by an acquaintance, the musical genius Costanzo Festa, of a choral work that may have deliberately been formulated to assist the ear and the eye in making sense of Michelangelo's awe-inspiring design. Festa's score was intended for performance exclusively beneath the frescoes of the Sistine Chapel, during the Tenebrae ceremony of darkness and light, which featured a ritualized extinguishing of candles commemorating the Last Supper during Holy Week each year.

↖ 👁 Michelangelo, Sistine Chapel
ceiling frescoes, 1508–12

↓ Detail of 'Ignudi' (four naked men
who appear seated around each of
the five central minor panels), Sistine
Chapel frescoes, 1508–12

→ Detail of the 'Creation of Adam',
Sistine Chapel frescoes, 1508–12

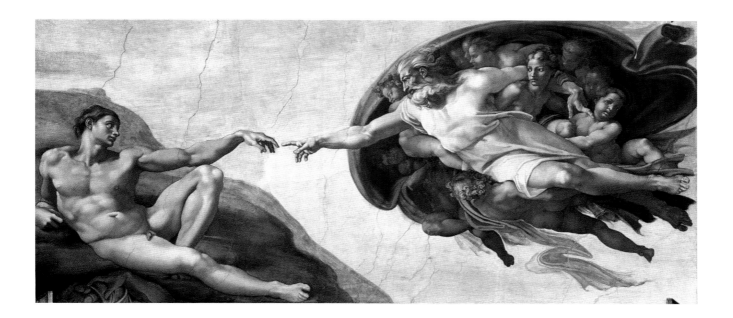

Innovatively written to be sung by two asymmetrical choirs of four and five singers respectively, Festa's harmonic setting of Psalm 51, *Miserere Mei* ('Have mercy on me') – famously re-arranged by Gregorio Allegri a century later – draws the senses' attention to an easily overlooked ratio in the scheme of Michelangelo's frescoes.

Festa's unconventional partitioning of voices (a novelty in medieval choral music and an element retained by Allegri and every composer and choir performing the *Miserere* since) is intriguing, not least for its coincidence at this particular moment in music history with the accelerating acceptance across Europe of the musical interval of the major third, whose pitch corresponds to the ratio of 5:4. The innovations pioneered by Festa exposed previously underappreciated harmonies of the 5:4 ratio – a proportion which was soon being seized on by contemporary artists and intellectuals as constituting a mathematical link between the spiritual and phenomenal worlds.

For scientific thinkers such as Johannes Kepler, according to Jamie James, author of *The Music of the Spheres: Music, Science, and the Natural Order of the Universe* (1993), the ratio 5:4 was 'not a pair of notes to be twanged on the lyre or plucked on the keyboard of virginals, although those are valid expressions of it; rather it is a mathematical ideal of a divine substance, that need not even be expressed in order to exist, for it is eternal'. The divinity which James suggests was perceived as embodied in the major third accords with mystical notions of four earthly elements transmuted through salvation into an eternal fifth element – precisely the transformation that was understood as being undertaken by Christ in the Tenebrae liturgy, with which the *Miserere* would become particularly associated. The *Miserere*, in other words, was performed by a ratio of voices whose very proportion reflected the arithmetic of salvation that the congregation believed was being represented in their presence, choreographed mesmerically by Michelangelo's genius.

As though deliberately conceived as a soundtrack for the complex frescoes, the *Miserere*'s repetition of 5:4 (both structurally and performatively) imposes schematic sense on Michelangelo's biblical illustrations. Elevated by Festa's transcendent score, the soul attending Tenebrae mass in the Sistine Chapel suddenly finds itself in sync with a hidden order as the nine scenes of the ceiling's centre organize themselves into an alternating sequence of five minor frescoes separated by four major ones. Further amplifying the asymmetry of Michelangelo's plan is the painter's decision to surround each of the five minor panels with four seated male nudes, or what he collectively called his 'Ignudi'. Add to this the ratio of Creation stories represented to non-Creation stories – again 5:4 – and it becomes difficult to ignore the systematic insistence of this neglected cipher. Numerologically sensitive contemporaries would have equated the mathematical ideal of 5:4 not only with the musical triad of a major third, but also with salvation's ability to redeem the four elements of this world into the quintessence of the next. To comprehend the frescoes' subtle design, the eye and the ear are subliminally hooked by a divine ratio – a hypnotic key that unlocks the secret music of Michelangelo's symphonious masterpiece.

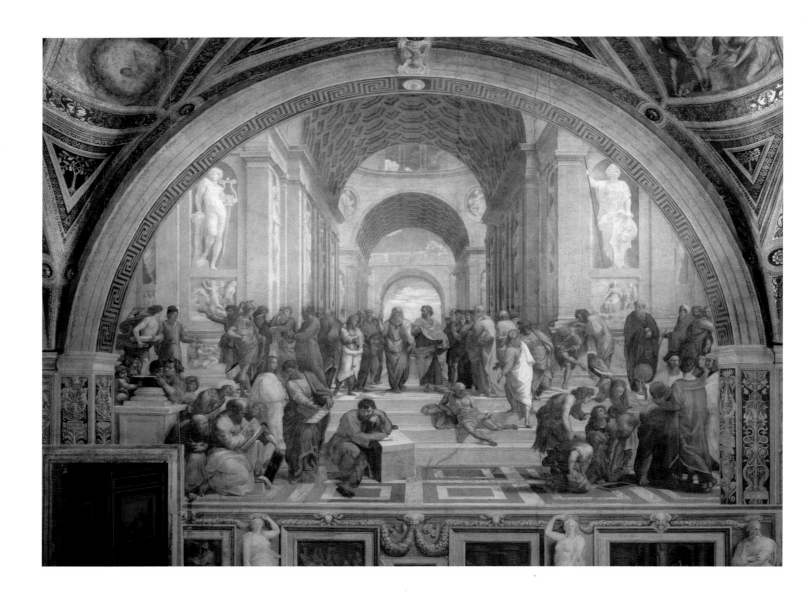

↓ Raphael, *The School of Athens,*
1510–11, fresco, 500 × 770 cm
(197 × 303 in.)

Raphael's eternal dialogue among luminaries is widely admired as an ideal of rational discourse. But the most humble of objects at its centre invites us to question the stability of everything we think we see.

At first glance, it would hardly seem a consequential detail on which to focus amid the feverish confabulation of famous philosophers: a small pot of ink teetering precariously on the corner of a marble block at which a melancholic figure sits scribbling near the centre of Raphael's early sixteenth-century masterwork, *The School of Athens*. Like all eye-hooks, however, once spotted, the unpretentious shape shapes the shapelessness of all that surrounds it.

'Of all the frescoes in the Stanza della Segnatura,' the art historian H. W. Janson once said of Raphael's famous mural, commissioned by Pope Julius II to decorate one of the walls of the Vatican's Apostolic Palace, '*The School of Athens*, facing *La Disputa*, has long been acknowledged as Raphael's masterpiece and the perfect embodiment of the classical spirit of the High Renaissance.' One of a quartet of frescoes undertaken by Raphael to adorn the walls of Julius's study, which had been used historically for the signing of official documents, *The School of Athens* was conceived as the very apotheosis of philosophical disquisition and is accompanied by murals that respectively exemplify the collateral disciplines of poetry, law and theology (the branch of learning to which *The Disputation of the Holy Sacrament*, or *La Disputa*,

just opposite *The School of Athens*, is devoted). Awe-struck by Michelangelo's bold symphonic physiques that were then beginning to blare from the ceiling of the Sistine Chapel nearby, Raphael undertook to convene his own eternal seance of mythic figures.

Yet there is a considerable difference in how easily and confidently observers of the two works can read what – and, more importantly, who – is depicted in the two paintings. Where Michelangelo's ceiling frescoes rely for their exegetical impact on the recognizability of the biblical scenes and characters portrayed, Raphael's fresco goes out of its way to befuddle with indeterminacies of identity. At first glance it may appear easy enough to decode, by the tomes they carry, the presiding presence of Plato (who holds his treatise on the nature of man's existence in the physical world, the *Timaeus*) and his pupil Aristotle (toting a book from his ten-volume *Nicomachean Ethics*). But look again, and doesn't the face of the more senior philosopher uncannily resemble the wizened stare and cascading beard of Leonardo da Vinci's famous self-portrait? Look closer still, and isn't the figure's hand gesture also oddly familiar – as if this doppelgänger of Raphael's distinguished contemporary is being made to

mimic the mocking body language of his own depiction of the disciple Thomas in *The Last Supper*, which da Vinci completed a decade earlier? What initially seemed a straightforward identification of a key figure in classical thought has quickly fragmented into a curious collage of character: Leonardo playing Plato playing doubting Thomas.

Nor is this the only peculiar palimpsest of personality in Raphael's complex painting. While it is tempting to assume that the figure jotting in a book in the left foreground of the fresco is Pythagoras (a tablet at his feet reveals a very Pythagorean harmonic scale), the tender attendance of an angel at his left ear complicates the iconography. The representation is just as credibly a likeness of St Matthew, who is conventionally accompanied by an angel on his left side. And so it goes, figure after figure – the doubling and tripling of enmeshed identities throughout the fresco. Take the figure twiddling his compass on the other side of the painting. Opinion is divided over whether we ought to call him Euclid or Archimedes. Either works from the clues provided. And what about the man in military garb to the right of Plato/da Vinci/Thomas – the one who is being harangued by a pug-nosed pontificator about how the universe works? Some are convinced this is Alcibiades, while others insist it's Alexander the Great. Who is that between them – Nichomachus or Paramenides? On the other side of the fresco, the man holding the orb of stars is surely neither Strabo nor Zoroaster, but both.

So elastic and convertible are the props, gestures and characteristics that distinguish the *dramatis personae* of Raphael's *The School of Athens*, the fresco creates the impression of being an even more crowded cultural space than it is, as each individual portrayed vibrates with poly-personality. In scrabbling for decisive clues that might help us disentangle these compressed characteristics, our eyes eventually alight on a tiny detail: a simple inkwell crouching beside the left elbow of the leather-booted and knobble-kneed man who sits nearest the centre foreground of the fresco. Echoing subtly the central position of a resplendent monstrance (or Eucharist vessel) that beams from the mural devoted to Theology just opposite, the humble ink pot is unexpectedly deep in its philosophical implications.

We know from surviving cartoons and preparatory studies which Raphael made for the fresco that the pensive figure seated at the marble block (long believed by scholars to be a composite portrait of the artist's rival, Michelangelo, and the pre-Socratic Greek philosopher Heraclitus, lost in thought and scribble) was a late addition to the work.

The fact that, on reflection, Raphael felt it necessary to insert into the foreground of his painting an allusion to a writer famous for insisting that life is flux is revealing of the artist's intentions in the work. Seen through the lens of Heraclitean belief in constant change, *The School of Athens* is a spirit level of endlessly elastic being – of identity merging and fragmenting, splintering and dissolving.

That none of the actual writings of Heraclitus, who was known as 'The Obscure', have survived lends a poignancy to the conjuring of his inkwell – at once a vessel for self-assertion and an evaporated relic of his ever having been. By prominently featuring Heraclitus's inkwell in a papal apartment historically devoted to signing official documents, Raphael unsettles the sacred symbolism of the space. Where the monstrance in *La Disputa*, opposite *The School of Athens*, glints with the promise of Christian redemption, Heraclitus's ink pot posits an alternative eternity of infinite dissolution of self.

👁 Detail showing the ink pot in
The School of Athens, 1510–11

↓ Leonardo da Vinci, *The Last Supper*,
1495–98, fresco, 460 × 880 cm
(181 × 346½ in.)

Like a Rubik's Cube of the soul, Grünewald's altarpiece is engineered to twist along hinges into an array of possible displays. The secret of its peculiar power lies in its ingenious swivelling.

'If the doors of perception were cleansed,' William Blake famously wrote in his prophetic book *The Marriage of Heaven and Hell*, 'every thing would appear to man as it is, Infinite. For man has closed himself up, till he sees all things thro' narrow chinks of his cavern.' Nearly three hundred years earlier, the German painter Matthias Grünewald created for the Monastery of St Anthony in Isenheim (which specialized in treating skin diseases) a complex contraption of hinged altar panels – doors within doors within doors – that encased at its centre a wood-carved shrine. The sculptures at the heart of the complicated carpentry are devoted to the memory and intercessory power of the third-century Christian monk St Anthony, who, it was believed, miraculously intervened to help those suffering from the excruciating complications of the gangrenous affliction known as 'St Anthony's fire', and are the work of Grünewald's creative collaborator, Niclaus of Haguenau. But for over half a millennium, it's the doors themselves – the ten painted panel scenes by Grünewald depicting key Christian scenes from the Annunciation to the Nativity, the Crucifixion to the Resurrection and Ascension – that have mesmerized pilgrims and inspired subsequent artists for their ability to offer an intense glimpse out of the dark cavern of suffering of this world into the Infinite.

To appreciate fully the renowned power of the Grünewald altarpiece, one must first understand the object's multi-layered construction and sophisticated engineering. This is not a static work that hangs inert on a wall, but a profoundly kinetic contraption – a machine – intended to transport the soul from anguish to glory. 'When these wings were closed, as was the case ordinarily, and regularly during Lent,' the art historian Arthur Burkhard explained in an article explicating the altarpiece in 1934,

the large central expanse, formed by two wings joining, was covered by the Crucifixion scene, while on stationary panels stood, on the left, St Anthony, the patron saint of the Isenheim monastery, and on the right, St Sebastian. When the wings were opened for special occasions, the sombre Crucifixion gave way to brighter scenes: on the left wing, the Annunciation, in the centre, the Incarnation, and on the right wing, the Resurrection. When the second pair of wings was opened, a shrine appeared with St Anthony, carved in wood, seated in the centre,

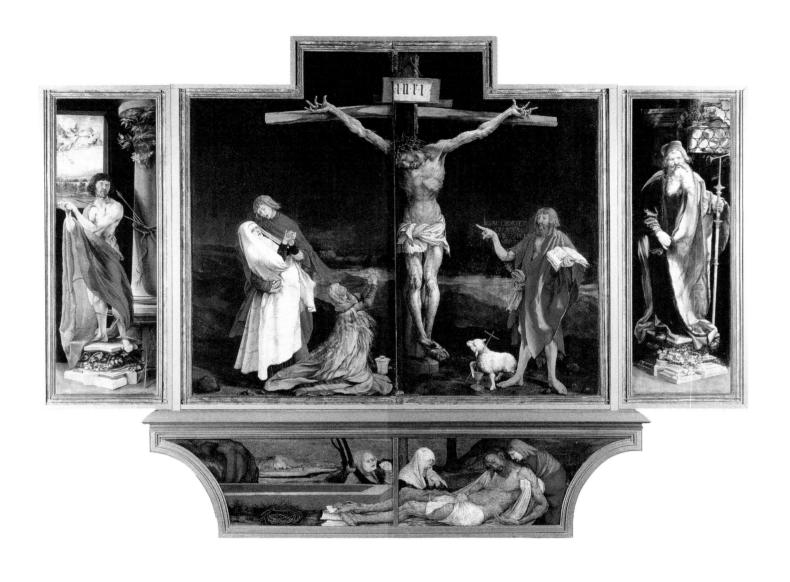

↑ Matthias Grünewald, The Isenheim
Altarpiece (closed: showing the
Crucifixion at its centre), 1512–16,
oil and tempera on panels,
376 × 534 cm (148 × 210¼ in.)

↓ The Isenheim Altarpiece
(opened with first wings: showing
four biblical scenes), 1512–16,
oil and tempera on panels,
376 × 668 cm (148 × 263 in.)

↓ The Isenheim Altarpiece (opened with second wings: showing the wood-carved shrine at the centre), 1512–16, oil and tempera on limewood panels and polychrome limewood sculptures, 376 × 668 cm (148 × 263 in.)

Detail of the seam that severs
Christ's arm in the Isenheim
Altarpiece, 1512–16

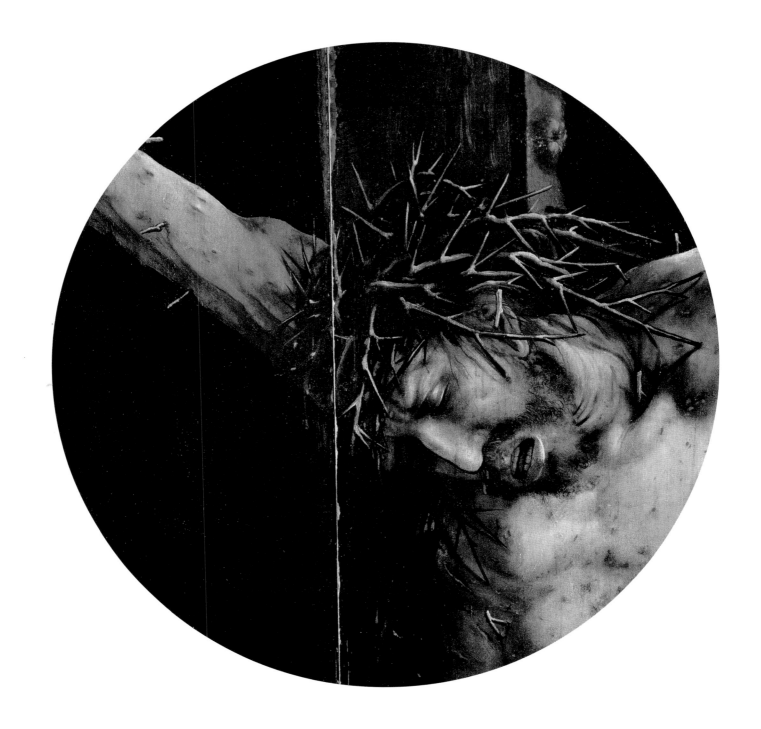

flanked by the standing figures of St Augustine and St Jerome, while in paintings on the backs of the wings were portrayed the temptation of St Anthony and his visit to St Paul.

The soul's journey, therefore, begins with the unutterable torment depicted in the Crucifixion scene that patients of the hospital would have encountered on most occasions when the wings were closed. Never before had Christ's suffering been portrayed so unflinchingly. Earlier depictions, such as Rogier van der Weyden's that we've already discussed (see p. 62), managed to sculpt from pain and humiliation a kind of brutal beauty. But Grünewald has tempered nothing in his ruthless rehearsal of Christ's murder. Indeed, not only has he given us Christ's gnarled digits, hammered to the roughest of planks and scratching helplessly toward heaven, and livid lips from which all life has been cruelly drained, and the vicious concavity of an asphyxiated thorax, he has added an extra layer of agony with which those being treated at the Monastery of St Anthony could particularly relate: a violent veneer of weeping pustules riddling his rancid skin, marking him out as a victim of the very disease for which they have desperately come seeking a miraculous remedy.

But the consolatory power of the work hinges on its hinges, and the eye-hook that enables the panel (and our perception) to penetrate past the horrors that we see unfolding in the dark light of this cavernous world is the almost invisible edge or seam that runs the height of the scene, breaking Christ's right arm off at the shoulder blade. In the centuries before it was discovered that the disease also known as 'Holy Fire' was caused by the fungus ergot growing on rye flour (the breakthrough came in 1676), doctors caring for sufferers experimented with all kinds of dangerous remedies to alleviate the horrifying pain, including amputation, which some believed might help extract the evil. By placing the seam where he does, Grünewald enables us literally and conceptually to crack open Christ's body and sever from his aching corpse the superficial physical afflictions that tormented him.

Once unhooked and swung wide, the outermost doors, or wings, of Grünewald's panels give way to a dizzying psychedelia of hallucinatory colour and vibrant vision. Suddenly, the rotting husk of dreadful dinginess that encrusted the altar is superseded by hopeful vignettes of Christ's coming, arrival and transcendence into heaven. It is a rather intriguing cultural coincidence that this giddiness of widened perception should overlap with a work dedicated to those tortured by the ergot fungus, from which the awareness-enhancing substance Lysergic acid diethylamide, or LSD, would eventually be derived in the 1930s (a substance that the counterculture of the 1960s would associate with the opening of 'the doors of perception' as attested to by the English writer Aldous Huxley, who borrowed the phrase from Blake for a memoir about his experience taking mind-altering drugs). Whether Grünewald was deliberately equating the delirium that some sufferers of St Anthony's Fire allegedly experienced with the heightening of spiritual perception is impossible to know. What is clear is that no work in the history of art more empathically or emphatically endeavoured to offer consolation from mortal misery by constructing for its audience a threshold of soulful release from which a vista of dazzling bliss can be unshuttered.

It is widely adored as the most enchanting depiction of infatuation in art history. But is it really love that has propelled Bacchus into the air, or something rather less fragrant?

'Love', according to the seventeenth-century English poet (and inventor of the card game cribbage) Sir John Suckling, 'is the fart / Of every heart; / It pains a man when 'tis kept close, / And others doth offend when 'tis let loose.' You might reasonably be concerned that summoning Suckling's malodorous doggerel is a rather crude way to begin a discussion of a painting that has come to be regarded as the single greatest representation in art history of love-at-first-sight: *Bacchus and Ariadne* by the sixteenth-century Venetian artist Titian. Indeed, what could be less in harmony with the enchanting moment depicted by Titian (drawing on versions of the classical story by the Roman poets Catullus and Ovid), when the god of wine leaps up from his chariot in lovestruck abandon after first locking eyes with the daughter of Minos, than gratuitous talk of flatulence?

Surely the Duke of Ferrara, Alfonso I d'Este, who commissioned the painting from Titian for display in a private room of his palazzo, would have turned his nose up at a work that brought with it even the faintest whiff of whiffiness as a leitmotif. Alfonso had approached some of the greatest artists of the day, including Michelangelo and Bellini, to contribute to the cycle of paintings that would adorn his Camerini d'alabastro (or 'little rooms of alabaster') overlooking the grand Via Coperta. The task of tackling this particular scene had initially been offered to Raphael, who accepted an advance payment, but died before he could complete more than a few preliminary drawings. In his early thirties and still striving to establish his reputation as a gifted portraitist when invited to take over the project, Titian would have been on his best behaviour and keen to make a good impression among the duke's circle of wealthy and influential patrons. Filling the eye's air with unnecessary noxiousness could have cost the emerging master dearly and left him scraping the bottom for future commissions.

But once you have spotted the eye-hook that unlocks hidden levels of the painting's meaning, there is no putting Titian's pungent genie back in its bottle. At the dead-centre of the work's scrappy foreground, swaying between the hooves of the impish satyr who drags behind him the head of a deer and is being barked at by a small dog, are the unfolding petals and stamen of a plant that would seem to serve no purpose in the logic of the canvas apart from demonstrating the painter's delicate touch and extraordinary eye for detail: a blossoming caper flower. Prized for its tart edible buds, this

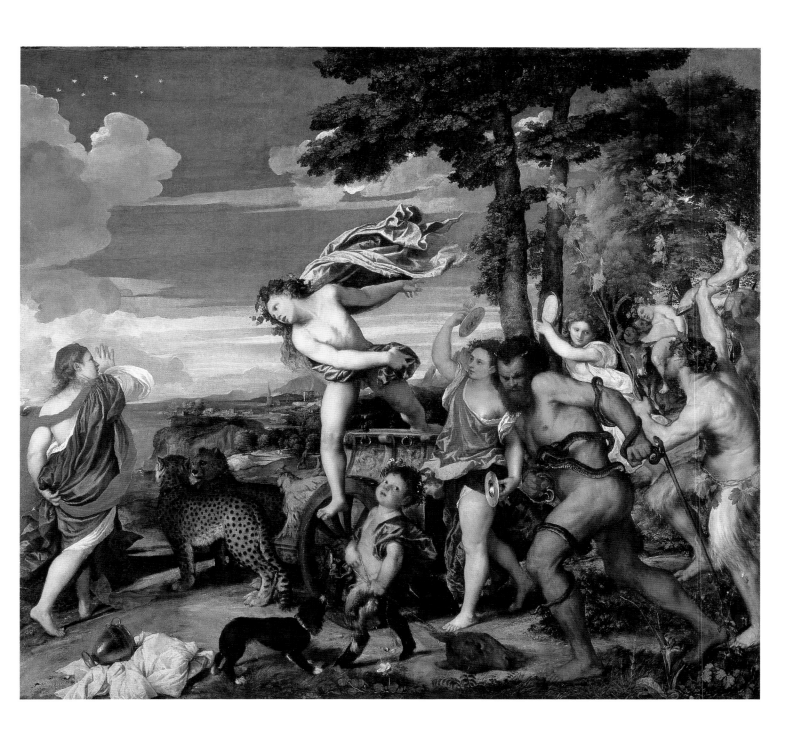

↑ Titian, *Bacchus and Ariadne,*
1520–23, oil on canvas,
176.5 × 191 cm (69½ × 75⅛ in.)

↑ Frank Auerbach, *Bacchus and Ariadne*, 1971, oil on board, 122.3 × 153 cm (48⅛ × 60¼ in.)

Four centuries after Titian, the German-British artist Frank Auerbach vaporizes the famous depiction of infatuation into a miasma of harsh and clashing tones.

prickly perennial Mediterranean plant (known by the species name *Capparis spinosa*), is linked, etymologically, with the Italian word *capriolare*, meaning 'to jump into the air'. Follow the single flower's over-extended style and stigma upwards to where it is gesturing, and our eye finds itself bisecting the legs of Bacchus who has indeed just been propelled into the air. Anyone familiar with the medicinal use of plants, however, would also be aware that, since Ancient Greece, capers have been prescribed as a potent carminative (a drug used to treat the excessive expulsion of gas). That our eye must first travel through the groin of the satyr, a figure that is itself famously linked with flatulence in classical literature (Sophocles said they 'boasted of their farting power') only amplifies the visual suggestion. In the light of those bawdy clues, the awkward propulsion of Bacchus's body becomes ribald and ambiguous. Is it really love that thrusts him upwards or has he been hoisted by his own putrid petard?

If that sounds fanciful, consider a clutch of further clues that only reveal themselves in the lewd light of Titian's playful caper. In the background on the right side of the painting, a figure can be seen lifting and blowing robustly through a horn. If our eye follows the horn's gentle curve, the trajectory connects the wind instrument to the animal that the drunken and obese silenus next to the hornblower is riding: a donkey, or ass. In both Latin and Italian (as in modern-day English) ass and arse pun on each other, meaning the musical expulsion of wind in the painting is being issued simultaneously from an animal and the buttocks. Further heightening the cheeky clamour is the position of the boisterous bacchante, or priestess who follows Bacchus, who holds a cymbal directly beside her own backside, as if suggesting a boom should sound from that very spot.

Nor is the leading lady of the painting allowed to escape the scandalous symphony the artist is covertly conducting. It has always been assumed that Ariadne, fixated on her lover Theseus's desertion of her (his slowly retreating ship is visible in the distance to her left), has been caught off-guard by the sudden appearance of Bacchus and his raucous posse – her surprise explaining her ungainly pivot in Bacchus's direction. Look closer at her posture, however, and suddenly the strange rearward-reach of her left hand, which appears to have collected a posterior cheek in its rotation, is less graceful than it once might have seemed. Accentuating the curious grip Ariadne appears to have on her own backside is the rising skein of rose fabric – a fragrant choice of colour by Titian – which wafts upwards and surrounds her. That Ariadne's electric-blue gown, which tonally defines her in the work, rhymes perfectly with the skirt of the bacchante, who also clings from the waist, only strengthens the suggestion that Titian has laced his work with mischievous fun.

👁 Detail showing the small white flower at the centre of *Bacchus and Ariadne*, 1520–23

A miracle of complex mirroring,
Hemessen's deceptively simple painting
is thought to be the first ever self-portrait
of an artist at work, standing before
an easel – an aesthetic invention that will
ricochet mesmerically down the centuries.

In the otherwise empty space between the easel on the left and the artist on the right are wedged the deceptively simple words:

> I, Caterina of
> the Hemessens,
> painted me in 1548
>
> at the age of
> 20

But to whom do we attribute this existential assertion of self-creation? Are we to hear these words whispered from the closed lips of the depicted painter who stares out from the canvas past our own gaze to an imagined mirror in the distance to our left? Or are we to feel them breathed from behind us, as if by the actual historical figure of Catharina van Hemessen – the pioneering sixteenth-century female Flemish painter responsible for what is generally accepted by art historians to be the first self-portrait to depict an artist at work at an easel? Or do the words constitute the projected will of the ghostly countenance that is just beginning to loom into view in the top left-hand corner of the painting-within-the-painting – the self-portrait that the self-portrait is forever starting to create in the primed white void of the oak panel on which she's working? In other words, in the context of a painting that presumes the existence of three separate selves who are forever caught in a trinity of ricocheted stares – the painter, the painted, and the yet-to-be-painted – it is difficult to square the circle of refracted identities and decode from the phrase 'I ... painted me', precisely to whom the 'I' and 'me' belong, and what we should call the interloping third.

There is, in short, nothing simple about this seemingly simple painting. Likely trained by her father, Jan Sanders van Hemessen, a leading figure of the Low Countries Romanist school (so-called after the pilgrimages undertaken by its members to Rome where the attitudes and techniques of the Italian Renaissance were absorbed), Catharina van Hemessen was a gifted stylist who managed to attract considerable praise and patronage in her own right (the queen consort of Hungary and Bohemia, Mary of Austria, retained her in her retinue of favoured court painters).

Hemessen's self-portrait exudes confidence in both her acquired skills and social status – considerable achievements

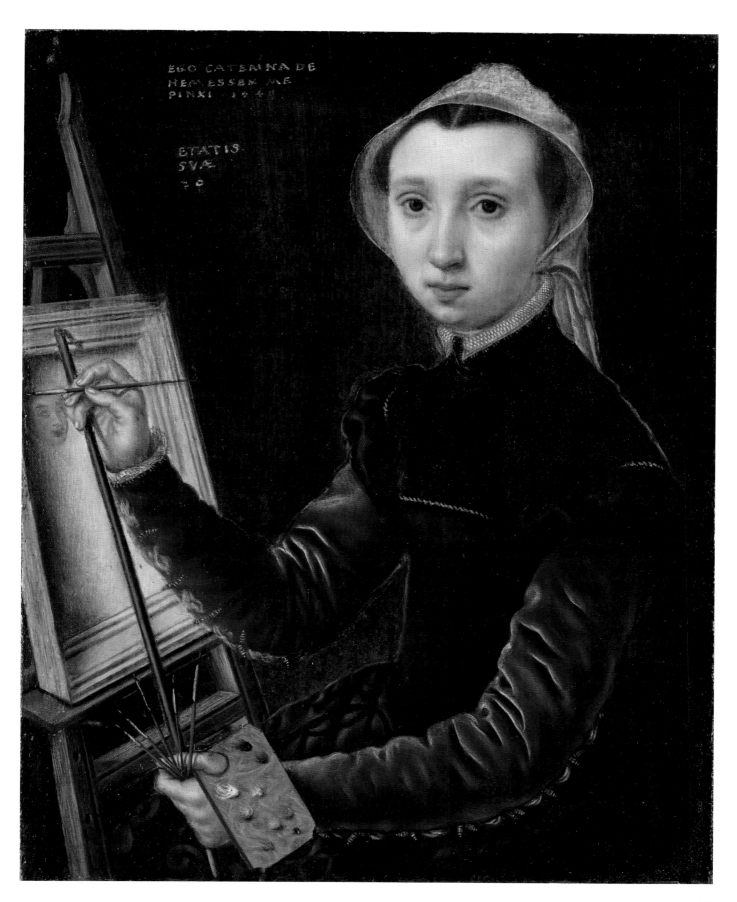

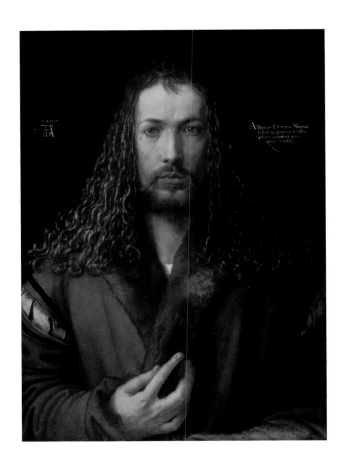

↖ Catharina van Hemessen,
Self-Portrait, 1548, oil on panel,
30.8 × 24.4 cm (12 ⅜ × 9 ⅝ in.)

↑ Albrecht Dürer, *Self-Portrait*,
1500, oil on panel, 67.1 × 48.9 cm
(26 ⅜ × 19 ¼ in.)

👁 Detail of the cross-shaped
brush and maulstick, with the
portrait-within-a-portrait in the
background, *Self-Portrait*, 1548

→ Cindy Sherman, *Untitled Film
Still #2*, 1977, gelatin silver print,
25.4 × 20.3 cm (10 × 8 in.)

Four and half centuries after Catharina
van Hemessen choreographed herself
in the act of reflecting on the creation
of her own reflection, American
photographer and serial self-portraitist
Cindy Sherman has embarked on
a career testing the limits of such
extroverted introspection and has
revealed that there aren't any.

in an age when painting was not a profession that women were encouraged to take up. Clad not in grubby studio garb but in an expensive dress with plush velvet sleeves, Hemessen multitasks with her left hand by clenching a fistful of paint brushes as well as a full palette of freshly concocted hues, while with her right hand she dexterously balances both a long maulstick (a prop used by artists to steady their hands while painting) and the brush with which she is just starting to describe the features of her own face. At first glance, she has everything under control.

But there's a problem. Shouldn't the face of the smaller self-portrait that the larger self-portrait is in the act of painting be positioned on the other side of the oak panel if it is to be consistent with the finished work that we see before us? Shouldn't, in other words, her head be in the upper right of the endlessly emergent painting-within-the-painting and not the upper left, as we find it here? Surely a work whose entire *raison d'être* is the demonstration of technical competence could not risk so conspicuous an aesthetic miscalculation. Or is it we, the observer of the work, who has things turned inside out? Since the painting on the easel is actually a mirror image of the mirror image that we see, does it constitute a kind of correction of the first inversion that occupies the main field of the panel? That is to say, is the self-portrait's self-portrait, the one still leaning on the easel, ultimately a work that is more true to life than the image we see depicted in the 'real life' of the painting before us?

The mystery of mirrors and their faithfulness to truth was a topic of profound religious contemplation by Hemessen's contemporaries, particularly as it pertained to a Christian's spiritual duty to 'mirror' the life of Christ. Thomas à Kempis's devotional book, *The Imitation of Christ*, published in Latin a century before Hemessen created her portrait, is devoted to the meaningfulness of endeavouring to be a perfect reflection of all that is holy in the universe. 'If your heart were right,' à Kempis explained in the book's fourth chapter, 'then every created thing would be a mirror of life for you and a book of holy teaching, for there is no creature so small and worthless that it does not show forth the goodness of God.' Forty-eight years before Hemessen's self-portrait, at the turn of the sixteenth century, the German master Albrecht Dürer created what remains a mesmeric likeness of himself ostentatiously adopting the air of Christ – imitating him in the most literal of senses.

But is there any reason to suppose that Christian notions of imitation play any role in the mirrored mirroring of Hemessen's panel? If our eyes return to the foreshortened easel on the left side of the painting, they are soon distracted by the suggestion of a makeshift crucifix discernible from the perpendicularity of the maulstick (as the cross's vertical beam) and the brush that Hemessen holds in her right hand (forming the crossbeam). That Hemessen might have felt so boldly empowered as to imagine herself in the posture of the crucified Christ is sanctioned by the popular teachings of the fourteenth-century Italian mystic, St Catherine of Siena, whose writings had been in circulation since the beginning of the sixteenth century. Dismissing the idea that women are not equally called upon to imitate Christ, she insisted that He is 'a mirrour that needis I moste biholde, in the which myrrour is representid to me that I am thin ymage & creature'.

Sometime before or after Hemessen painted her self-portrait (no one knows for sure which), she turned her hand to the Passion scene in which Christ, bearing the heavy weight of the wooden cross on his way to Golgotha, pauses to wipe his brow on a cloth that St Veronica offers him. In Hemessen's painting, the Veil of Veronica (as the object came to be known) is miraculously imprinted with Christ's likeness – a marvel that symbolizes the mirroring of Christ and his suffering in all things. Plotted carefully along the X and Y axes of the momentary cross in her self-portrait, Hemessen's half-draughted face appears, like Christ's sacred self-portrait on the Veil of Veronica, to be slowly developing like a Polaroid picture from the emptiness of the primed panel. For the eternal instant that the eye-hook of Hemessen's brush and maulstick intersect, the artist's endlessly divided identity – the painter, the painted, and the yet-to-be-painted – confound the physics of reflections and merge into a higher mystery.

Though Tintoretto's sprawling portrayal of Christ's crucifixion may be one of the largest and most imposing ever attempted, its impact on the eye is one of weightless evanescence – a luminous lifting that levitates us with it.

Most painters make pictures. A rare few conjure visions. The sixteenth-century Italian artist Jacopo Tintoretto was one of those. Said by his contemporary Giorgio Vasari to have possessed 'the most extraordinary brain that the art of painting has ever produced', Tintoretto melted the bold physicality of the flexing physiques that populated his paintings into an evaporative evanescence, as if merging into a single cosmic substance matter and spirit. His huge crucifixion scene (among the most expansive treatments of the subject that had ever been undertaken), created for the Sala dell'Albergo, a Venetian hall in the Scuola Grande di San Rocco (a space in which wealthy board members of the Confraternity of St Roch met), is exemplary of his skill in balancing the heft of the here-and-now with the airiness of an imagined elsewhere.

At once pulsingly muscular and delicately diaphanous (many of the bodies are described with a misty translucence), Tintoretto's sprawling work offers a panorama of the tenebrous slope where Christ was executed. Through Tintoretto's eyes we find Golgotha agitating with drama as a pair of crosses are being prepared to flank Christ's, which has already been hoisted into place. To Christ's left, the 'bad',

or impenitent, thief struggles to free himself from the ropes that loosely lash him to the crossbeams, while beside him a man bends over a gimlet (a tool for boring holes) and twists strenuously – a foreshadow of the wrenching pain that the condemned will soon find himself suffering. Meanwhile, to Christ's right, a cross bearing the body of the 'good', or penitent, thief, already strapped to the planks, is being levered cumbersomely into the air.

Each at different stages in their painful journey towards death, the crucified trio form a kind of before-during-and-after narrative of torture that dominates the painting's surface. In such a teleology, the sturdy stasis of Christ's resplendent body at the centre, beaming light, provides the apex of elevation. Or does it? Look more closely at the rays emanating from Christ's torso and their measured splay soon begins to look more and more like the unfurled feathers of outstretched wings, as though Christ were a bird of prey, poised on a perch, scouring the landscape below before mounting a further aerial ascent.

It is not, of course, unusual to encounter characters, especially angels, possessing wings in religious works from the period. But a winged Christ affixed to the cross is,

Detail of the 'winged' Christ,
in *Crucifixion*, 1565–87

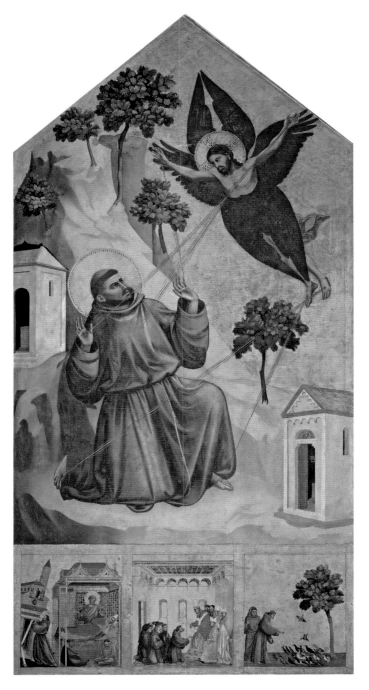

↑ Salvador Dalí, *Christ of St John of the Cross*, 1951, oil on canvas, 205 × 116 cm (80¾ × 45⅝ in.)

Tintoretto's elevating vision of a propulsive Christ, winged and preparing for lift-off, would prove influential on the imaginations of artists after him. Salvador Dalí's famous depiction of Christ, rocketing above the world, takes Tintoretto's fancy to another level.

← Giotto, *St Francis Receiving the Stigmata*, c. 1295–1300, tempera and gold on panel, 313 × 163 cm (123¼ × 64⅛ in.)

iconographically, relatively rare and tends to be linked to a singular story: the stigmatization of St Francis. According to Christian tradition, the Roman Catholic friar St Francis of Assisi received a vision in 1224, on the feast day of the Exaltation of the Cross, in which a winged figure appeared, stapled to a cross. The powerful vision heralded the subsequent appearance on St Francis's own hands and feet of wounds, or stigmata, mirroring those driven into Christ's palms and feet. St Francis receiving the stigmata was a popular subject in medieval and Renaissance art. Well-known depictions of the story by Giotto and Van Eyck are typical of the manner in which the cause-and-effect of seeing the vision and then mysteriously suffering the stigmata is conventionally conveyed by the superimposition across the painting's surface of angular lines – like bolts of blinding light – shooting directly from the body of the crucified to the extremities of St Francis.

Seen in the context of such precursors, Tintoretto's painting takes on a new geometry and a more urgently intimate meaning. Suddenly, a shatter of straight shafts bursting outwards from Christ's arms, shoulders and hands is discernible in the perspective lines of the ropes that are tied to the crossbeam of the crucifix on Christ's right, as well as in the long sharp spear that stretches downwards towards the soldier who holds it in the distance, just below Christ's punctured left palm. The explosion of lines is detectable, too, in the long mast of the cross that is just beginning to be lifted skywards, and just below that, in the diverging sides of the foreshortened ladder which, if imaginatively extended towards their shared vanishing point, would converge in Christ's body.

These outward flowing lines, beaming from Christ's winged frame, hammer our imagination. No wonder first-hand testimony of those who have experienced the work is so raw and enraptured. 'Never did a painting', according to the author of an influential nineteenth-century travelogue, *The Travels of Theodore Ducas in Various Countries in Europe, at the Revival of Letters and Art*, 'make a more powerful impression upon me than Tintoretto's Crucifixion.' By attaching to Christ a pair of refulgent pinions, the unexpected eye-hook of Tintoretto's work, the artist's otherwise conventional depiction of a set religious scene is transformed into something intimate: a pulsating vision, one capable of punching indelible marks into the supple palms of our consciousness.

↑ Tintoretto, *Crucifixion*, 1565–87,
oil on canvas, 536 × 1224 cm
(212 × 482 in.)

Celebrated for its astonishing realism, Caravaggio's depiction of the moment the resurrected Christ reveals himself to two of his disciples relies for its powerful effect on a detail that suggests the slow unravelling of the physical world.

There is nothing still about the 'still life' that Michelangelo Merisi da Caravaggio has inserted at the forefront of his masterpiece *The Supper at Emmaus*. The arrangement of overflowing fruit that teeters on the edge of the table is in a suspended state of unceasing flux – ravaged by rot and exploding from over-ripeness. The frozen flames of the striated rustic apple, emblem of original sin, have been perforated by the wormhole of a larval grub that stirs secretly in the host fruit's flesh. Even the basket is agitated. It simultaneously pushes us away and pulls us in, poised precariously as it is between two realms: the world of artifice in which it tentatively sits and the world of reality into which it might fall. The basket hampers us from taking our seat opposite the resurrected Christ and between his two dumbstruck disciples, Luke and Cleopas, who have just this moment realized his identity as the risen Messiah. At the same time, it snags our eye on a brightly illuminated fray in its wicker weave – a loose twig that rips at the fragile fabric that separates the looker from the looked-at.

That tiny tear in the braid of willow that cradles the spoiling apples and grapes, medlars and pomegranates, quinces and plums may seem, at first glance, an eye-hook too slight and pedestrian to detain our attention. And then we see it: the secret symbol that the stray strand inscribes against the arcing swerve of another loose sprig that droops in partial shadow behind it: the *Ichthys*, or Christian sign of a fish. If there is any doubt that Caravaggio intended us to decode from the unravelling wicker the encrypted profile of a fish, he amplifies the symbol's insinuated presence by casting to the right of the basket, against the white, shroud-like tablecloth, a rather less subtle silhouette of a lunate tail fin, propelling the fish's shadow back into the basket.

The echoed scales of Caravaggio's hidden symbol, whose significance as a cipher for Christ dates back to the second century, are key to comprehending the power of a painting that is all about the soulful necessity of physical and spiritual change. On a scriptural level, the work portrays the pivotal moment described in the New Testament when Christ, whose physical appearance has changed since resurrection, reveals himself to a pair of oblivious followers as the three share a meal in the town of Emmaus, outside Jerusalem. We know from the three hunks of crust on the table that Christ has just broken and blessed the bread. It is at that instant, according to the Gospel of Luke, that the eyes of his followers

↑ Caravaggio, *The Supper at Emmaus*,
1601, oil and tempera on canvas,
141 × 196.2 cm (55½ × 77¼ in.)

👁 Detail featuring the fish symbol
in *The Supper at Emmaus*, 1601

'were opened and they knew him; and he vanished out of their sight'.

In that eternal blink between awakening and disappearance much unfolds on the shadowy stage of Caravaggio's imagination. The follower to our left, usually identified as Cleopas (Christ's paternal uncle in some traditions), begins to bolt upright from the folding savonarola chair in which he has been sitting. Meanwhile, to our right, his fellow disciple, Luke, throws his arms out wide in amazement at what he is witnessing: material proof that the Son of God, whom he saw with his own eyes perish on the cross, has overcome death. Luke's flabbergasted gesture mimics the painful final posture that Christ himself had been forced to adopt while nailed to the crucifix. The nonplussed innkeeper, standing to Christ's right, stares blankly with gormless eyes, utterly blind to the wonder taking place directly under his nose.

But how does an artist make certain that we, the observers of his work, do not remain equally blind to the mystery of a transmogrifying, now-you-see-me-now-you-don't, spiritual identity unfolding before us? How does a painter transform a static work into something existentially elastic? To achieve such resilience of essence Caravaggio appeals unpretentiously to the everyday plasticity of the world of humble substance and evocative shadow: a ragged wicker basket unweaving itself into an archetypal symbol of salvation and the greater substance it gains when further fluidified into nebulous shade.

The Supper at Emmaus is characteristic of the uncanny realism tinged with tenebrous mystery for which Caravaggio became both famous and controversial in his lifetime: bold physiques that are only slightly less palpable than the darkness from which an unseen light source has chiselled them. Having struggled to sell his work and attract lucrative commissions until only a few years before painting *The Supper at Emmaus*, Caravaggio became something of a shape-shifter himself in Rome after the turn of the seventeenth century. His skill in sculpting scenes from shadows earned him a formidable reputation as one of the most innovative artists of the day. But that ingenuity was matched by a self-sabotaging tendency to loiter, in the off hours, in the shadier corners of the city. The drama of the years following the painting of *The Supper at Emmaus* (which would see the notoriously irascible artist serially arrested for carrying a sword in public, guilty of killing a man in a brawl, and dying in obscure circumstances while on the run) is the stuff of art-historical legend. To understand Caravaggio, one must be prepared to follow his light to its ragged edges and interrogate what lurks in the dusky gloom.

→ Rembrandt van Rijn, *Supper at Emmaus*, 1648, oil on paper on panel, 68 × 65 cm (26¾ × 25⅝ in.)

Rembrandt too was fascinated by the biblical story of Christ's mysterious revelation and disappearance. Like Caravaggio before him, the Dutch master wove from dusky light an intense spiritual drama in which the lines between shadow and substance shift and blur.

↓ Caravaggio, *The Supper at Emmaus*, 1606, oil on canvas, 141 × 175 cm (55½ × 68⅞ in.)

Caravaggio was obsessed with the story of Christ's mysterious metamorphosis from stranger to intimate connection. Five years after painting *The Supper at Emmaus* that now hangs in the National Gallery, London, he returned to the subject for a work that is now in the collection of the Pinacoteca di Brera, Milan.

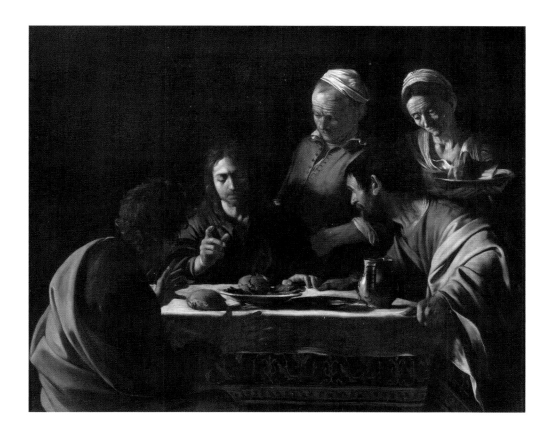

← Gian Lorenzo Bernini, *The Ecstasy of St Teresa*, 1647–52, marble, stucco and gilt bronze

A masterpiece of fluidified stone, Bernini's work is among the marvels of Renaissance sculpture and treads a fine line between the religious and the risqué.

'The greater danger for most of us', Michelangelo is said to have said, 'lies not in setting our aim too high and falling short, but in setting our aim too low, and achieving our mark.' It is clear enough by the expressions on both of their faces that the spear-wielding angel who floats above his moaning victim in Gian Lorenzo Bernini's Baroque masterpiece *The Ecstasy of St Teresa* has indeed hit his mark. The question is, where was the angel aiming – high or low? If Bernini has stayed true to the story's source – the autobiography of the sixteenth-century Spanish mystic St Teresa of Avila – the assaulting seraph should be pointing his resplendent skewer squarely at the Carmelite nun's prayerful chest:

> Beside me, on the left hand, appeared an angel in bodily form, such as I am not in the habit of seeing except rarely… In his hands I saw a great golden spear, and at the iron tip there appeared to be a point on fire. This he plunged into my heart several times so that it penetrated to my entrails. When he plunged it out, I felt that he took them with it, and left me utterly consumed by the great love of God. The pain was so severe that it made me utter several moans. The sweetness caused by this intense pain is so extreme that one cannot possibly wish it to cease, or is anyone's soul then content with anything but God. This is not physical, but a spiritual pain, though the body has some share in it – even a considerable share. So gentle is this wooing which takes place between God and the soul that if anyone thinks I am lying, I pray God to grant him some experience of it.

Looking at Bernini's work, one has no difficulty at all hearing the moans triggered by an 'intense pain' mingled with 'sweetness'. But is it really the heart that has been 'penetrated'? No one who follows the trajectory of the angel's phallic weapon, which he pinches teasingly between his fingers, can conclude that Bernini has taken the high road in locating the epicentre of St Teresa's ecstasy. By tilting the angle of the angel's spear a few degrees – an adjustment that forces our eyes to thrust an imaginary vector from the weapon's eye-hook shaft through the heaving folds of St Teresa's robe, to her loins – Bernini has turned the Cornaro Chapel of Rome's Santa Maria della Vittoria into a saucy sanctum of pious porn.

↓ A view of the Cornaro Chapel in the church of Santa Maria della Vittoria, Rome. High-relief portraits show the family and friends of the patron who commissioned the elaborate *Ecstasy of St Teresa*.

→ Guido Ubaldo Abbatini, *Gian Lorenzo Bernini's Cornaro Chapel*, c. 1650, oil on canvas, 168 × 120 cm (66⅛ × 47¼ in.)

If that sudden realization of what is actually taking place – the orgasm of a saint – makes us feel at all awkward about the voyeuristic gaze we are forced unwittingly to adopt, Bernini rather wants us to know we're not alone in our perverted peeping. The two sculpted figures we see engaged in cosmic coitus are merely the dominant components of a much larger installation that also includes the levitating cloud on which Teresa floats (bolted invisibly to the wall), the golden shower of sensual light that cascades down on the two, and a pair of kinky theatre boxes overlooking the sculpture from both sides of the chapel – each astir with high-relief portraits of the family and friends of the patron who commissioned the elaborate work, the Venetian cardinal Federico Cornaro. All that's missing is a flashing neon sign.

Peeping, sex and physical assault were themes that loomed disturbingly in Bernini's past in the years preceding his work on *The Ecstasy of St Teresa*. Suspecting his brother, Luigi, of sleeping with Costanza Bonarelli, a married woman with whom he himself was having an affair, Bernini hid opposite her house in order to catch a glimpse of the tryst. Once certain of their dalliance, he beat his brother severely, breaking his ribs. He then instructed a servant to visit Costanza and disfigure her face with a razor blade. The puny fine that Bernini subsequently faced as punishment for his barbaric behaviour was waived by his friend, Pope Urban VIII, on condition that the sculptor demonstrate remorse by agreeing to an arranged marriage.

Though it is said that Bernini, who would remain faithfully married to a Roman beauty of the Pope's choosing, Caterina Tezio, would never again be accused of violence, it is difficult when looking at his sculptures to separate the chiselled from the chiseller. Haunted by his unconscionable actions, our eyes struggle to polish clean from the surface of his miraculous marble the horror of which his hands were also capable. While it is true to say that no artist before or since has liquified stone with the same poetic passion as Bernini, the provocative tilt of the angel's spear reminds us just how few degrees separate the hammering of the body and the elevation of the soul.

→ Gian Lorenzo Bernini, *Self-Portrait*,
c. 1623, oil on canvas, 39 × 31 cm
(15 ⅜ × 12 ⅛ in.)

↓ Kevin Francis Gray, *Ballerina*,
2011, Statuario marble; sculpture
175 × 46 × 36 cm (68 ⅞ × 18 ⅛
× 14 ⅛ in.), base 26 × 50 × 40 cm
(10 ¼ × 19 ⅝ x 15 ¾ in.)

Bernini's mastery of stone continues to
chisel away at popular consciousness.
The flowing fabric that accentuates the
liquid physique of contemporary Irish
sculptor Kevin Francis Gray's *Ballerina*
echoes the intensity of its Renaissance
forebear.

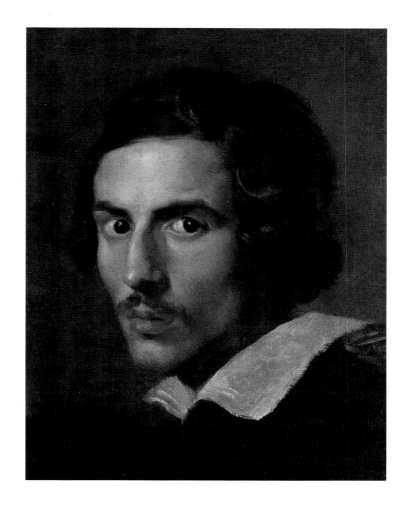

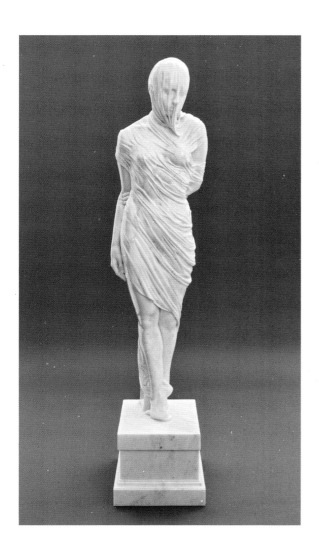

Few works in the history of art have inspired as wide a range of interpretations as Velázquez's complex group portrait of the Spanish court. To digest its secrets properly, we must know how to sink our eyes into it.

'It is impossible', the Spanish painter and biographer Antonio Palomino wrote in 1724 of the Baroque masterpiece *Las Meninas*, 'to overrate this painting, because it is truth, not painting.' Effusive as it is, Palomino's exalted estimation of Diego Velázquez's most famous work begs a question that Palomino himself does not quite come around to answering: what, exactly, is the 'truth' that the painting captures or conveys?

Is this merely a snapshot of the artist, whom we see standing before an easel on the left side of the work, brush and palette in hand (his only known self-portrait), busy in his palace studio in the Royal Alcazar of Madrid, working on a portrait of the five-year-old Infanta Margaret Theresa, daughter of King Philip IV of Spain and the Queen Consort of Spain, Mariana of Austria? Or are we witnessing instead Velázquez painting a double portrait of the Infanta's parents, who would have been standing approximately where we find ourselves on this side of the invisible barrier that separates art from reality? (We can see their faces reflected ghostly in the mirror bolted to the back wall of the cavernous room behind Velázquez.) Or is *Las Meninas* a grand metanarrative – a painting about painting – that

captures the artist creating the very work that we now see before us? After all, the relative dimensions of the work-within-a-work we see would appear to match nicely the huge scale of the canvas we are discussing here.

Having eluded conclusive decryption for over 350 years, *Las Meninas*, it is fair to say, uniquely inhabits a space beyond objectivity and outside our shared consciousness. Its mind is at once altered and altering, conjuring in the imagination of all who behold it an elastic reality that is wholly subjective and shifts depending on who is doing the looking. 'The knowledge', according to the art critic Laura Cummings, 'that this is all achieved by brushstrokes, that these are only painted figments, does not weaken the illusion so much as deepen the enchantment. The whole surface of *Las Meninas* feels alive to our presence.' With all its talk of 'illusions' and 'enchantments', Cummings's response is appropriately trippy and sounds more like a description of a hallucination than a painting. Perhaps it is.

If there is a main action taking place in the centre of the canvas (in addition to the self-reflecting act of painting by Velázquez), it is surely the interaction that occurs between the Infanta and one of her maids of honour (or *meninas*),

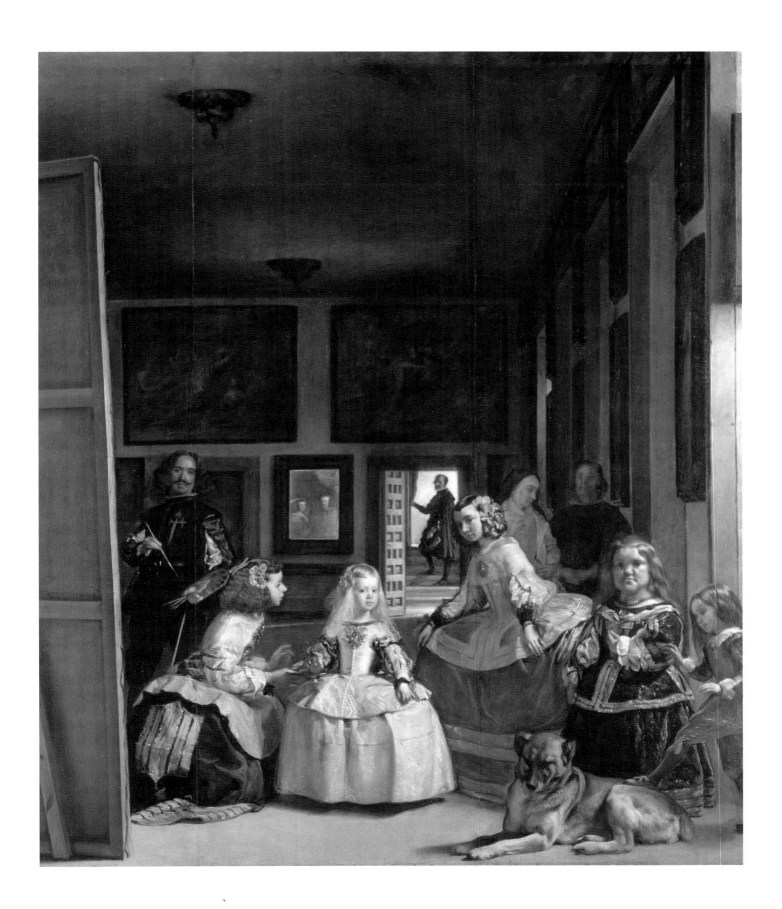

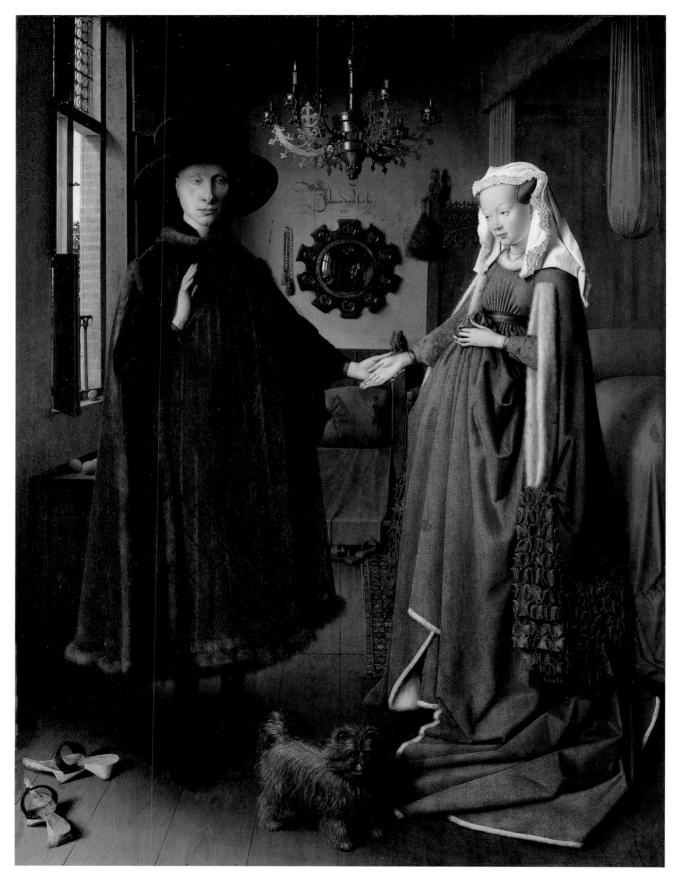

María Agustina Sarmiento de Sotomayor, to her right, who bows slightly in profile to her while either delivering or taking away a small red earthenware pot. Insofar as anything happening in the painting can credibly be said to be the primary activity in it, this exchange is arguably the most prominent, compositionally.

The small vessel around which the Infanta's fingers are forever suspended – either on the verge of grabbing or releasing – is known as a 'búcaro': an earthenware water jug much in vogue among the Spanish elite in the seventeenth century. Imported variously from Portugal and Latin America, these red clay pitchers were fragranced with spices when kilned in order to infuse the water they held with a delicate flavour. But if that was the búcaro's outward function, it also held a rather curious inner secret. Spanish women, wishing to lighten their complexions, would nibble the vessel's rims, ingesting small chunks of the red clay. Some ate the whole jug. While there is some evidence that eating the pottery would have the desired effect (and some undesired ones, too, including altering a woman's menstrual cycle), there is also testimony that the act of geophagy (or 'earth eating') was hallucinogenic and induced euphoria and lightheadedness. The Spanish poet and contemporary of Velázquez, Lope de Vega, crystallized the effect in a famous lyric: *Niña de color quebrado / O tienes amores o comes barro* ('Girl of sallow colour, you're either in love or you eat clay').

Is it possible that the painting captures the moment just after the Infanta has polished off a peck of clay and is feeling a little floaty? Is this why Velázquez, with a carefully controlled shadow under the parachute-like dome of her crinoline dress, has made her appear as though she is levitating? Suddenly, the butterfly clip affixed to the hair of María Agustina Sarmiento de Sotomayor, who is supplying the mind-altering substance, makes sense. That the artist is keen for us to pay attention to the búcaro is suggested by the smear of pigment on his palette to which he is pointing with his brush – the same vibrant hue from which the jug is articulated. Like a bottle containing a genie, the búcaro is the locus around which the hazy hubbub of *Las Meninas* spins – a woozying scene of making and unmaking, of reality and reflections, comings and goings, whispers and shadows. Orchestrating it all, the artist stares out at us inscrutably, confident that those endeavouring definitively to demystify his work have bitten off more than they can chew.

↖ Diego Velázquez, *Las Meninas*, 1656, oil on canvas, 318 × 276 cm (125⅛ × 108⅝ in.)

← Jan van Eyck, *The Arnolfini Portrait*, 1434, oil on panel, 82.2 × 60 cm (32⅜ × 23⅝ in.)

A painting about painting, Velázquez's *Las Meninas* deliberately vibrates back from its surface allusions to key moments in the history of art, and in particular Jan van Eyck's *The Arnolfini Portrait*. Behind the artist at his easel in Velázquez's work, a mirror on the back wall captures the murky images of Philip IV and Mariana of Austria – a detail that echoes a similar reflection in a convex looking glass at the back of Van Eyck's painting.

👁 Detail showing the red earthenware jug in *Las Meninas*, 1656

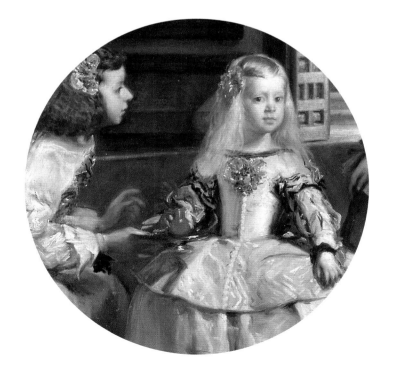

She stares back at you from a kind of cosmic darkness, as if on the threshold between realms of existence and nothingness. Look closer. Is she even there at all?

At the same moment that Johannes Vermeer was painting his masterpiece *Girl with a Pearl Earring*, the King of England, Charles II, was busy amusing himself with optical illusions. By positioning the heads of prisoners in his blind spot (a kink in the eye's engineering that had recently been identified by the French physicist Edme Mariotte), the king entertained himself by rehearsing the decapitation of the condemned before the executioner did so on the chopping block. Strange as it may seem, the two phenomena – Vermeer's masterpiece and the king's macabre pastime – have a great deal more in common than you might suppose.

We now know that our blind spots – those ophthalmological quirks at the back of the eye where the cluster of nerves creates a gap in vision – do not appear as blank spaces in our sight because our brains fill in the missing information from the patterns they perceive around us. Whether consciously or not, Vermeer's *Girl with a Pearl Earring* is a clever case-study in cutting-edge optics, whose power relies on precisely this capacity of the human mind to fabricate what isn't there. Look closely at the girl's face, which seems suddenly to have turned our way, and so much of what we believe defines her features is merely implied rather than explicitly articulated.

Think she has a nose? Lean in close and you'll soon discover that what you thought was a delicately delineated bridge has, in fact, dissolved without a trace into the supple skin around it. Only a soft shadow cast against her left cheek – just enough to signal to our brain that, in context, a nose should be here – conjures the feature. Comb the small canvas for evidence of precision in translating the world of solid surfaces and hard edges into paint, and one eventually realizes that it is only the eyes themselves, her eyes, that are described with painstaking care.

It is thought that Vermeer is unlikely to have given his painting a title (few artists at the time did so), and even less likely that he knew the work, per se, as 'Girl with a Pearl Earring'. (Indeed the painting has gone through periods when it was known as 'The Girl in a Turban' and, more generically still, 'Head of a Young Girl'.) But whether its title deliberately directs our attention to it or not, the ornament that dangles opulently from the girl's left ear commands our stare, despite the fact that, less so even than almost any other detail in the work, it is hardly there at all.

Barely hinted at by two deft dabs of paint, the swollen teardrop around which the painting's mysterious story spins

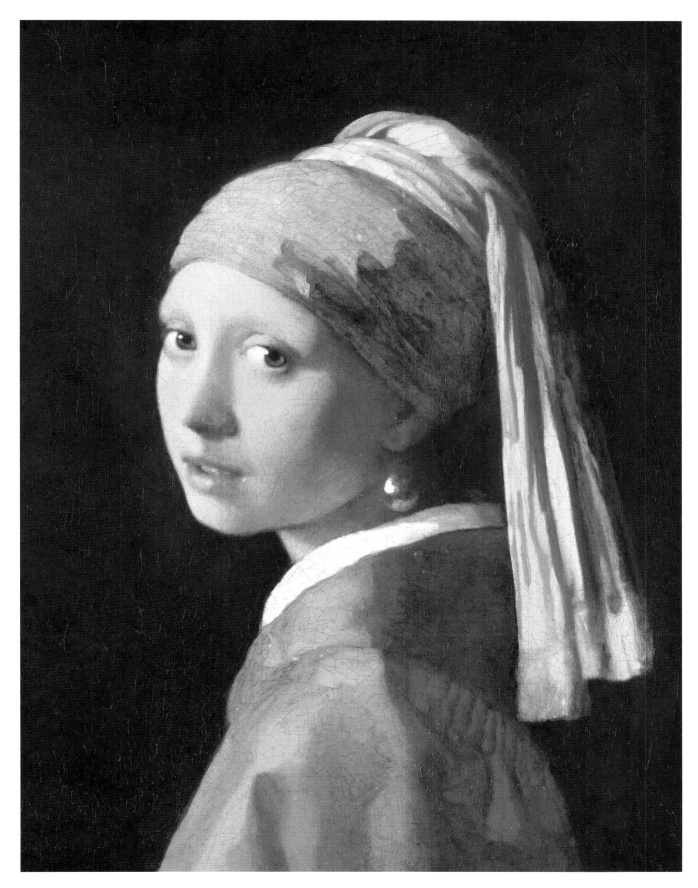

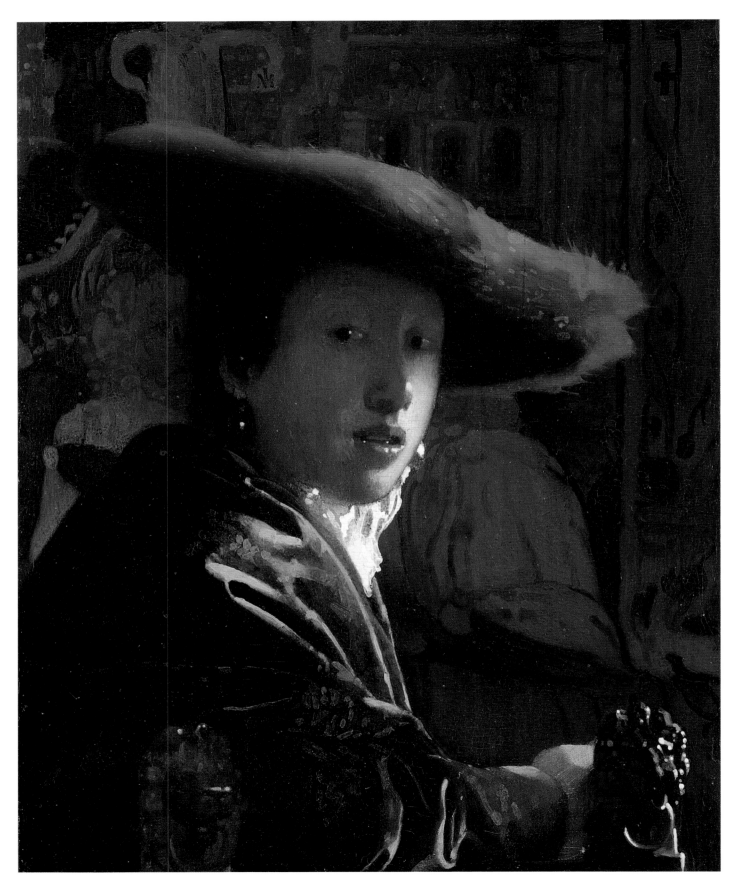

↖ Johannes Vermeer, *Girl with a Pearl Earring*, c. 1665, oil on canvas, 44.5 × 39 cm (17½ × 15⅜ in.)

← Johannes Vermeer, *Girl with the Red Hat*, c. 1665–66, oil on panel, 22.8 × 18 cm (9 × 7⅟₁₆ in.)

Unlike its simpler and more beloved sister painting, Vermeer's *Girl with the Red Hat* suffers from a surfeit of staring. Our eyes are never able to lose themselves in the mystery of the sitter's, but forever find themselves distracted instead by that faint hint of the absurd in the foreground – the polished lion finials panting for breath.

Detail of the earring in *Girl with a Pearl Earring*, c. 1665

is magicked into existence by the primary visual cortex of our brain's occipital lobe from a few tiny clues. No matter how hard you squint, there is no loop that links the shiny bauble to the girl's earlobe. The earring levitates, propelled into suspension as much by our minds as by any substantive crafting by the artist.

Had we encountered those same smidgens of pale paint hoisted, say, in the night sky above a lunar-lit landscape, they would convincingly persuade our minds that a lustrous moon was swimming through the night. Put simply, Vermeer didn't paint a pearl. He told our brains to go and fetch one for themselves. That instance of visual dictation has the effect of transforming the canvas into a kind of stenography where generic gesture and simple markings no longer aspire to mimic the way the physical world actually looks, but rather to tease the imagination into creating in the mind's eye a more vibrant image than any brush can forge.

Once understood as a kind of scrivener's shorthand, the brilliant twist of eye-hook white that stands in for the pearl's sphericity – a sleight of hand that appears to have been executed with the deftest flick of the artist's wrist – is suddenly seen for what it is: a floating apostrophe. As a species of punctuation used to indicate the elision of letters in writing – in the manner of *will'd* for *willed* – the apostrophe had, around the time Vermeer was painting *Girl with a Pearl Earring*, begun to be widely adopted in European punctuation. In the ever-evolving grammar of beauty, Vermeer's mysterious girl hovers somewhere between the absence of ellipsis and the presence of exclamation – here not there.

In this, one of the greatest self-portraits ever made, an artist with nothing left to prove calibrates the diminishing angles of time.

The miracle of a successful self-portrait, let alone a masterpiece of that genre, lies in its ability to ensnare in its closed circuitry of staring, observers who should, by all logic, find little with which they can personally relate in the endless ricochet of the artist gazing at the artist gazing. Yet the Dutch master Rembrandt van Rijn's late *Self-Portrait with Two Circles*, created sometime within the last few years of the artist's life, does precisely that – magnetically drawing the viewer into its hypnotizing orbit. Among some eighty self-likenesses that Rembrandt made over the course of his career (more than any other artist before him, and most artists since), this particular portrait possesses an elusive allure that historians struggle adequately to quantify.

The canvas belongs to a final phase of some dozen portraits that Rembrandt made in maturity – a chapter of late creative candour and freer gestures that followed formative stages of aesthetic development in which the artist gradually honed his skills. Though self-portraiture fascinated Rembrandt from the very outset of his career, initial experiments with the form show the artist using his own countenance not as a stand-alone statement but as a means to an end – a kind of prop with which he could demonstrate his precocious

skills. These early efforts were followed by a period of self-assuredness in which the esteemed artist treated his likeness as a kind of shop-window mannequin on which he could drape the outward trappings of professional regard.

Considered by many critics and observers to comprise the most moving chapter in Rembrandt's self-portraiture, those dozen created in the artist's last years portray a figure whose concerns have transcended the fleetingness of reputation. His spirit gradually ground down by the relentlessness of life's setbacks – the loss of his wife and three of their children in the 1640s, brushes with bankruptcies in the 1650s, and the deaths of his lover and of his only surviving son in the 1660s – Rembrandt made works that stare out from the murkiness of a soul's solitude with an air of nothing-to-prove defiance. Slowly whittled away is any trace of the artist's former compulsion to ingratiate himself into the patronage of those who could promote him financially or reputationally, as exemplified by the flattering portrayal of a company of civic guardsmen in his painting *The Night Watch* (1642), among Rembrandt's most famous works.

But what distinguishes *Self-Portrait with Two Circles* within this superlative group; what element in it hooks the

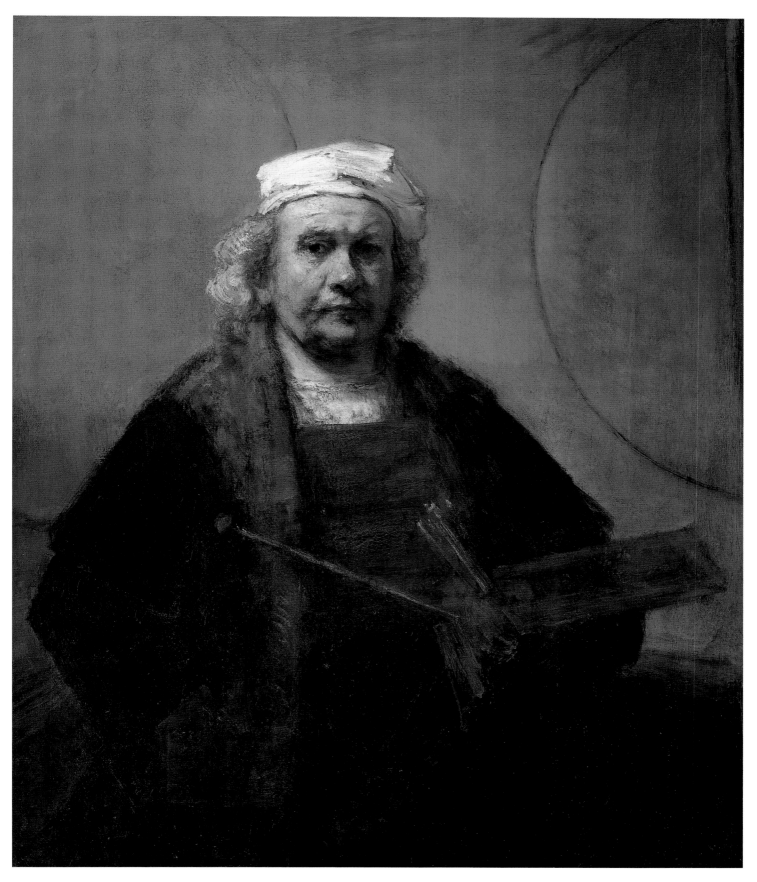

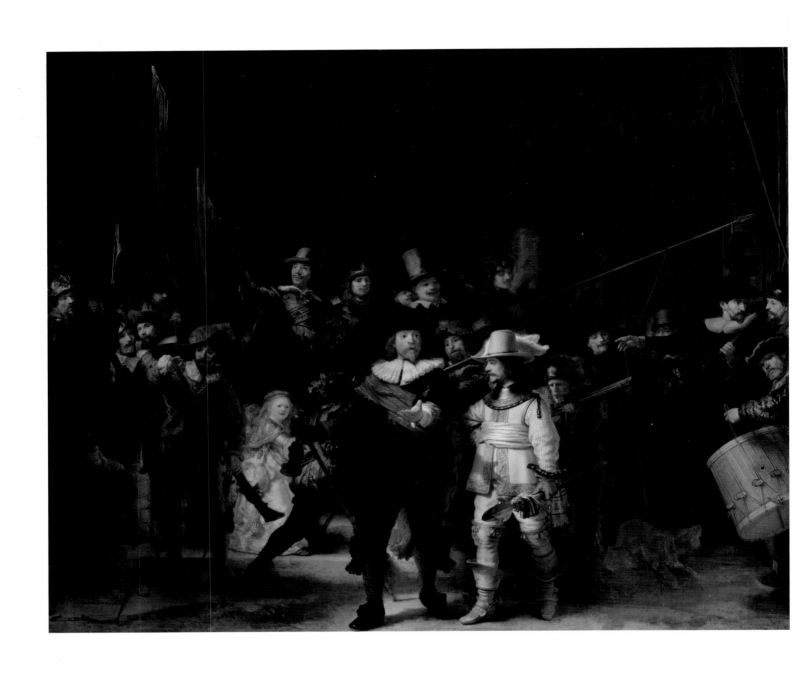

↑ Rembrandt, *The Night Watch*,
1642, oil on canvas, 363 × 437 cm
(143 × 172 in.)

↖ Rembrandt, *Self-Portrait with Two Circles*, c. 1665–69, oil on canvas, 114.3 × 94 cm (45 × 37 in.)

👁 Detail of the maulstick in *Self-Portrait with Two Circles*, c. 1665–69

eye and keeps the mind spinning in its irresistible orbit? Critics scrutinizing the canvas have tended to focus on the juxtaposition of the emotive complexity of the artist's face with the spare geometry of the two circles on the pale wall behind him. Some historians have speculated that the shapes are an allusion to the maps and hemispheres visible behind figures in paintings by Vermeer, Rembrandt's illustrious Dutch forebear, thereby inviting comparisons between the two artists' achievements. Others have proposed that the fragmentary arcs are an echo of a legend involving the Italian master Giotto that the Renaissance historian Giorgio Vasari tells. According to Vasari, Giotto impresses the Pope by being able to draw, freehand and without the aid of any instrument, a perfect circle – a feat thought to be impossible. By placing himself outside their gravitational pull, Rembrandt – such a hypothesis implies – is the calibrator of even greater marvels.

Though intriguing, the partial circles are not, to my eye, the element that elevates the painting from marvellous to masterful. Far more compelling is a related, if neglected, detail that the artist keeps closer to his chest: the leather-tipped maulstick that he clutches in his hand along with a quiver-full of brushes. Used by artists since the Middle Ages as a stabilizing crutch on which the painter's brush-gripped fist can rest while painting, the maulstick is part of the invisible scaffolding on which the finished look of a painting depends, but which disappears from view entirely when the painting is displayed. The maulstick is responsible for maintaining an artist's balance and, as such, is an extension of the physical laws of equilibrium to which the painter, however skilled, is bound. Like a conduit between two realms, the maulstick is the imagined tightrope that connects the will of the artist to the final accomplishment of his or her work.

In Rembrandt's painting, the maulstick can be seen establishing the trajectory of a tangent that, if followed, would barely intersect the large circle behind the artist. By shaving off only a slender piece of the larger circle, the tangent posited by Rembrandt's maulstick suggests that, of the totality of life, only a slender sliver remains. The position in which the instrument is held by Rembrandt creates, moreover, an acute angle with the brushes he is also holding. The shape created by the angle of the maulstick and brushes is that of a draughtsman's compass – the very device necessary for drawing the circles that whirl behind the artist. But in Rembrandt's hands, the angle at which the imagined compass is set appears to be gradually decreasing, one brush at a time – as the hands of life's invisible clock slowly pinch him in.

Wright of Derby's depiction of a natural philosopher demonstrating the science of vacuums dramatically illustrates just how difficult it can be to prise apart the spheres of science and the spirit.

According to legend, one of the most dramatic scientific experiments ever performed occurred on 8 May 1654, at the Reichstag in Regensburg, Germany. Before an audience of assembled luminaries of the Holy Roman Empire that included Emperor Ferdinand III himself, the pioneering inventor Otto von Guericke marshalled the muscle of thirty horses (divided into two teams of fifteen each) to demonstrate the supreme power of nothingness: the vacuum. Prodded to pull in opposite directions, the horses endeavoured to rip apart a pair of large copper hemispheres that Guericke had joined by simply sucking the air from inside the globe they formed when the two bowls were placed rim-to-rim. To the audience's astonishment and delight, no amount of haunch-whipped horsepower could break the bond – a triumph for Guericke that attracted widespread praise for the new-fangled contraption he had recently conceived: the air pump.

One hundred and fourteen years after Guericke's experiment, a miniature version of his ingenious globe (or what came to be known as 'Magdeburg Hemispheres' in honour of the inventor's hometown, where he repeated the demonstration in 1656) is the key to understanding one of the most absorbing and misunderstood paintings of the eighteenth century: Joseph Wright of Derby's *An Experiment on a Bird in the Air Pump*. From its utilitarian title and scatter of gadgets glistening in candlelight, Wright's work would appear, at first glance, to be nothing more than a suspenseful celebration of Enlightenment wonder at contemporary advances in scientific knowledge. Once the observer of the work has decrypted the central action being portrayed – a bird in a glass chamber slowly being deprived of air in order to demonstrate the lung's dependency on oxygen – the superficial shadowiness of the work's gothic melodrama is demystified by the carefully calibrated workings of rational thought. Or is it?

Associated with the group of intellectuals who called themselves 'The Lunar Society', Joseph Wright of Derby was both fascinated by and a first-hand witness to the acceleration in scientific innovation that was driving forward the Industrial Revolution in England. On a literal level, the painting tells the story of a late-night visit by a travelling lecturer (or natural philosopher, as he would have been known in the 1760s) to the home of a prominent member of society – perhaps himself a wealthy factory owner or baron of industry.

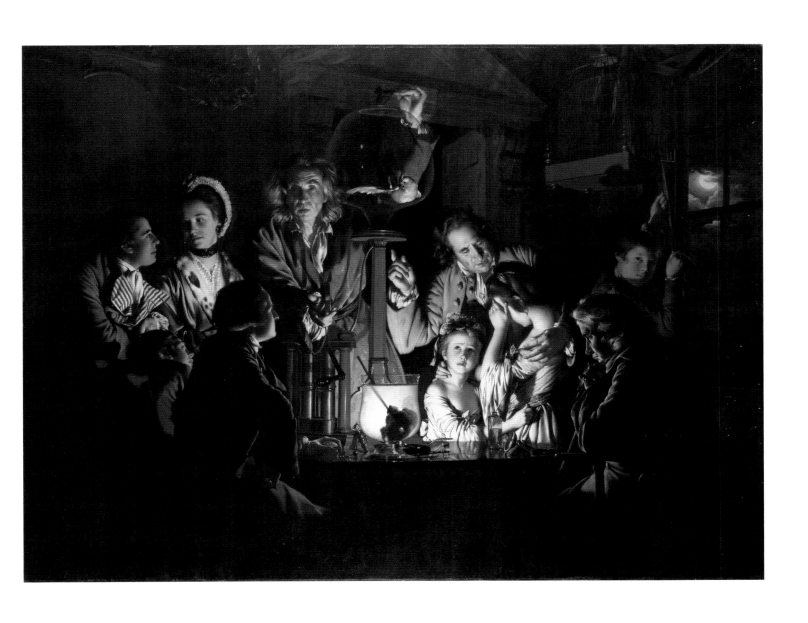

↑ Joseph Wright of Derby,
An Experiment on a Bird in the
Air Pump, 1768, oil on canvas,
183 × 244 cm (72 × 96 in.)

← Joseph Wright of Derby, study
for *An Experiment on a Bird in the
Air Pump*, 1767

This oil sketch – a rare study
of a Wright of Derby painting –
was discovered on the reverse
of a self-portrait of the artist.

→ Joseph Wright of Derby, *The
Synnot Children*, 1781, oil on canvas,
152.4 × 125.8 cm (60 × 49½ in.)

The claim, here, that *An Experiment
on a Bird in the Air Pump* – a painting
obsessed with science – is really a kind
of Annunciation may seem eccentric.
But Wright of Derby would continue
to experiment with the biblical subject
for the rest of his life. *The Synnot
Children*, painted thirteen years after
Air Pump and flapping with allusions to
it, has long been thought itself to be
loosely based on Renaissance versions
of the Annunciation.

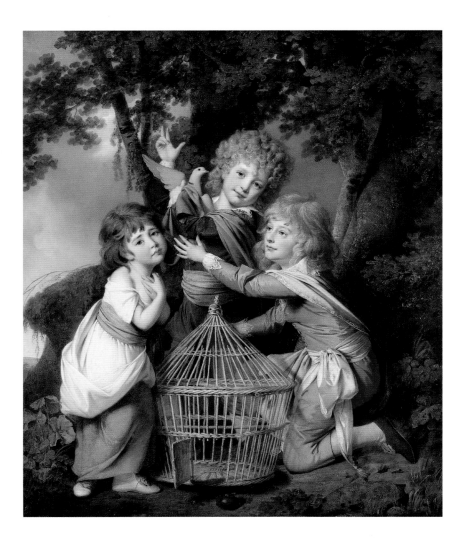

The householder, clad in expensive clothes that denote his elevated socio-economic status, is seen reassuring his daughters who are terrified by the fate slowly befalling their pet bird, trapped in the glass chamber above them. By pointing to the expertly engineered glass globe (designed to withstand the evacuation of air inside it without imploding) that is being controlled by the wizened figure of the itinerant philosopher who stands above it (his hand poised on the pump's stopcock – a lever that swivels between life and death), the father tries his best to keep his family's focus (and ours) on the power of reason.

As our gaze rotates around the table, the faces we encounter appear, one by one, to reflect the range of emotions sparked by the friction of faith and science, religion and rationality. Sculpted from a chiaroscuro that we would expect to find in a biblical scene from centuries earlier, where the spiritual brilliance of a Madonna or Christ Child would ignite the action mystically from its centre, the half-lit countenances spin from fear to fascination, anxiety to awe. The young men on the left are absorbed by the terrifying physics of asphyxiation. One holds a stopwatch, measuring the bird's stamina. How long is too long? The girlfriend of another

stares at him admiringly. The literal light source of the work, a candle, is obscured behind the large glass snifter in the centre of the table, which contains a lung pierced by a straw whose simple trajectory towards the pump's pistons and the gesturing right hand of the lecturer is split, spectrally, by the optics of refraction.

That this is a heightened, unreal drama unfolding on an idealized plane of meditation rather than one occurring in reality is accentuated by the artist's unrealistic choice of bird: an expensive cockatoo, rather than a mere songbird (as was featured in an early study for the painting and would have been the type used in an actual experiment). By choosing a species of parrot, one capable of mimicking human language, Wright has made the central focus of his work a creature associated in the history of art with depictions of the moment in the New Testament when the angel Gabriel, who is often portrayed with parrot feathers, whispers in the Virgin Mary's ear that she is pregnant with Christ.

Seen in this light, the cockatoo's tilt of head and the mute cry of his eye-hook beak, projecting along the length of his outstretched wing directly to the ear of the lecturer, complicates the meaning of Wright's painting and places it on an irresolvable threshold between religion and reason. Though never before understood as such, *An Experiment on a Bird in the Air Pump* is an Annunciation, but one in which the survival of spirituality in the face of accelerating science and reason is deeply in doubt. The glass globe is merely a projection of the physical emptiness Guericke created inside his hemispheres a century earlier. The set of miniature Magdeburg Hemispheres that lie cracked open on the table symbolize a world slowly being ripped apart by the competing horsepowers of the head and the heart.

↓ Henry Fuseli, *The Nightmare*, 1781,
oil on canvas, 101.6 × 126.7 cm
(40 × 49⅞ in.)

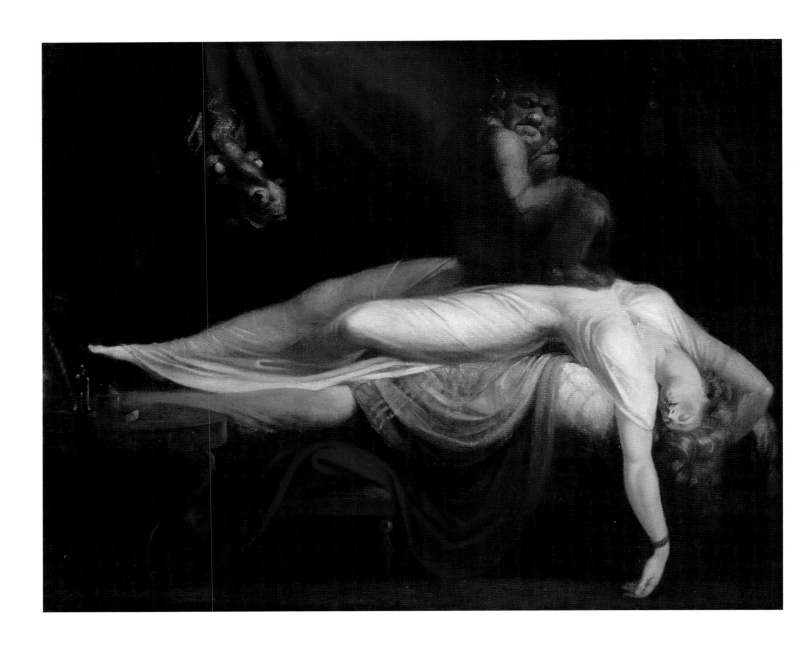

Some paintings stare right through you. Other works dare you to gaze through them. Fuseli's pre-Freudian psychodrama conceals behind itself, in layers hidden from the eye, as much as it consciously reveals.

The giveaway is the horse's bulging, sightless stare. All but popping out of its head as if awestruck by something it has just seen, the stallion's eye-hook eyes are eerily blank. Lacking pupils, they are incapable, anatomically, of sensual perception. That is not, of course, the same thing as saying that they are bereft of vision. They provide our first clue, corroborated by the dark and empty looking glass on the bedside table that seems to record no reflection of the space, that this is not a physical scene to be inspected for forensic details, but a plane on which an intense introspection is being played out – a theatre of the mind. To understand what is behind Henry Fuseli's gothic masterpiece *The Nightmare* will require less analysis and more psychoanalysis. We will need to access the work's subconscious – the hidden inner drama of the painting that, on its surface, only the unseeing stallion seems to see.

The action that appears to unfold in the work is easily enough summarized: an excretory imp squats on a swooning girl while the head of the horse that brought him pokes phallically through the folds of the heavy velvet drapes that surround her. As with all great works, the scene has become so familiar (*The Nightmare* was among the most parodied

and reproduced images of the Romantic age) that it is easy to look right through it. In a sense, it is a pity we can't. On the other side of the canvas, the artist has concealed a dusky portrait – an underconsciousness – that may well unlock the dark calculus of his painting.

It is thought that the hidden likeness was executed two or three years before *The Nightmare*, after Fuseli had returned to his native Zurich following a lengthy exile. Fuseli had been forced to flee the city back in 1762, when he was a 21-year-old minister in the Zwinglian Reformed Church, having sensationally exposed an extortion scheme involving a local magistrate. He eventually landed in London, where he attempted to make a living translating the works of Winckelmann and writing refutations of Rousseau. Joshua Reynolds was enchanted by the spirited foreigner and persuaded Fuseli to abandon his literary ambitions in favour of becoming a painter instead. After an eight-year stint in Italy – during which he taught himself to paint, and distinguished himself among the growing circle of British artists congregating there – Fuseli returned to Zurich in 1778, where he fell passionately in love with the niece of his friend, the physiognomist Johann Caspar Lavater.

Detail of the horse in
The Nightmare, 1781

→ The painting on the obverse side
of Fuseli's canvas of *The Nightmare*

An impoverished, though promising painter, Fuseli felt unable to declare his feelings for the sultry Swiss blonde, who now, and forever, turns her back on the world and stares into the wall.

The secretive portrait is dim and humid and depicts a smirking seductress in a low-cut dress, stroking the feather boa that dangles from her shoulder. Though we know that Lavater was an intimate friend of Fuseli's from before the artist's exile (and was himself involved in uncovering the magistrate's corruption), nothing can quite prepare us for the calibre of candour with which Fuseli expressed himself in a letter of June 1779: 'Last night I had her in bed with me — ', he wrote to the girl's uncle, 'tossed my bedclothes hugger-mugger — wound my hot and tight-clasped hands about her — fused her body and her soul together with my own — poured into her my spirit, breath and strength. Anyone who touches her now commits adultery and incest! She is mine and I am hers. And have her I will...'

Although Fuseli never did 'have' Anna Landolt, who was engaged to a gentleman deemed to have better prospects, the resemblance between the forgotten portrait and the dishevelled victim with whom she shares a canvas is striking. The two have the same dishwater hair, the same thick lips, the same build and bosom. They are, as it were, two sides of the same coin, not only physically but psychologically. By flipping his canvas over, and abandoning the coquettish representation in favour of a genreless vision of psycho-sexual possession, Fuseli embarked on a journey of personalized aesthetic expression from which Western art would not return. Though *The Nightmare* is, on one level, a sponge of artistic allusions (art historians have spotted echoes of da Vinci and Veronese, Salvator Rosa and Tibaldi, Romano and Reynolds), its enduring interest derives from something less culturally traceable and more primally archetypal. The incubus who hunkers on the girl's stomach has been variously linked with fertility gargoyles and Hellenistic hunchbacks, Etruscan Gorgon-figurines and Roman satyrs, but those who see in his lascivious eyes, above all else, a resemblance to the artist, are perhaps closer to the imp's true essence.

Never mind the bayonets of the faceless firing squad. Never mind the shadows. If you want to comprehend why Goya's terrifying masterpiece continues to grip two centuries after it was created, you need to listen to the painting's hands.

'For the last six years', Francisco Goya confessed to King Charles IV of Spain in a letter from March 1798, 'I have been greatly indisposed, especially having lost my hearing to the extent that I am unable to understand anything without the use of sign language.' Even before suffering hearing loss, the artist had been more attuned than most to the music of the hands. His paintings reveal a genius of gesticulation. From a child's loose grip on the cruel string that tethers the talons of his pet magpie in Goya's early portrait of the son of one of his patrons, Manuel Osorio Manrique de Zúñiga (1787–88), to the effortless pinch of the artist's own fingers on a paintbrush that floats like a wand in his *Self-Portrait before an Easel* (1792), in Goya's hands we find a silent symphony of signing.

Little is known of the serious illness that Goya suffered around 1793, when he was 47 years old, that left him impaired for the rest of his life. What is clear is that, from then on, his works vibrate with an even greater awareness of the volubility of gesture. Once detected, the waving and pointing, gripping and fondling that agitate from the surfaces of Goya's paintings and drawings transform them into an elaborate pantomime that our eyes do not so much look at as read.

Rarely do his silent hands whisper. More often than not, they scream. In his gruelling masterpiece *The Third of May 1808*, which depicts the horrifying retaliation of French soldiers against innocent citizens of Madrid, after a group of Spanish rebels had revolted against Bonaparte's takeover the day before, Goya explores the poignant poetry that flows from hands with only milliseconds left to express themselves. Painted the year after the French occupation had ended, the canvas contrasts the humanity of those being executed with the faceless – and handless – military machine that recedes in seemingly endless regression to the right. From the ordinary citizens who have been caught in this shocking drama, we see an excruciating pageant of desperate hand gestures – now clenching, now praying, now being chewed, now gripping a head in abject despair. Compare those with the single fist of a French soldier at the dead-centre of the painting – one hand standing synecdochally for the entire rigid regiment, more like an extension of the firearm it grips than of a human arm.

But what draws us into the terror of Goya's scene are the upraised arms and expressive palms of the figure on whom the guns are pitilessly trained. Light blaring coldly from the

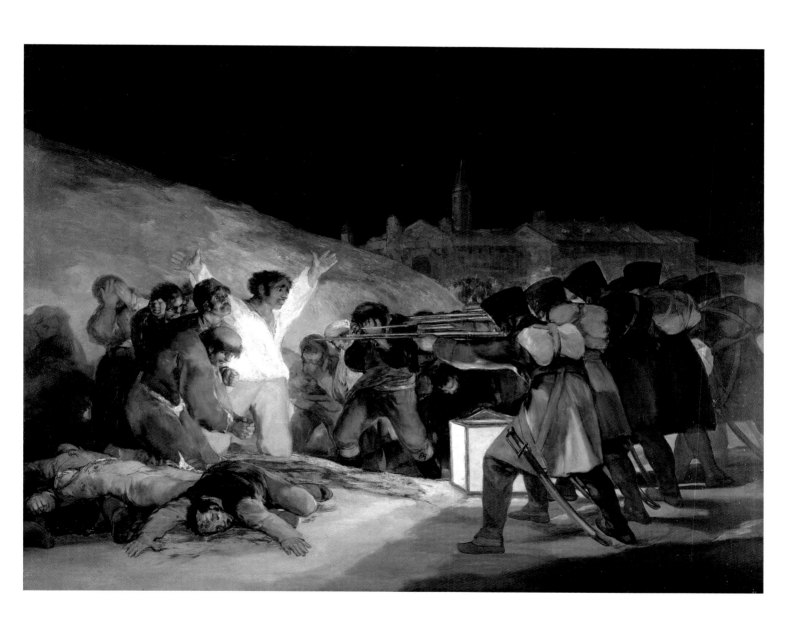

↑ Francisco Goya, *The Third of
May 1808*, 1814, oil on canvas,
266 × 345 cm (104¾ × 135⅞ in.)

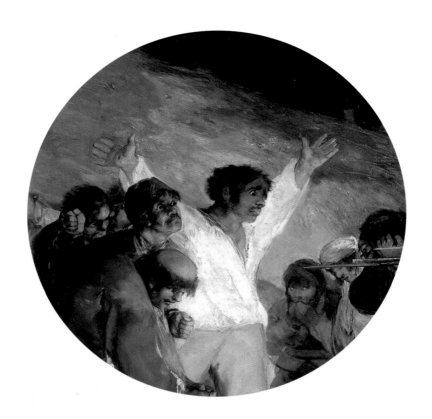

Detail of hands in
The Third of May 1808, 1814

angular grenade of a cubical lamp – amplifying the machine-like harshness of the soldier's side – has picked out not only every rumple of the Madrileño's spiritually unstainable overlit shirt, but also every crease and callus of his hardworking hands. It has long been noted by critics that a strategically positioned shadow falling across his right palm seems to describe a deep dimple, or bloodless stigmata, echoing the perforation of Christ's hand while on the cross. Such an allusion enhances the sense of crucifixion boldly suggested by the elevated arms as though hoisted in place by an invisible crossbeam.

What has not been explored, however, is any possible meaning decodable from the body language of the fingers themselves. A dab hand at signing since losing his hearing twenty-one years earlier, Goya had become obsessed with the secret grammar of knuckles, pinkies and thumbs. Two years before painting *The Third of May 1808*, Goya created a detailed drawing of gestural language that captured the choreography of hands in a variety of different poses. The twenty attitudes he depicts in his chart are reminiscent of a similar chart produced in 1644 by the English physician John Bulwer for his eccentric tome *Chirologia: Or the Naturall Language of the Hand, Composed of the Speaking Motions, and Discoursing Gestures*

Thereof. Accepting a challenge posed by the philosopher Francis Bacon some four decades earlier, Bulwer set about decoding the mysterious language of the fingers and single-handedly invented the science of 'chirology', or hand reading. Bulwer's chart – what he called his 'chyrogram' – provided a handy glossary on the unspoken significance of typical gestures by attaching to each a simple deciphering phrase.

Bulwer's book and chyrogram remained influential across Europe well into the nineteenth century and would likely have been known to an artist 'unable', as Goya said he was, 'to understand anything without the use of sign language'. Placed alongside Goya's *The Third of May 1808*, Bulwer's chart reveals that the eye-hook hands of the Christ-like figure who is about to be executed may be less defeated than defiant in their expressiveness. Both hands are open, but they differ ever so slightly in the degree to which their fingers are spread. The less widely fanned digits of his left hand correspond nicely to Bulwer's classification 'O', or 'Protego', meaning 'protection', whereas the more broadly stretched fingers of his right hand align perfectly with the chyrogram's 'P', or 'Triumpho', meaning 'victory'. Like all great works of art, the mute message of Goya's painting is anything but cowering or conquered.

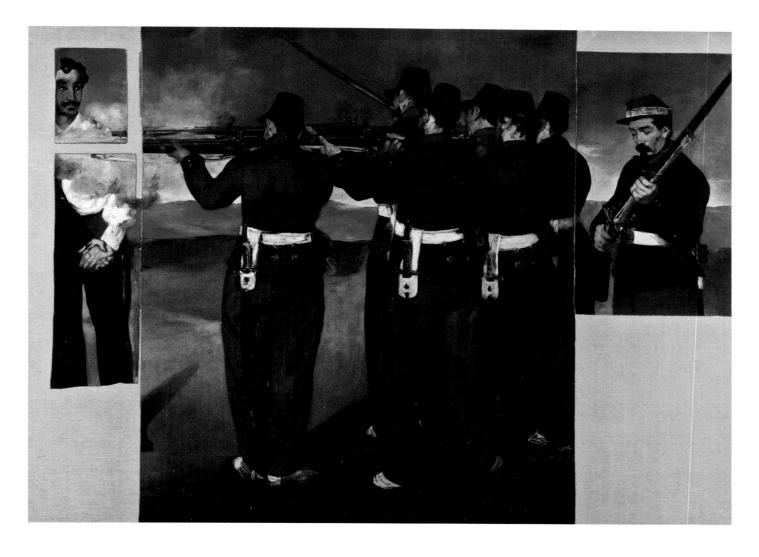

↑ Édouard Manet, *The Execution of the Emperor Maximilian of Mexico*, c. 1867–68, oil on canvas, 193 × 284 cm (76 × 111¾ in.)

The unflinching brutality of Goya's *The Third of May 1808* would change forever the way artists portrayed the barbarity of faceless power. Half a century after Goya undertook his painting, Édouard Manet recreated a similarly compressed stage for his depiction of the execution by firing squad in June 1867 of the Austrian-born Emperor of Mexico. What remains of Manet's work – cut into pieces after the artist's death in 1883 – is a jumble of fragments rescued and reassembled by the artist's contemporary, Edgar Degas.

↓ John Constable, *The Hay Wain*, 1821,
oil on canvas, 130.2 × 185.4 cm
(51¼ × 73 in.)

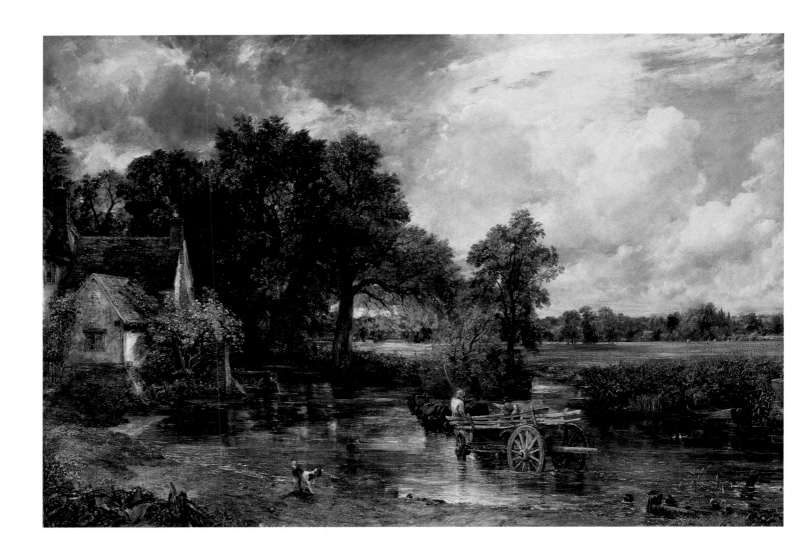

It may be among the most widely reproduced images of the English countryside, perfect for biscuit tins and kitchen aprons, yet Constable's seemingly idyllic landscape is as haunted by ghosts as any painting in art history.

To move from the cruel crack of murderous gunshots in Goya's *The Third of May 1808* to the gentle dapple of cloud-wrung radiance on a lazy late summer stream in Constable's *The Hay Wain* is almost unconscionable. But even the quietest idyll is unsettled by something stirring beneath its surface; by muffled anxieties wriggling restlessly to the fore.

Like Goya's canvas, undertaken years after those horrific events it recounts, Constable's work was painted not *en plein air* during the season it depicts, nor indeed even in the East Anglian landscape it memorializes. Rather, Constable created his masterpiece of lyrical lucency (originally entitled 'Landscape: Noon') in the cold quiet of his London studio during the winter months that stretched from the end of 1820 to the spring of 1821. The vision it recalls, and the feelings evoked, harken back to the artist's childhood in the region. In that sense, it is as much a deeply felt memoryscape of energies that once were as it is a careful transcription of an actual site in Suffolk, near Flatford, on the River Stour.

In his mid-forties when the painting was undertaken, Constable had witnessed the countryside change dramatically. He had observed first-hand not only the effects of rapid industrialization, but also how the same Napoleonic Wars that would generate Goya's painting were fed by a steady stream of men vacating the idyllic scene. Though celebrated as a work that painstakingly captures the physics of sunlight and physicalities of clouds and trees and water, *The Hay Wain* is as much about the haunting heft of what (and who) is no longer there as those solidities and selves that are.

The scene is framed by physical fixtures of the place that Constable knew as a child: to the right, a hint of brickwork from Flatford Mill (which his father owned), and, to the left, the cottage owned by the tenant farmer Willy Lott (among the dramatis personae of the artist's childhood). Between these two bulwarks of monumental memory a waggon (or 'wain'), pulled by the current-cooled legs of three horses, makes its difficult way across the river, leaving us behind on the water's edge in the foreground. The strange liminality of the hay wain, struggling to shift from one plane of existence to another – from one realm to the next – is echoed eerily in the ghostliness of a figure that is neither wholly present nor entirely absent in the painting, yet both at the same time.

Next to the barking dog that pads the shore, a wraithlike rider, spookily stalking the scene, is barely visible. This

mysterious player was deliberately described on the painting's surface, before being painted over and out of the scene. It's believed by art historians that time has gradually thinned the layers of paint that had buried the figure from view, thereby slowly resurrecting his presence. Once detected, the spectral horseman, whose disappearance darkens the air around him, is impossible to unsee.

Suddenly, the dog beside him appears to be barking at the rider's almostness. Though gauzy and insubstantial, the shadowy re-emergence of a figure from the work's subconscious – whether intentional or not – now asserts itself as a palpable reality in the work we see before us on the wall of the National Gallery in London. Rather than leading the observer's gaze in the direction of the trudging hay wain, as some assume he is intended to do, the dog yaps stirringly in the mind's ear, recalling us instead to the sense of loss that is at the heart of the work.

The endlessly evaporating equestrian, who flusters forever between being and nothingness, complicates an otherwise troublingly uncomplicated scene. Is he a metaphor for all the landscape has relinquished, as history has trundled forward into war and industrialization? Or is he a misty likeness of the artist himself; a restless vestige of energy that vibrates beneath the surface of all the painter paints? Certainly Constable himself came to equate the diaphanous atmosphere that is captured in the painting with the construction of his very identity. 'The sound of water escaping from mill dams,' he once wrote, describing that sense of slow release embodied by the ghostly horseman, 'willows, old rotten planks, slimy posts and brickwork ... these scenes made me a painter.'

The real subject of Constable's painting is not, it would seem, the immutable beauty of the English countryside, but the airy alchemy of art itself – a medium capable of transforming the see-er and the scene into something endlessly emergent and vanishing. No wonder the artist was drawn to the drawing of shape-shifting clouds, whose impalpable empire of change has never found a more attentive cartographer than Constable. In her poem 'Cloud Painter', Jane Flanders describes the deep dissipations of Constable's imagination: 'the canvas itself begins to vibrate / with waning light, / as if the wind could paint'. Flanders's language attaches as tellingly to the painter's mastery of meteorology as to his mystic mingling of the seen and the unseen:

And we too, at last, stare into a space
which tells us nothing,
except that the world can vanish along with our need for it.

↑ Berndnaut Smilde, *Nimbus Dumont*,
2014, digital C-type print on
aluminium, 75 × 110 × 2 cm
(29½ × 43⅜ × ¾ in.)

The truest heir of John Constable's
genius for conjuring convincing clouds
that symbolize the evanescence of
being is not a painter but a pioneering
sculptor, who has managed to
alchemize from air levitating clouds
indoors.

*In his famous image of technology
on the move and nature in retreat,
Turner demonstrates how even the
most powerful forces can be signified
by the smallest of symbols.*

In May 1844, when J. M. W. Turner was in his seventieth year, a nine-year-old boy found himself transfixed at the sight of the celebrated artist putting the finishing touches to a large oil painting, about to be shown at the Royal Academy in London. Decades later, George Leslie's recollection of Turner's technique remained undiminished. 'He used rather short brushes,' Leslie recalled, 'a messy palette, and, standing very close up to the canvas, appeared to paint with his eyes and nose as well as his hand... He talked to me every now and then, and pointed out the little hare running for its life in front of the locomotive.'

The work that the young boy had watched Turner complete on Varnishing Day was *Rain, Steam, and Speed – The Great Western Railway*, among the greatest paintings of the nineteenth century. Turner's compulsion to draw attention to an otherwise easily overlooked detail is telling and offers a clue as to how best to interpret his work. Until now, much of the thought regarding Turner's larger achievement, and particularly the distinction of the paintings he created in the last fifteen years of his life, has been preoccupied with the bold broadening of brushstroke and use of expressionistic colour that anticipated by decades avant-garde movements in Paris in the 1870s and '80s and in New York in the 1940s and '50s.

Caricatured by contemporary cartoonists as requiring a long-handled mop in order to paint, the 5-foot-4-inch (1.6 m) Turner is an artist whose canvases we, too, have been encouraged to stand back from, the better to measure the wide cadmium abstractions of vaporizing light for which they have become almost exclusively known. Step back from *Rain, Steam, and Speed*, for instance, and what initially absorbs the viewer is the clash, materially, between the solidity of the locomotive slanting across a newly built bridge in Maidenhead, designed by the celebrated engineer Isambard Kingdom Brunel, and the diaphanous light through which the machine thrusts. At first glance, the work appears to balance – in fragile equilibrium – mythic forces of nature in retreat and technology on the move.

But a closer inspection of many of Turner's works, including *Rain, Steam, and Speed*, reveals that the clotted dusks and luminous dawns were merely intended to set the stage for smaller details that offer observers a way into the artist's otherwise overwhelming visions. These intimate eye-hooks can easily go unnoticed and are best appreciated from the

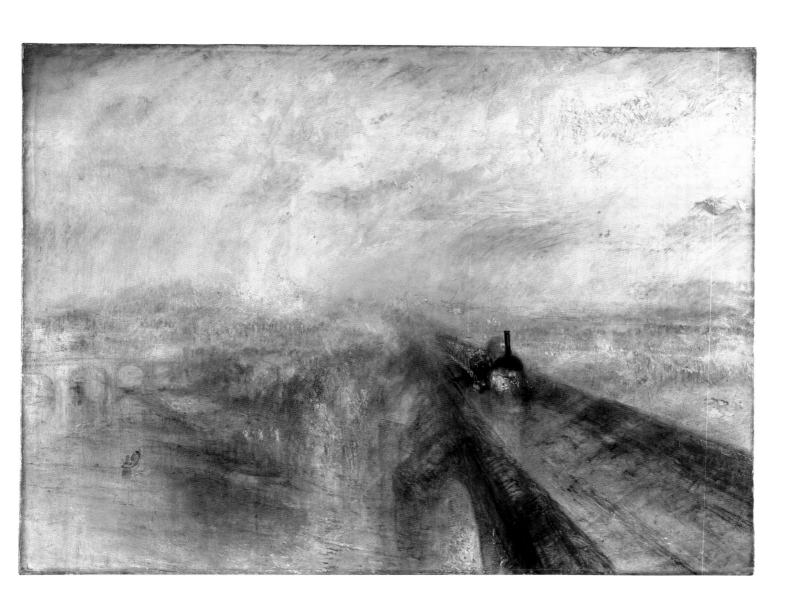

↑　J. M. W. Turner, *Rain, Steam, and Speed – The Great Western Railway,* 1844, oil on canvas, 91 × 121.8 cm (35 ⅝ × 47 ⅞ in.)

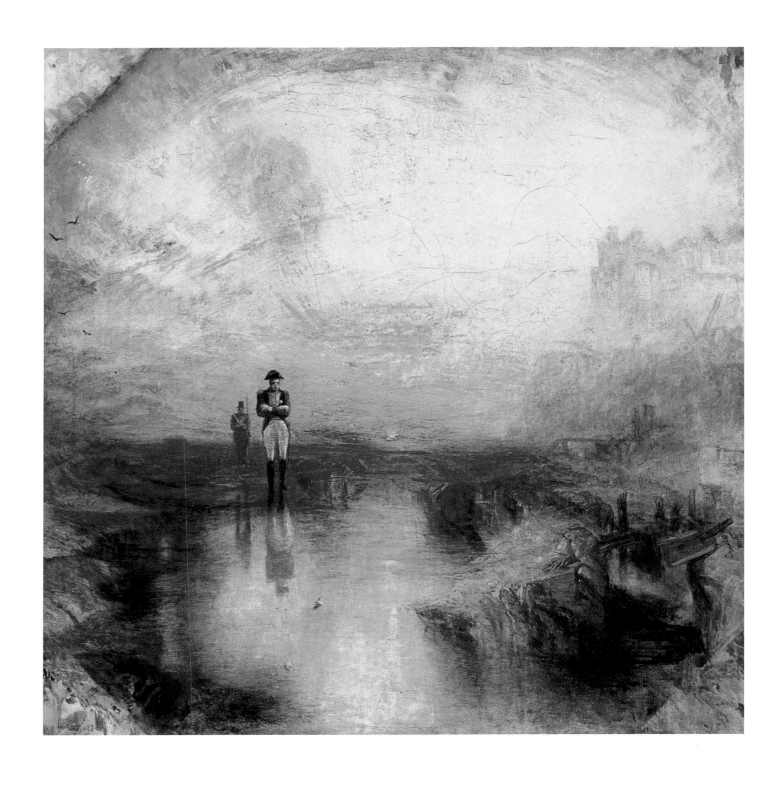

↑ J. M. W. Turner, *War – The Exile and the Rock Limpet*, 1842, oil on canvas, 79.5 × 79.5 (31¼ × 31¼ in.)

Detail showing the hare in *Rain, Steam, and Speed – The Great Western Railway*, 1844

same micro-distance at which they were created. Visitors to the 1844 Royal Academy exhibition would have been reminded by Turner's *Rain, Steam, and Speed* of the tragedy that had occurred two and a half years earlier on Christmas Eve in 1841, just ten miles from the bridge depicted in the painting, when the open-top carriages of a train derailed and nine third-class commuters were killed and another sixteen disfigured. While an etherealizing insinuation of souls dancing in the light to the left of the locomotive rids the scene of a relentless realism, it is the painterly touch of the deftly enunciated hare – since antiquity a symbol in art of rebirth and hope – that connects the work at once to a broader cultural tradition and to the vulnerable viewer who is torn between competing virtues: nature and progress. It is the presence of the hare alone that rescues the work from being something archetypally abstract to something intimately felt. Only through the impressionistic dash of the eye-hook hare is the painting simultaneously brought down to earth and elevated into transcendent art.

The tension between tiny details and enveloping atmospherics in Turner's art requires a constant focusing of our eyes, as they zoom and retract from his paintings' surfaces. Take his work *War – The Exile and the Rock Limpet*, painted in 1842, which imagines the final banishment in 1815 to St Helena of Napoleon Bonaparte, whose ashes had recently been brought back to Paris. The painting is among the artist's most daringly expressionistic in its agitated gestures of humid haemoglobin hues that encircle the dejected general at the centre of the work. Yet it is clear from the painting's extended title that a crucial level of its meaning involves the minuscule mollusc that crouches at Napoleon's feet, approximately the same distance from the stare of the exiled tyrant as the hare who, two years later, would find himself forever frozen ahead of the oncoming train in *Rain, Steam, and Speed*.

At once fragile and obstinate, the vulnerable snail becomes a gentle counterpoint to the culpable warmonger – a frail foil that transforms Napoleon's predicament into an ageless archetype of loneliness and suffering. The raging chaos of the whirling atmosphere becomes a glimpse into the imperilled consciousness of the limpet, whose survival depends on the unpredictable ebb and flow of the island's tide. Turner's tendency to go big meant also bigging up the small.

*Whistler's sidelong portrait of his
aging mother may have merged in popular
imagination with maternal ideals;
in truth, the painting conceals in
plain view a clue to a dark disposition.*

It's there and yet it isn't: the etching that hangs, mounted and framed, on the back wall of James Abbott McNeill Whistler's famous sidelong portrait of his seated mother. What, exactly, is depicted in the etching is too hazy to discern in any meaningful detail. Yet it forms a substantial and more direct focus for our gaze than the oblique countenance of the elderly Anna Whistler herself – the ostensible focal point of the work. Perched askance, Anna fixes her eyes elsewhere, on an indeterminate point someplace in the left-hand margin of the work, if not beyond it. With so little else on which our scrutiny can gain traction in the painting, the shadowy figure who hunkers in the etching's foreground, and the dingily diaphanous structures that loom behind him, begin to worry away at our estimation of the painting's achievement. Who is this stranger lurking in plain sight on the surface of one of the most familiar images in cultural history?

Surely the privileged position that the etching occupies, hovering in the airspace above the only portrayal of the artist's mother that Whistler is known to have executed, suggests that it is more than merely incidental to the painting's logic and narrative. As if to make certain that no viewer of his canvas should fail to recognize its elevated significance within the composition, the artist has pinned his famous monogram (a butterfly with an extended stinging tail) to a spot not beside his mother, but adjacent to the murky etching – superimposed against the pleated curtain, just to the left of the work-within-a-work. So glaringly dominant is the etching, one begins to wonder whether it does not, in fact, possess a key to unlocking the very psyche of this otherwise teasingly inscrutable work.

At the time that Whistler undertook in 1871 *Arrangement in Grey and Black No. 1* (more commonly known as 'Portrait of the Artist's Mother', or simply 'Whistler's Mother'), he had been preparing for publication *A Series of Sixteen Etchings of Scenes on the Thames and Other Subjects* (or what has come to be known as the 'Thames Set') – a clutch of works that the artist had initiated over a decade earlier, after first arriving in London in 1858. One etching in that series, which chronicles the changing temperaments of the River Thames, is a scene whose arrangement is strikingly similar to the work that hangs near the artist's mother in his famous portrait. Entitled 'Black Lion Wharf', the picture captures in right-facing profile a young sailor sitting in a barge – a figure who bears more than a passing resemblance to the artist himself. Behind

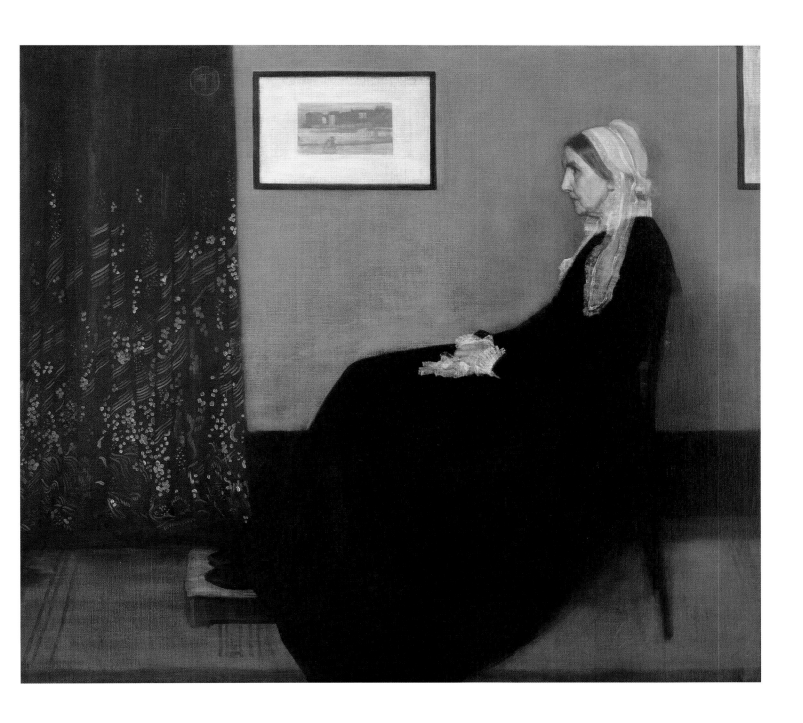

↑ James Abbott McNeill Whistler,
Arrangement in Grey and Black No. 1
(also called 'Portrait of the Artist's
Mother'), 1871, oil on canvas,
144.3 × 162.5 cm (56⅞ × 64 in.)

↑ James Abbott McNeill Whistler,
Black Lion Wharf, 1859, etching on
paper, 14.3 × 22.5 cm (5⅝ × 8⅞ in.)

→ 👁 Detail of the etching on the
wall in *Arrangement in Grey and Black
No. 1*, 1871

him, a jumble of moored boats and rickety piers lead our eye to a stretch of shabby warehouses and crumbling wharves that line the riverfront.

The district featured in Whistler's etching is Wapping, which was, at the time, among the most inglorious precincts of the city. This is where, for four centuries, pirates and mutineers had been executed and left to rot until three tides had washed over them. But it is Wapping's connection with another ignoble human history that is arguably more urgently relevant both to the etching and to the famous portrait of the painter's mother that encompasses it. The role of Wapping's wharves and warehouses in what came to be known as the 'Triangular Trade' between Britain, West Africa and the sugar plantations of North America constitutes a heinous chapter in the biography of the Thames. It is also a history about which Whistler and his family were neither disinvested nor indifferent.

Anna Whistler was, herself, born in the American South to a slave-trading, plantation-owning family. Her son, the painter's brother William, had served as a surgeon in the Confederate Army, as it strove to advance the South's chief objective, the right of one human being to own another. Nor was Anna ambivalent about the outcome of emancipation in America. She would go on to sue the enslaved black widow of her uncle in an attempt to prevent her and their mixed-race children from receiving an inheritance. Whistler himself is known physically to have assaulted African-Americans in public, to have used racist epithets, and to have slapped abolitionists in the face.

Seen in the context of Wapping's connection with the Triangular Trade and of the Whistler family's own intolerable intolerance, a coded allusion to slavery takes on a kind of terrible, taunting logic. The etching's seated sailor, whose resting arm is surrounded, but distinctly unencumbered by a heavy chain, looks more like a spiteful jeer at those whose voyages were not so free. Even the curiously dehumanizing title of the celebrated portrait – *Arrangement in Grey and Black* – begins to sound less and less like an invocation of musical terminology (in accord with the artist's 'symphonies' and 'nocturnes') than an allusion to the racial struggle in which the survival of the Confederacy (occasionally referred to as 'grays', after the colour of their uniform) and the freedom of blacks had been held in precarious balance. Suddenly, the canvas's heroine is more accurately understood as a gristly relic of a bygone disposition than as an enduring icon of maternal fortitude.

Though Rodin presents his impossibly famous sculpture as the apotheosis of sober thought, his work monkeys around with our imagination as playfully as any in the history of art.

What makes *The Thinker* the most recognizable sculpture in art history? Look closely at the work, and the contorted posture it portrays – the right elbow wrenched uncomfortably to rest on the left knee – is, at best, ergonomically awkward. It hardly strikes a familiar physical chord, however lost in thought and oblivious of our bodies we may find ourselves. Nor is the broader situation in which the subject is depicted likely to be one with which most observers can intimately connect. How often do you perch stark naked on a craggy rock daydreaming? And yet, for all its preposterous gimmickry and muscular contrivance, *The Thinker* is indisputably archetypal, as though its famously fabricated physique has always existed.

Auguste Rodin, the nineteenth-century French artist who began conceiving the work in 1880, believed *The Thinker*'s power lay in the impression it gives that it preternaturally preceded its own making – that it is less a thing created than the creator of things. '*The Thinker* has a story,' Rodin once explained:

In the days long gone by, I conceived the idea of *The Gates of Hell* [an elaborate doorway for a projected, but never constructed, museum of decorative arts in Paris]. Before the door, seated on a rock, Dante, thinking of the plan of his poem. Behind him, Ugolino, Francesca, Paolo, all the characters of *The Divine Comedy*. This project was not realized. Thin, ascetic, Dante separated from the whole would have been without meaning. Guided by my first inspiration I conceived another thinker, a naked man, seated upon a rock, his feet drawn under him, his fist against his teeth, he dreams. The fertile thought slowly elaborates itself within his brain. He is no longer a dreamer, he is creator.

Rodin's studio assistant, the Bohemian poet Rainer Maria Rilke, movingly attested to the mysterious energy that throbs from, under, and through the sculpture's skin. 'His whole body', Rilke observed, 'has become head and all the blood in his veins has become brain.'

Such fluidity of static form is remarkable. But to what, exactly, can we attribute this mystical elasticity and the sculpture's ability to appear as though it is in a state of infinite flux, forever in the process of being made? Here, as elsewhere in Rodin's work, the secret lies in the handling of hands.

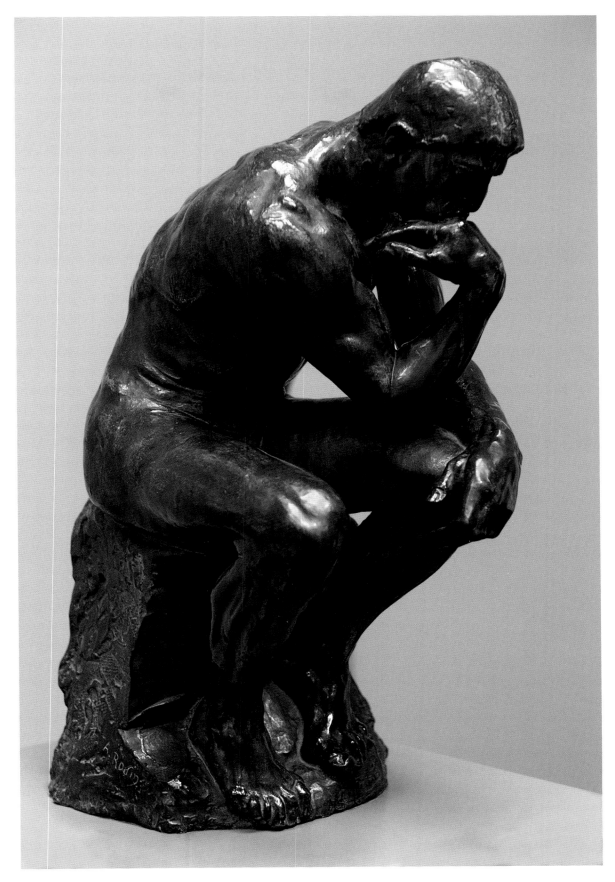

↖ Auguste Rodin, *The Thinker*,
1880–1904, bronze, 189 × 98 × 140 cm
(74⅜ × 38½ × 55⅛ in.)

👁 Detail of the hands in *The Thinker*,
1880–1904

verge of clasping, equates the sensual architecture of touch with spiritual sanctuary.

If you want to comprehend what Rodin's subjects are contemplating, don't stare into their eyes. Read their hands. When it comes to *The Thinker*, what subliminally grips our fascination is the amplified proportion of the work's hands (and, indeed, feet) to the rest of the body – an exaggeration easily overlooked at first glance. Once spotted, the figure's outsized metacarpi (one hand folded under his chin, and the other drooping from his left knee) start to squeeze our imagination. Suddenly, this paradigm of pensiveness begins to look unexpectedly primitive and peculiarly paleo. Look again and the scale of hands-to-body is more obviously that of an unevolved anthropological antecedent of *homo sapiens* than the *ne plus ultra* of polished cogitation. Rather than epitomizing the evolution of cultivated thought, it embodies the devolution of human form.

That Rodin's conception of *The Thinker* coincided with a major milestone in evolutionary science, the discovery in 1880 of the remains of a Neanderthal child, is likely nothing more than cultural happenstance. After all, Rodin is said to have astounded his friends by knowing nothing of Charles Darwin. But whether or not Rodin was conscious of the English naturalist's pioneering and controversial theories, Darwinian notions were in the air he breathed. A cartoon by the French caricaturist André Gill of Darwin, swinging like a monkey from a tree (which appeared on the cover of a French satirical magazine in 1878), is indicative of just how pervasively Darwin's claims had spread into European conversation.

A witty bronze sculpture from 1893 by the German artist Hugo Rheinhold of a contemplative chimpanzee sitting on a stack of Darwin's books, in a posture that could be a parody of *The Thinker*, suggests that Rodin's contemporaries may have been conscious, too, of the resemblance between his sitter and evolutionary precursors of man. By blurring the boundaries between primitivity and sophistication, Rodin has created a kind of living fossil – a missing link with which we intuitively connect to distant ancestries, whose roots wire our blood. Perhaps we recognize in *The Thinker* a familiar but forgotten posture, one we adopted long ago – one pivotal, primordial evening when we dreamed ourselves into being.

In Rodin's art, hands are never idle or incidental. They hold the key. Rodin was obsessed by hands. Whole works, such as *The Hand of the Devil Holding Woman* (which imagines Satan's fingers cradling a nude figure, as if either about to release or crush her) and *Hand from the Tomb* (in which an outstretched splay of fingertips and knuckles, jutting upwards from a coffin, waves desperately, as if gasping for a last breath), are conceived around the delicate choreography of digits. *The Cathedral*, a stone statue consisting entirely of the teasing dance of two right hands, forever on the

→ André Gill, caricature of Charles Darwin as a monkey on the cover of *La Petite Lune*, August 1878

↓ Auguste Rodin, *The Hand of the Devil Holding Woman*, 1903–25, bronze, 40.6 × 65.4 × 48.3 cm (16 × 25¾ × 19 in.)

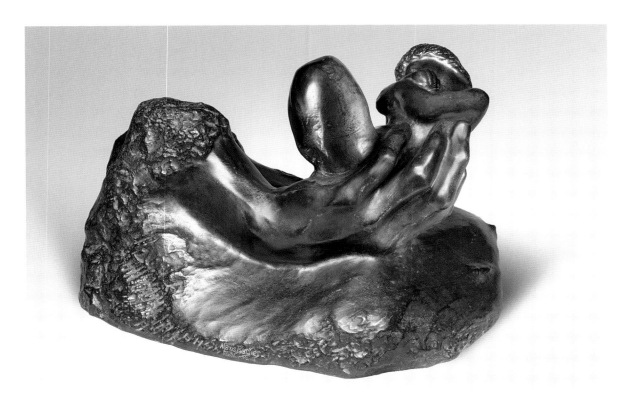

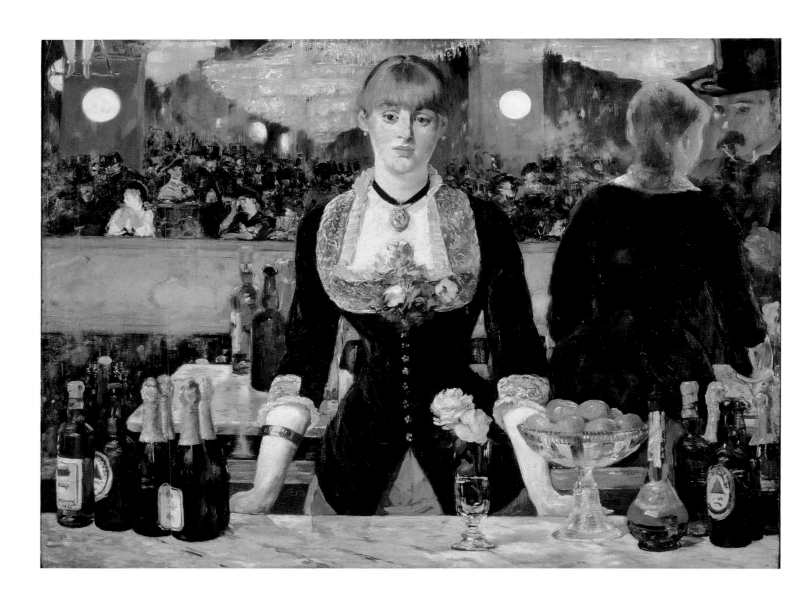

↓ Édouard Manet, *A Bar at the Folies-Bergère*, 1882, oil on canvas, 96 × 130 cm (37¾ × 51⅛ in.)

The complex perspectives of Manet's mirrored interior have caught admirers of his painting in an endless crossfire of possible readings. Yet it is the simplest of geometric shapes that unlocks the work's elusive meaning.

Few paintings have flummoxed critics as profoundly as Édouard Manet's *A Bar at the Folies-Bergère*. Painted in the last years of the artist's life and career – a career that bridged the contradictory instincts of Realism and Impressionism – the famous depiction of a Parisian cabaret is perhaps best known for its confounding optics and for the inscrutable nature of the young woman who stares out ambiguously from the centre of the canvas. Art historians who have scrutinized the painting (whose surface is dominated by the reflections of a large mirror behind the barmaid) wrestle most with Manet's manipulation of the angle of visual ricochet in the work – a tweak of perspective that is surely key to the enduring fascination of the painting.

By dramatically dislocating the reflection of the woman's back from being (where it should be) directly behind her, to the right side of the painting instead, the artist allows us to catch a glimpse of a shadowy stranger who approaches her. This hazy individual, according to the logic of the painting, is standing precisely where we, the viewers of Manet's painting, are. He's us and we're him. But is the artistic licence that Manet takes – this bogus bouncing of selves in glass – nothing more than a simple sleight of reflected light; a fun-house

effect meant merely to amplify the dynamic atmosphere of the cabaret scene? (The dangling legs and green slippers of a trapeze artist, forever swaying into and out of the painting in the top left-hand corner of the work, corroborates the woozy sense of acrobatics that lies at the heart of the work's tipsy energy.) Or is the aging artist, himself on the verge of swinging out of life's frame, making a profounder statement about the very nature of image-making – an enterprise to which he has devoted his entire life?

For all its curious complexities of perspective, the painting organizes itself around the simplest of geometric shapes. The triangle – pointing up and pointing down – pulls the canvas together, both visually and conceptually. A late decision by Manet to portray the barmaid's arms as slanting downward to grip the marble counter into which she leans (he initially had them crossed) ensures that the shape of her entire body conforms to the sloping sides of a triangle. That triangle, in turn, is echoed by a string of three triangular shapes created by the bottom hem of the young woman's black coat. The empty space between the barmaid's body and her reflection to the right is itself a sharp, upside-down triangle – one reflected in the upturned triangles of the

chandeliers (above and behind her) as well as in the glass bowl of the fruit dish and the green bottle of absinthe in front of her.

Once detected, triangularity is everywhere. It's there in the clasped yellow gloves of the woman on the left of the painting (speaking to another shadowy man) and in the arms of the lady seated next to her, who lifts a pair of binoculars. It's even there in the three-cornered hat of the decorated soldier sitting behind those two women. But what does such an insistence on trilateralism mean? A clue to deciphering the symbolism is right before our eyes in the blatant product-placement of a pair of ale bottles that bookend the bar at which we're standing. On either side of the barmaid, bottles of a British beer manufactured by the Bass Brewery call attention to themselves by the distinctive, red triangle logo printed on the label. The simple eye-hook emblem is significant as it represents the very first officially protected trademark in the United Kingdom, registered by the Bass Brewery just five years before Manet created his painting.

Seared into Bass's barrels as a way of protecting its proprietary product, the red triangle became synonymous with the shifting of mass-produced merchandise and the global distribution of goods. That Manet was keen for observers of his work to fix on, and extrapolate from, the

logo is suggested by his decision to attach his signature to an adjacent label, implying perhaps that even artistic genius is moving in the direction of commodification. But it is the implication of the branding to the identity of the barmaid that is perhaps most poignant. Seen in the context of the Bass label, the spray of roses across her cleavage, which take the organic shape of a red triangle, marks her out as a product to be purchased and consumed – a prostitute to be bought and sold. Suddenly, that shadowy man, who doubles for us in the painting's manipulated reflection, is a trader in souls, and the shatter of triangles all around is a reminder that everything in life comes at a price. Decades before Pop artists played with notions of commercialization and the commoditizing of beauty, Manet copyrighted the concept with his shimmering *Bar at the Folies-Bergère*.

It took Seurat almost a year and two dozen studies to complete this, his first exhibited painting. From a mizzle of colour, the artist weaves a visual manifesto and conceals in its fabric a coded homage to one of his greatest influences.

'All things keep on in everlasting motion', the Roman poet Lucretius observed in his influential philosophical work *De rerum natura* (*The Nature of Things*):

> Out of the infinite come the particles,
> Speeding above, below, in endless dance.

A French translation of extracts from Lucretius's poem, which sees the universe as a living canvas composed of a blizzard of disassembling and reassembling particles, was published (along with a commentary on such a system's implications) by the philosopher Henri Bergson in 1883. That same year, elsewhere in Paris, an aspiring young artist, Georges Seurat, began work on his own masterpiece of granular synthesis and division: *Bathers at Asnières*.

As if consciously illustrating the Lucretian cosmology of restless atoms, which invigorated the imagination of students across France when Bergson's publication appeared, Seurat seems to shake through a sieve his scene of men basking in the afternoon sun on the banks of the river Seine in a working-class suburb of Paris. Though the young artist has yet fully to adopt the technique for which he will eventually be most remembered (composing scenes out of countless dots of paint), *Bathers at Asnières* represents a decisive shift from conventional brushwork to more abbreviated strokes. Comprised of contrasting cross-hatches and abrupt dabs of unmixed colour, the work relies on the observer who encounters it from a distance to blend pigment and texture on the palette of his or her mind.

To inspect the green grass on which the five figures on the left side of the work while away their afternoon is to discover a shimmering salmagundi of hedging hues: yellows and violets, blues and whites, all elbowing for distinction. At first glance, the bodies of the workers themselves, as if chiselled from alabaster, appear more tonally integral and sculpturally sound than the fragmenting earth and air and water that surrounds them. But look again at the edges that delineate these figures and a slow dispersal of form begins to reveal itself as their bodies break down into jots and scrapes. Suddenly, what initially seemed a palpable presence dissolves into a summery mirage.

A mist of molecules that envelops the outline of the body of the young man wading waist-deep in the right foreground of the work weaves itself into a lustrous aura – a nebulous

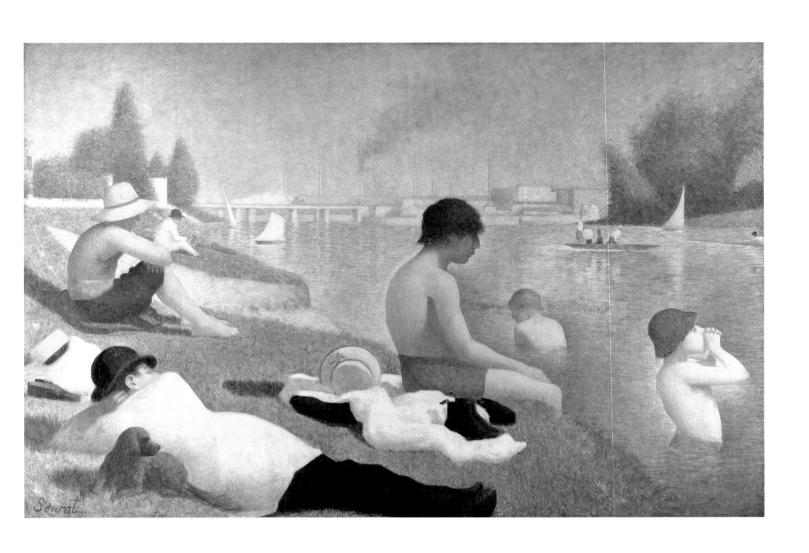

↑ Georges Seurat, *Bathers at Asnières*,
1884, oil on canvas, 201 × 300 cm
(79⅛ × 118⅛ in.)

↑ Georges Seurat, *A Sunday on
La Grande Jatte – 1884*, 1884–86,
oil on canvas, 207.5 × 308.1 cm
(81¾ × 121¼ in.)

Detail of the factory chimney in the background of *Bathers at Asnières*, 1884

buffer between self and world. Through cupped hands, he calls or whistles to an audience to the right, beyond the painting's frame, as a bright margin of atoms exhales almost imperceptibly from his skin – at once connecting him to and separating him from the dreamy universe he inhabits.

This crumbling of solidity into evanescence is vital to the painting's energy – crucial to the way our eyes experience its static vibration. In the middle distance of the work, a skiff ferrying a parasol-twirling woman and her well-to-do stove-top-hat-wearing companion to the fashionable island of La Grande Jatte (a spot that would also preoccupy Seurat's attention) is as insubstantially described as a hazy daydream; as out of focus as it is socially and economically out of reach.

Amid so much fluctuation of fluid form and humid hue, our eyes float unhooked by any single aspect of the effulgent scene, until, at last, they see it, in the far distance of the painting: a chimney respiring soot among a thicket of smokestacks in the nearby town of Clichy, rising like the slender handle of a paintbrush ceaselessly generating the work. At first blush, one is tempted to interpret the dissolution of factory fumes into vaporous skeins above, and into liquid echoes on the dappling river below, as nothing more than a subtle comment on the fleetingness of industrial zeal. But this is not a generic smokestack; it's a key to understanding the revolution in art that Seurat was on the cusp of triggering.

Clichy was known at the time that Seurat painted *Bathers at Asnières* as the centre of candle manufacturing in France

and, in particular, as the home of the nation's largest factory devoted to the production of so-called 'stearic' candles. These candles were the innovation of a French chemist, Michel Eugène Chevreul, who had isolated a solid white substance – what he called 'stearin' – from the liquid acids of animal fat. The smoke we see rising from the chimneys in the distance of Seurat's painting is a by-product of the manufacturing of these candles according to the method proposed by Chevreul, who was also a pioneer in artistic colour theory.

Chevreul's ideas about how the juxtaposition of hues can generate, in the mind of the beholder, a glowing retinal persistence of tones, was crucial in Seurat's development as a thinker and artist. ('Some say they see poetry in my paintings', Seurat once asserted. 'I see only science.') Without Chevreul's theories, Seurat's novel approach to image-making, the divisionism of dots and dabs of paint, would never have emerged. The chimneys that rise in the distance of Seurat's painting are surely the young artist's tribute. Glimpsed through the lens of Chevreul's influence, the smokestacks do not so much sully the atmosphere with pollution as become engines of infinite dispersal – the conduits through which the colours and particles of everlasting motion that comprise the painting, and the world, eternally flow, 'speeding above, below', as Lucretius wrote, 'in endless dance'.

Munch's portrait of a shrieking figure has become an archetype of existential angst. More than a century after it was painted, its elastic countenance still hypnotizes, like a bare bulb swaying above cultural consciousness.

In 1893, the year that the Norwegian Expressionist Edvard Munch created *The Scream* – his famous depiction of an androgynous figure eternally shrieking along an elevated road under an ominous sky – electricity was in the air. This was the year that the celebrated Serbian-American engineer and inventor Nikola Tesla marvelled audiences with his prediction that 'power' could one day be conducted, like an invisible surge through nature, 'to any distance without the use of wires'. 'I do firmly believe', Tesla proclaimed, 'that it is practical to disturb, by means of powerful machines, the electrostatic conditions of the earth.'

While many contemporaries were in awe of such potential, others were disturbed by the prospect of disturbing the earth's delicate balance. Munch was among them. Prone to bouts of melancholy, he was anxious about how the unchecked acceleration of science and technology might impact on the fabric of nature. In his private journals, the artist confessed to being haunted by a mysterious shape whom 'everyone feared' – a shadowy, apocalyptic presence:

who directed
the wires – and held
the machinery in
his hand

Having briefly pursued engineering at a technical college, Munch was acutely attuned to how technology is wired and wires the world. He took a keen interest in the scientific advances of the day and one can only imagine how he reacted to the spectacle at the Exposition Universelle (which sprawled across Paris when he was living there in 1889) of the elaborate exhibit devoted to celebrating the manifold inventions of the American innovator Thomas Edison. In addition to showcasing Edison's vast array of patented products (nearly five hundred of them), the exhibit featured an enormous and dazzling curiosity that rose upon a pedestal in the pavilion, a breathtaking spectacle consisting of 20,000 incandescent lamps arranged into the luminous shape of a single gigantic light bulb. Like a bulging glass skull whose bulbous cranium tapers to an elongated slender jaw, the apotheosized lamp rose above the pavilion's visitors as if it heralded a new idolatry – the crystalline countenance of a futuristic god.

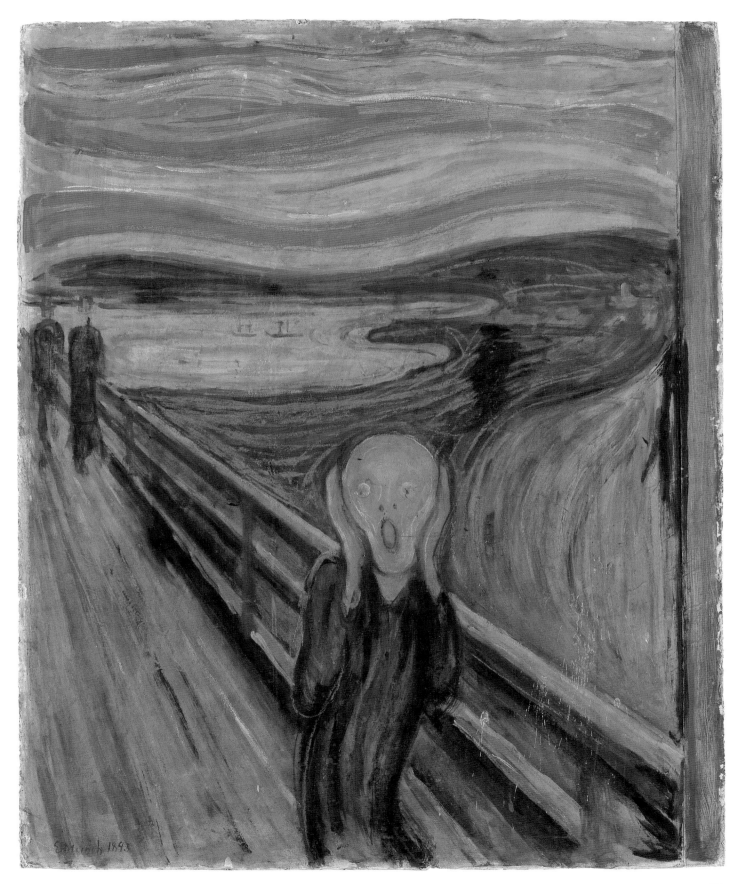

↖ Edvard Munch, *The Scream*, 1893, oil, tempera, pastel and crayon on cardboard, 91 × 73.5 cm (35⅞ × 28⅞ in.)

👁 Detail of the head in *The Scream*, 1893

→ Paul Gauguin, *Where Do We Come From? What Are We? Where Are We Going?*, 1897, oil on canvas, 141 × 376 cm (55½ × 148 in.)

↓ Engraving of Thomas Edison's incandescent giant lamp (model of the Edison-type bulb), Exposition Universelle, Paris, 1889

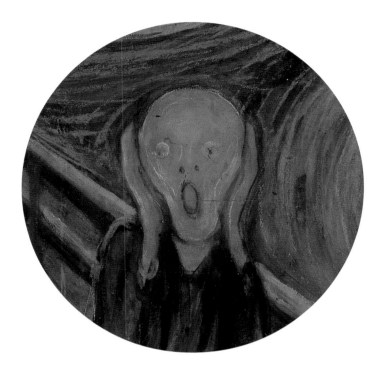

As a venerated shape, the Edison bulb had gradually emerged in cultural consciousness as the very emblem of the electric age. In time, its archetypal form would serve as universal shorthand for the very idea of an idea, as cartoon light bulbs popped up above caricatures of anyone thinking. In the meantime, the shape, as a symbol, appears to have seeped deep into the imagination of Munch, whose own invention of an iconic form a few years later (the yowling eye-hook head that glows at the centre of *The Scream*) would echo with uncanny precision the proportions of Edison's exalted lamp.

It has long been entertained by art historians that another exhibit at the Paris Exposition, a Peruvian mummy petrified into an aghast expression, its hands raised in horror to either side of its open-mouthed skull, likely influenced the facial expression around which Munch's painting rotates (as indeed that same mummy had influenced the imaginations of Munch's contemporaries, including Paul Gauguin). Given Munch's anxieties about modern culture, it is easy to see how the newly patented symbol of science, the light bulb, may have merged in the artist's mind with the mien of the evocative mummy, an unsettling relic of a civilization long since extinguished.

Placed side-by-side, Munch's screaming skull and Edison's monstrous lamp create an unexpected aesthetic logic of technology's threatening thrust. Suddenly, one senses, pulsing through Munch's own famous description of the inception of *The Scream*, another kind of energy:

I was walking along the road with two friends — the sun was setting — suddenly the sky turned blood red — I paused, feeling exhausted, and leaned on the fence — there was blood and tongues of fire above the blue-black fjord and the city — my friends walked on, and I stood there trembling with anxiety — and I sensed an infinite scream passing through nature.

Under an end-of-days sky whose fierce complexion may have been tinged by the memory of smoke drifting from the volcanic explosion of Krakatoa in Indonesia, Munch detected an excruciating wireless surge that, to use Tesla's language, composed the same year, 'disturb[ed] ... the electrostatic conditions of the earth'. When seen as a symbol of abject dread at the direction in which technology was shoving society, *The Scream* transcends the melodramatic articulation of one man's angst and is elevated into something incandescently universal. Munch's elastic skull, kindled by the ghost of electricity that howls in the bones of its face, is more than merely an emblem of an age. It is plugged into the very generator of the soul.

Cézanne's late masterpiece of abstracted nudes, whose bodies blur into the tessellated landscape they inhabit, merely corroborates the opinion held by Picasso and Matisse that the pioneering Post-Impressionist was 'the father of us all'.

'As soon as we are painters,' Paul Cézanne told his friend, the writer Joachim Gasquet, 'we swim far from the shore, in full colour, in full reality.' In Cézanne's imagination, the act of swimming symbolized the immersion of being in deepest reality and became a metaphor for a heightened consciousness arrived at by the synchronized strokes of looking and feeling and painting. For the pioneering Post-Impressionist, to swim was to be alive, as if, in the submersion of the body, the soul is returned to a more indigenous element. It was a symbol forged in Cézanne's mind from a warmth of intimate memory. His fondest recollections from childhood were of gilded summer days spent in Aix-en-Provence with his friend, the future novelist Émile Zola, and of diving into the river Arc – of 'the joys', as Zola would himself later write of the experience, 'of plunging into the deeper pools ... to live in the river'.

Time and again throughout his life, Cézanne would equate art's alchemizing of life into permanence with the transformative power of swimming, which he believed could transport the spirit from a realm of cold materiality to a liquid luminescence that is eternal. 'We are drawn to the great works that have come down to us through the ages,' he wrote in a letter in 1904, two years before he died, 'from which we take comfort, support, like a swimmer clinging to a board.' To paint and to swim were comparably purifying and mystically metamorphic. 'The miracle', he explained to Gasquet, 'is within, water changed into wine, the world changed into painting. We swim in the truth of the painting.'

No work in Cézanne's oeuvre more compellingly captures the artist's conviction that art is the plank to which the swimming soul clings than his late masterpiece *The Large Bathers*, a canvas to which he himself desperately clung for several years, until his death in 1906. Among a clutch of seemingly unfinished and similarly themed works that the artist ceaselessly revised in his last years, the canvas has been celebrated for its synthesis of Cézanne's ambitions to merge into a single work the enduring grandeur of Old Master subjects and the dynamism of the radical visual language that he and his Impressionist contemporaries were busy coining.

Though Cézanne's painting may recall a conventional theme tackled by many Old Masters (historians have found echoes especially in works by Titian and Rubens), no artist before him has ever portrayed the human form and the

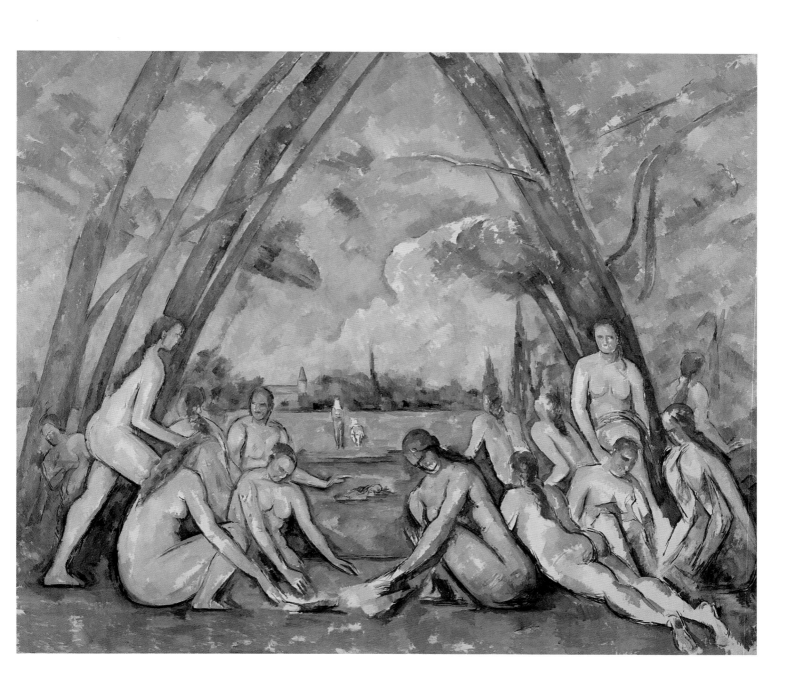

↑ Paul Cézanne, *The Large
Bathers*, 1900–6, oil on canvas,
210.5 × 250.8 cm (82⅞ × 98¾ in.)

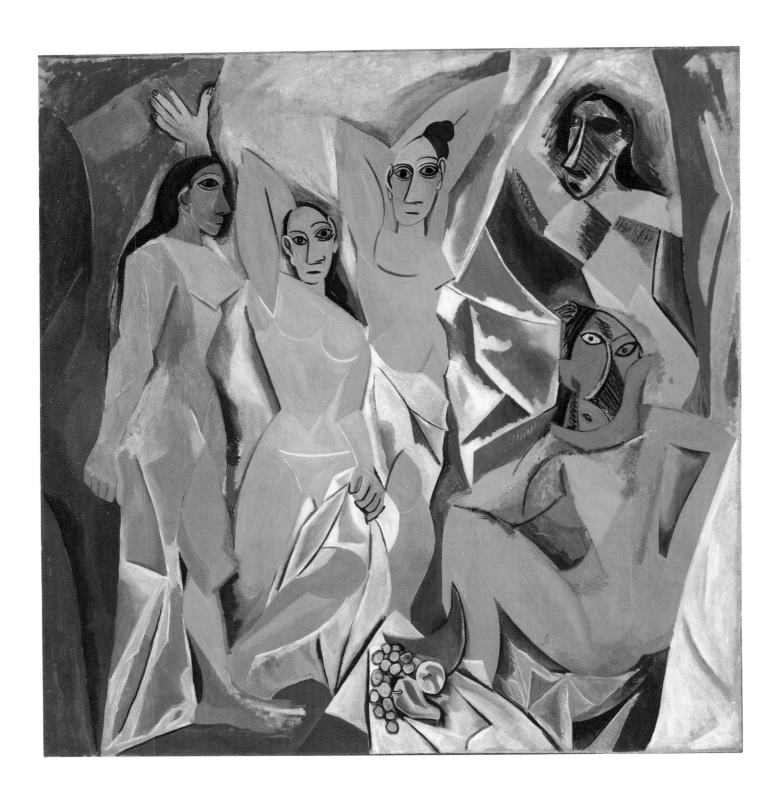

↑ Pablo Picasso, *Les Demoiselles d'Avignon*, 1907, oil on canvas, 243.9 × 233.7 cm (96 × 92 in.)

landscape it occupies so arrestingly. The bodies Cézanne depicts appear as sculpturally hefty as Doric columns and yet, paradoxically, as sketchy and restlessly fleeting as shadows. They inhabit a world where clouds are dense and the land is light – where air and substance abut and blur. Perspective, which, in centuries gone by, was mapped out carefully against a precise vanishing point, has now become a fluid property, as the rendering of figures appears to account for an elasticity of shape and a multiplicity of vantage. Anticipating Cubism, *The Large Bathers* was, unsurprisingly, admired by Picasso, whose own groundbreaking *Les Demoiselles d'Avignon*, painted the year after Picasso first saw Cézanne's work, is a direct heir.

The painting's innovative architecture – particularly its reliance on the choreographing of the fourteen nude females in the foreground into mirroring pyramids that echo the overarching triangularity of leaning trees above them and the pointy-top tower in the distance – is often credited for investing the work with its extraordinary aesthetic stability. The artist's decision to leave raw and unpainted swatches of skin in his rendering of the bathers' bodies, and his refusal fully to enunciate the facial features of any of the figures whom his brush has summoned, are also frequently cited as aspects of the painting that snag our attention, challenging us to define what is necessary to perceive a body as fully described.

But perhaps the painting's poignancy relies on a dimension of the work that is rarely mentioned, let alone discussed. Mid-way between the bathers who dominate our focus in the foreground and the lonely figure on the far side of the lake, who, striding with his four-legged companion, is forever retreating from our stare, is a faintly insinuated swimmer who troubles the water's surface at the centre of the work. Gestured to by the one bather in the pyramid on the left-hand side to face out from the painting, and stared at by a pair of leaning bathers on the right pyramid, the eye-hook's position is clearly a point of intended interest. Comprised of nothing more than a smudge of pink to denote a shoulder and a wad of lines to suggest hair, the immersed figure invites us to plunge into the work's deeper meaning, 'to swim in the truth of the painting'. Reduced to the merest of half-hints, the figure represents the utter unravelling of gesture and representation, precariously on the verge of slipping below the surface level of expression to a realm beyond paint. This is Cézanne coming full circle to childhood, heading to a farther shore. This is the aging artist saying goodbye.

Years before her better-known male contemporaries began their celebrated flirtations with abstraction, af Klint single-handedly, and in relative cultural isolation, invented the genre.

In 1904, everything changed. It was then that an obscure Swedish painter with a flair for lyrical landscapes had a vision and heard a voice. Instructed from the great beyond to create works based not on the objects of this world, but on abstract shapes and forces that vibrate below the surface of seeing, the artist began creating an expansive series of paintings that caught the art world off guard. Instantly heralded as a milestone in the history of image-making, the Swedish genius's secret language of pulsing waves and amorphous forms, of organic geometries and indecipherable scrawl, ignited popular consciousness.

Triggering nothing less than a revolution in creativity, the inventive visual vocabulary rippled across Europe, nudging the far-flung imaginations of Wassily Kandinsky, Kazimir Malevich and Piet Mondrian. Nearly every -*ism* that would follow in the course of the twentieth century, from Surrealism to Abstract Expressionism, from Orphism to Minimalism, emerged as a consequence of the otherworldly whisper that the Swedish artist heard in 1904. Every balletic bacterium that would squidge across the works of Joan Miró and every smudgy splotch that Arshile Gorky would scrub into his canvases, the fantastical flora and fauna of Yves Tanguy,

and even the abstruse flowerscapes of Georgia O'Keeffe's magnifying mind, is indebted to that unprecedented burst of vision.

That is not, of course, the way modern art actually unfolded. But it might have been. In 1904, Hilma af Klint, a Stockholm artist and adherent of the esoteric teachings of the celebrated theosophist, Madame Blavatsky, did begin conceiving an astonishingly original and ambitious series of paintings. Those works, she attested, were indeed in fulfilment of a mystical directive that she said she had received from a divine entity. Instructed to operate on 'the astral plane', where the immutable and eternal dimensions of mankind reside, af Klint began articulating the 'new philosophy' of this 'new kingdom' by creating systematically non-representational works years before her better-known contemporaries would eventually achieve the same objective.

But af Klint's decision not to exhibit her groundbreaking works during her lifetime, together with her eccentric instruction that, after she died, her paintings should remain hidden for two more decades, ensured that her extraordinary inventiveness would stay a closely kept aesthetic secret. Disconnected from the artistic dialogue that energized

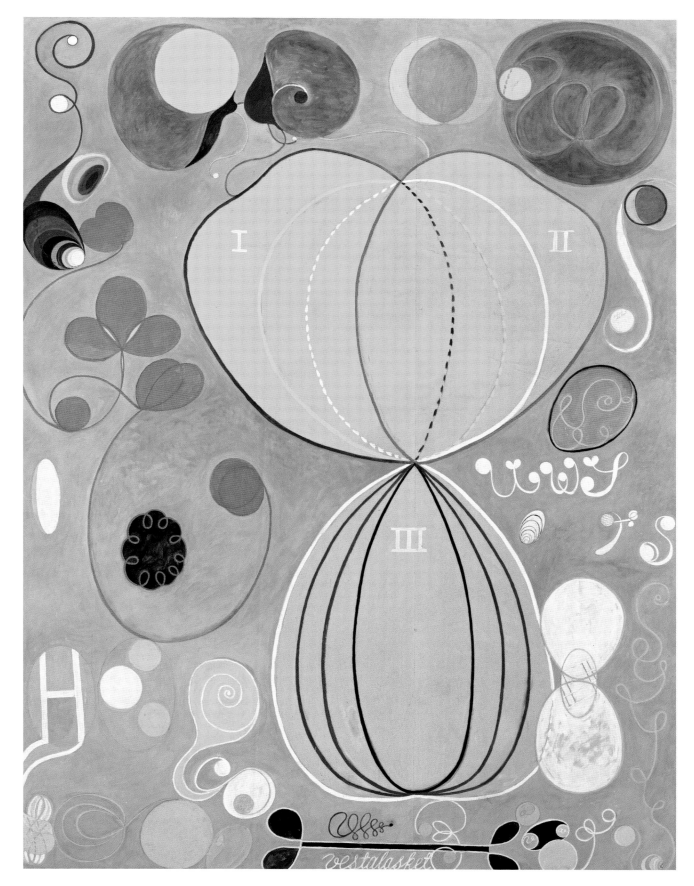

↖ Hilma af Klint, *Group IV, No. 7, Adulthood*, 1907, tempera on paper mounted on canvas, 315 × 235 cm (124 × 92½ in.)

👁 Detail showing the abstract form at bottom left of *Group IV, No. 7, Adulthood*, 1907

Europe in the early frenetic years of the twentieth century and that saw the rapid morphing of one movement into another, af Klint deprived her paintings of the oxygen necessary to influence others. That such a major breakthrough in cultural expression should be the unheralded achievement of a female artist, at a time when women were rarely encouraged to assert their artistic creativity, compounds the poignancy of her eventual rediscovery.

One can only imagine how the trajectory of art history might have been affected had af Klint's efforts been acknowledged during these dynamic decades. How, for instance, might one of her most intriguing visions, *Group IV, No. 7, Adulthood* (among 193 works that comprise the ambitious project 'Paintings for the Temple'), have changed the direction of aesthetic expression? At first glance, the bulbous blossoms of alien fruit and inscrutable squiggles of cryptic script that trouble the surface of the painting flummox the eye in ways that anticipate the chance discovery, five years later, of the mysterious medieval *Voynich Manuscript*.

Group IV, No. 7, Adulthood, like all of af Klint's work, is as symbolically elusive as it is intellectually evocative, absorbing into its fabric a range of intellectual references – from the teachings of the anthroposophist Rudolf Steiner to the writings of Charles Darwin, from the colour theories of Goethe to the electromagnetic discoveries of Heinrich Hertz – making it difficult to attach unambiguous significance to any one variable. But it's the work's potential allusion, in an easily overlooked detail, to the then-recently proved power

of X-rays to penetrate the surface of things, that is perhaps most revealing. In 1901, Wilhelm Röntgen, a German physicist, was celebrated in af Klint's hometown of Stockholm. It was then that he received the very first Nobel Prize in Physics for his scientific discovery of a few years earlier, when he glimpsed the bones beneath the skin of his wife's hand.

A curious coil of fibres helixed into a lemniscate (or infinity symbol), in the bottom left-hand corner of af Klint's painting, appears to be undergoing a kind of X-ray scan. The ribbon that has drifted in front of that shape exposes the symbol's otherwise invisible substructure – a revelation denoted by the broken lines that echo similar perforations in the upper regions of the huge, yellow, onion-like shape that dominates the centre of the painting. That this small X-ray eye-hook in the corner of the work should be tethered to an oversized initial of the artist's name ('H') above it, suggests the invaluable service that af Klint believed her secret oeuvre performed, but that the world was not yet ready to behold: the peeling away of the obfuscating layers that obstruct our perception of the infinite.

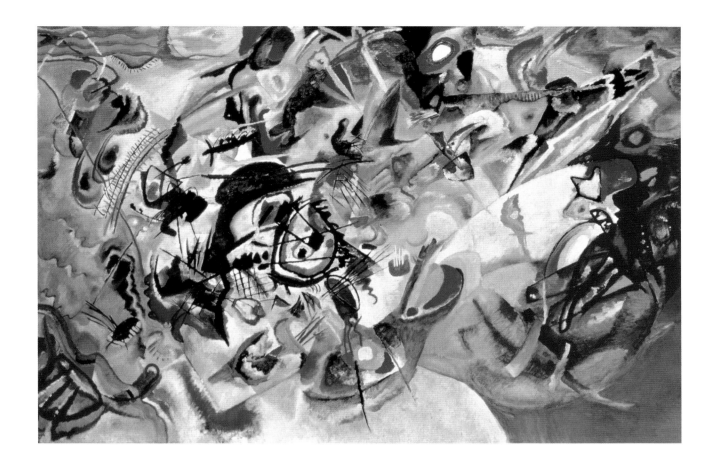

↑ Wassily Kandinsky, *Composition VII*, 1913, oil on canvas, 200 × 300 cm (78¾ × 118⅛ in.)

Hilma af Klint's abstract works pre-date by several years the first non-figurative works by Wassily Kandinsky, who is often credited as one of the originators of abstract art. By the time Kandinsky became interested in the teachings of Madame Blavatsky and eventually joined, in 1909, the Theosophical Society (associations that may have influenced his non-representational canvases, including *Composition VII*), af Klint was already making abstract works inspired by these same esoteric beliefs.

→ Johann Wolfgang von Goethe, Colour Wheel, 1809

In addition to the theosophical teachings of Madame Blavatsky and the writings of Charles Darwin, Hilma af Klint was fascinated by Goethe's treatise *Theory of Colours*, which explored how refraction is perceived by the human eye. Goethe's Colour Wheel, based on his belief that 'colours diametrically opposed to each other in this diagram are those which reciprocally evoke each other in the eye', appears to have been influential on the shaping of af Klint's abstract works.

Klimt's famous double portrait is more than a glitzy study of the superficies of intimacy. It is a work that gets under the skin and infiltrates the blood.

If you want to understand what makes *The Kiss*, Gustav Klimt's famous double portrait of embracing lovers, so widely and wildly adored, you will need to get the measure of its blood. To appreciate the painting's pulsing brilliance, we must first place it, and the moment it was conceived in 1907, within a wider frame of intellectual and personal reference. Thirteen years earlier, in 1894, the Austrian symbolist had been hired to decorate the ceiling of the University of Vienna's Great Hall. Though Klimt's acceptance of that commission may seem, in retrospect, at odds with the anti-academic temperament of the art movement that he would soon help found (the Vienna Secession), the artist nevertheless agreed to design three large panels devoted to a range of scholarly disciplines: Philosophy, Medicine and Jurisprudence.

When Klimt, in 1900, unveiled the first instalment of these works, an image allegorizing Philosophy that featured a cosmic cascade of despairing figures forever suspended in forlornness, the image was sharply criticized for its depressing portrayal of intellectual thought. Nor was the ensuing submission in 1901 of a panel illustrating the spirit of Medicine any more enthusiastically received. Its ominous torrent of skeletons and sedated figures, caught in a waterfall of woe that calls to mind the plummet of souls in Michelangelo's *Last Judgement*, was lambasted for its failure to convey any promise of hope or healing.

It would be easy to surmise that Klimt's opulently obtuse panels betrayed an indifference to their subjects. Yet Klimt was, in fact, profoundly interested in the body. He merely doubted medical science's capacity to cure it. In Klimt's mind, the body is controlled by destiny – its fate subject to the ebb and flow of invisible forces. A black ink-and-brush work on paper that Klimt created around this time, entitled *Fish Blood*, portrays a stream of bodies carried along in a supernatural current of surging mystical blood. As a realm of intellectual interest in its own right, blood was becoming a subject of intense research and exciting biological discovery coincidentally at the very same institution where Klimt had been commissioned to create his controversial ceiling panels.

At the forefront of that research at the University of Vienna was Karl Landsteiner, a leading immunologist who, in 1900 (just as Klimt was working on his Medicine panel), was keen to determine why blood transfusions were successful in some patients but failed in others. Landsteiner's pioneering investigation led to the discovery, in 1901, of human blood

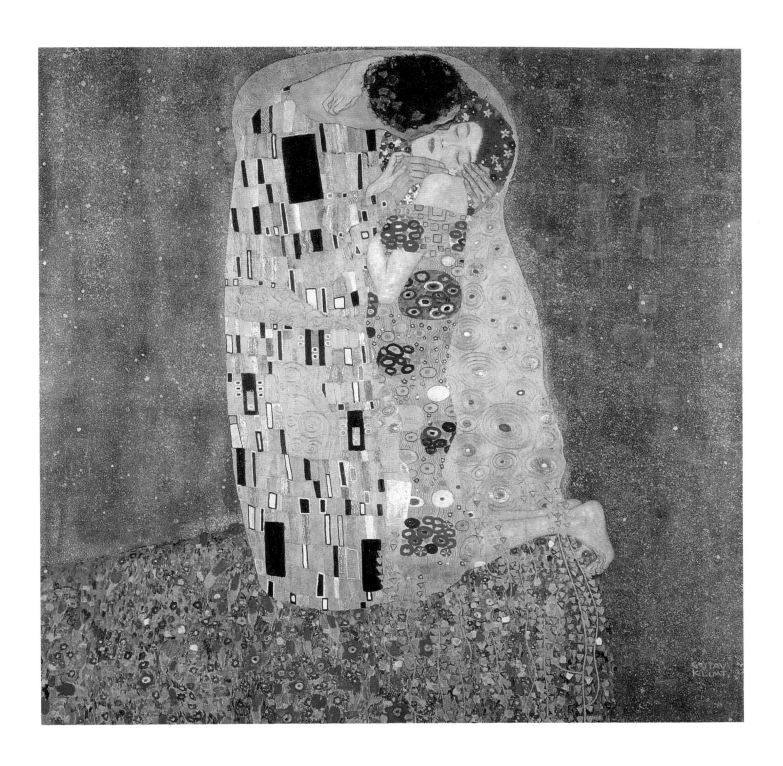

↑ Gustav Klimt, *The Kiss*, 1907,
oil and gold leaf on canvas,
180 × 180 cm (70⅞ × 70⅞ in.)

Detail of the dress in *The Kiss*, 1907

↓ Gustav Klimt, *Medicine* (detail of Hygieia), 1900–7, oil on canvas

→ Gustav Klimt, *Fish Blood*, 1897–98,
brush with ink, black chalk and
white heightening on paper; image
40.2 × 40.3 cm (15 ⅞ × 15 ⅞ in.),
sheet 43.1 × 46.9 cm (16 ⅞ × 18 ⅜ in.)

types and to the realization that if blood is transferred between individuals who share the same type, the procedure can succeed. The air in Vienna was abuzz with talk of platelets and plasma, red blood cells and white, as the opposing forces of destiny and science were suddenly beginning to cohere.

1907, the same year that witnessed the first successful blood transfusion based on Landsteiner's groundbreaking discoveries, also saw a resilient Klimt endeavour to rebound reputationally from the debacle of the Great Hall paintings, a contretemps that had motivated nearly ninety faculty members to protest and resulted in the offer to Klimt of a professorship being rescinded. Labelled a 'pornographer' by critics who believed his panels had transgressed social mores, Klimt had to choose his next move carefully. He answered by creating a new work to which even his most fervent detractors could hardly object – a life-affirming embrace of pure passion: *The Kiss*.

Set against a gloam of gold leaf that levitates their clinch into the spiritual splendour of a medieval icon, the interlocking couple in Klimt's work are forever frozen in a flex of poignant passion. The large square painting has been admired for its alluring collision of contrasting patterns that adorn the couple's robes, as if signifying the unity of the old (symbolized by the homespun spin of ancient spirals) and the new (symbolized by the austerity of Art Nouveau-esque rectangles). But it may be less what shapes shroud these refulgent figures that triggers our fascination and affection than what pulsates beneath their skin.

Look closely at the woman's resplendent slender frock, and the stylized pattern is constellated with a vertical alignment of ovate slides and round Petri-dish-like lenses. Within each of these ellipsoidal eye-hook slides, vibrant platelets and agglutinating blood cells judder and throb, as if a microscopic glimpse into her cellular constitution has been obtained. Having only recently refrained from celebrating the progressive thrust of science, Klimt now appears determined to crystallize, into an eternal archetype of what it means to be, the paradoxical states (flesh and spirit) of the universe's life force; to capture the impossible – a luminous biopsy of never-ending love.

Though widely admired for its graceful pace of colour and the rhythm of its dancers, Matisse's monumental painting is invigorated by a far more complex and ungainly choreography than initially meets the eye.

Great art trips us up. It dances to its own tune and keeps its own time. Take Henri Matisse's famous depiction of five nudes whirling exuberantly in a circle – a work variously described by writers as 'the essence of rhythmic movement' and 'the most beautiful painting of the modern world'. By the time the 40-year-old Matisse had begun working on the first of two versions of *La Danse* (or *Dance I*, as the full-scale preliminary oil painting for a work commissioned by a Russian merchant has come to be known), the French artist had already auditioned and discarded a succession of Post-Impressionist styles. Since abandoning a career in law for which he had trained, Matisse had tried his hand at the abbreviated brushwork of Seurat's Divisionism before being associated with the bold colorations of a school disparaged by its critics as 'Fauvist' (or 'beastly'). Where those movements relied for their intensity on the collision of abutting hues, Matisse found himself yearning for something simpler – a tranquillity of expression.

'What I dream of', Matisse confessed to an interviewer in 1909, just as he began to map out his approach to *Dance I*, 'is an art of balance, of purity and serenity, devoid of troubling or depressing subject matter ... a soothing, calming influence

on the mind.' Commissioned by the wealthy wholesaler and manufacturer Sergei Shchukin, as part of a suite of works to adorn the landings of a staircase, *Dance* was envisioned by Matisse from the outset as a painting whose architectural position would be key to its impact. 'I imagine a visitor coming in from the outside,' he mused, describing how he expected viewers to engage with his work. 'The first floor invites him. One must summon up energy, give a feeling of lightness. My first panel represents the dance, that whirling round on top of the hill.'

For a painting intended to epitomize 'serenity' and 'balance' and to offer 'a soothing, calming influence on the mind', *Dance* is surprisingly suspenseful in its klutzy choreography. Though the image may vibrate in our memory as a 'whirl in ecstasy ... in an unbroken linear flow', as the art critic Richard Dorment described the finished canvas Matisse eventually gave to Shchukin in 1910, in fact it is brokenness that ultimately defines the painting's form. Look again at the figure closest to us in the foreground of the work, the one whose head is nearest the centre of the canvas. Anything but gainly in her gambol, she appears to be frozen forever on the verge of a lunging stumble, as her right leg slips to the

↑ Henri Matisse, *Dance*, 1909–10,
oil on canvas, 260 × 391 cm
(102⅜ × 153⅞ in.)

canvas's bottom right corner and her left knee bends to break an imminent fall. Her left foot is sliding outside the frame.

Once her instability has been noticed, the easily overlooked eye-hook of the work sharpens into focus: her perilous loss of grip with the dancer that she is following in clockwise rotation. A painting that, moments before, seemed to be a joyous freeze-frame of sprightly spin now appears to teeter on complete collapse. Suddenly, the work is less about the cadence and rhythm of life in fullest swing than it is about the precariousness of our existence – the fragility of human connection.

Our surprise at the vulnerability of the dancer (and the dance itself) is ultimately ironic, as the artist has ensured that our eyes are implicated in her disequilibrium. Intended, as Matisse explained, to be situated on the landing of a staircase (and therefore approached from the bottom right by anyone ascending to the first floor), the canvas would be deliberately susceptible to the shifting perspective of its viewer as he or she mounts the steps. The space created by the unclasping of the two dancers' hands would, as an observer approached the work, appear to grow in size as the canvas became less and less askance. The optical effect created by climbing the stairs would be an amplification of the sense of separateness between the two dancers – an exaggeration of the letting-go.

Art historians have long sought to locate precursors of Matisse's iconic image, works with which he may have intended to slope arms in composing the complex music of his painting. William Blake's watercolour-and-graphite *Oberon, Titania and Puck with Fairies Dancing* and a detail of dancers in *The Golden Bough* by J. M. W. Turner, whose work Matisse studied closely, may have merged in the artist's imagination. In the background of his own earlier Fauvist masterpiece *Le bonheur de vivre* (*The joy of life*) is a circle of six nudes that is undoubtedly a seed. With its desperate lunge for a stabilizing touch that can close the circuit and keep the energy flowing, however, *Dance* is perhaps most compellingly aligned with that other work of almost-contact, Michelangelo's depiction of Adam and God on the ceiling of the Sistine Chapel (see p. 93), and the paradoxically tiny yet yawning gap between being and not being that it portrays.

← Henri Matisse, *Le bonheur de vivre*, c. 1905–6, oil on canvas, 176.5 × 240.7 cm (69½ × 94¾ in.)

↓ William Blake, *Oberon, Titania and Puck with Fairies Dancing, c.* 1785, watercolour and pencil on paper, 47.5 × 67.5 cm (18¾ × 26½ in.)

↓ Claude Monet, *Water Lilies*, 1916,
oil on canvas, 200.5 × 201 cm
(78 ⅞ × 79 ⅛ in.)

Begun in old age following the death of his beloved wife and at a moment when the world was slipping into devastating war, Monet's immersive masterpiece vibrates uniquely with intimate and universal meanings.

'Let's join hands,' Claude Monet said to Georges Clemenceau, the wartime prime minister of France, 'and help each other see things better.' The two had been standing in what was, by then, Monet's world-famous organic art installation, his gardens at Giverny, which the artist had translated into hundreds of lush, lyrical paintings. 'While you chase after the world,' the French Impressionist said to Clemenceau, amid the shimmering cacophony of willows and bamboo, gingko and Japanese quince, 'I put my own work into seeing every sight possible in connection with hidden realities. When we reach the level of deep relationships among the things that we see, we cannot be far from truth, or at least not far from what we can know of it.'

Monet's commitment to 'seeing every sight possible in connection with hidden realities' would reach a sublime crescendo with the creation, in the last years of his life, of a series of eight enveloping canvases that he called his *Grandes Décorations* (1914–26) – works that defied tradition by framelessly severing their panoramic vision from conventional coordinates of foreground and horizon. The chief motifs of the project were meditations on the water lily, or *nymphéas* – a flower that had obsessed Monet for decades, ever since he first caught sight of newly engineered varieties at the Exposition Universelle in Paris in 1889. Joseph Bory Latour-Marliac, a botanist from southwest France, had concocted a stunning range of coloured water lilies whose vibrant blossoms would niggle in Monet's imagination for another five years before he placed his first order with Latour-Marliac in 1894.

Before long, blue and pink, red and yellow water lilies had joined the diverse chorus of hues of irises and rhododendron, cherry trees and Oriental poppies, that Monet had assembled in a water garden established artificially by diverting water from the small river Ru. Though neighbouring farmers had registered concerns that the project risked introducing alien contaminants into the environment that could harm their livestock, Monet ploughed ahead with his dream of creating a lush little Eden of eclectic accents. Consciously or not, the jewel in the crown of that dream would be the water lily. 'It took me some time', Monet would later admit, 'to understand my water lilies ... and then, all at once, I had the revelation ... and reached for my palette.'

The ritual of painting and repainting the floating blossoms of his water lilies in hundreds upon hundreds of pondscapes

served the purpose of nudging the flower's meaning in Monet's mind from a physical property to an immaterial symbol of boundless spiritual poignancy. It would be tempting to say that the artist was consciously tapping into the cultural history of the flower. After all, the water lily (or lotus flower) features prominently in the art of ancient Egypt, where the reopening of the blossom's petals each morning signified rebirth. But the blue Egyptian hybrids that Latour-Marliac sent to Monet didn't survive their European transplantation. Or perhaps it was the narcotic potential of the plant, said to have been prised by Mayans, that lured Monet in and lent a mind-altering dimension to his perception of the flower's power. In reality, the trajectory of Monet's uncovering of hidden levels of metaphoric profundity in the water lily can be mapped against the undulations of personal and global traumas – his slowly failing eyesight, the death of his wife in 1911, and the onset of war.

With these realities now framing his work, the pondscape gradually lost its physical moorings of horizon, river banks, and even the demarcation of the reflected Japanese footbridge that had come to define so many iterations of Monet's paintings. By 1914 and the start of the First World War, the water lily had become a lens through which the deepest appreciation of the beauty of this world and the truth

that lies beyond it in the next, could be glimpsed, 'to produce', as Monet would later explain, 'the illusion of an endless whole, of a watery surface with no horizon and no shore'.

To achieve the illusion of endlessness, Monet inflects the pads and blossoms of his water lilies, which waver on a border between states of being – the world of air and the realm of water – with a kind of reverberating accent that neither wholly belongs to the physical flower itself, nor to any reflection of it in the water or mist that holds them. Here, the eye-hook is a synaesthetic echo that no longer can be explained by Impressionist commitments to capturing accurately the light effects of this world. These vivid visual vibrations issue from elsewhere and ensure that the work's impact pulsates past the retina to a deeper sense of perception. 'In that infinitude', the French art critic René Gimpel wrote after finding himself surrounded by Monet's canvases on a visit to the artist's studio in 1919, 'water and sky have neither beginning nor end. We seem to be present at one of the first hours in the birth of the world. It is mysterious, poetic, delightfully unreal.'

← Claude Monet, *Water Lilies*,
1919, oil on canvas, 101 × 200 cm
(39¾ × 78¾ in.)

→ Claude Monet, *Bridge Over a Pond
of Water Lilies*, 1899, oil on canvas,
92.7 × 73.7 cm (36½ × 29 in.)

👁 Detail of *Water Lilies*, 1919

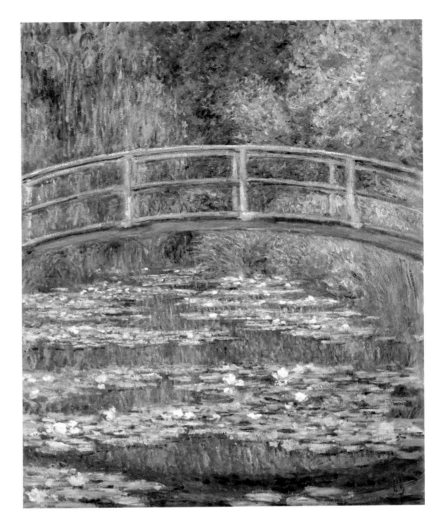

*Flippant and philosophical in
equal measure, Duchamp's
game-changing work checkmated
the way the world comprehends art.*

When asked why he abandoned making art to pursue playing chess, Marcel Duchamp responded that the game 'has all the beauty of art – and much more'. In retrospect, the works made by the influential French artist before he shifted his attention to the strategies of a board game appear part of a lifelong inclination towards cerebral playfulness. For Duchamp, both art and chess entailed skilful sleights of vision, decoys and distraction.

No work by Duchamp illustrates his dexterity more devilishly than a sculpture he submitted in 1917 to the recently formed Society of Independent Artists in New York. As a founding member of the association, Duchamp had helped establish the organization's open-minded avant-garde principles, including its promise never to empanel a jury in the selection of works for its exhibitions. To test the society's progressive spirit, Duchamp entered under an assumed artistic identity a work he knew would leave the other players in the society scrambling for their next move: a porcelain urinal that Duchamp had turned on its side and signed, in black paint, 'R. Mutt 1917'.

When receipt of the object was discussed by the society ahead of its exhibition in April 1917, Duchamp refrained from divulging his role in its submission, knowing that fellow members would feel obliged to display it. He then watched with disappointment when the question of whether to exhibit the work he called *Fountain* was put to a vote, in violation, he believed, of the society's widely publicized code of conduct. Labelled 'indecent', *Fountain* was rejected. In protest, Duchamp resigned. He then managed stealthily to retrieve the offending sculpture, and to smuggle it out of the society undetected. Duchamp's reluctance to sign his own name to the work, his refusal to claim credit for it, and his strenuous efforts to avoid being seen removing the work suggest a fundamental disjunction between the maker and the made, and are instructive in establishing the principles for appreciating one of the most controversial works of art in the past century.

When it comes to contemplating *Fountain*, observers must make a playful strategic slide from *eye*-hook to *I*-hook. Key, in other words, to the importance of Duchamp's sculpture is not any single detail perceivable by the eye in the work's making or appearance. After all, Duchamp did not fashion the sculpture from clay with his own hands. With *Fountain*, Duchamp mischievously checkmates the observer's eye by distracting it with philosophical questions

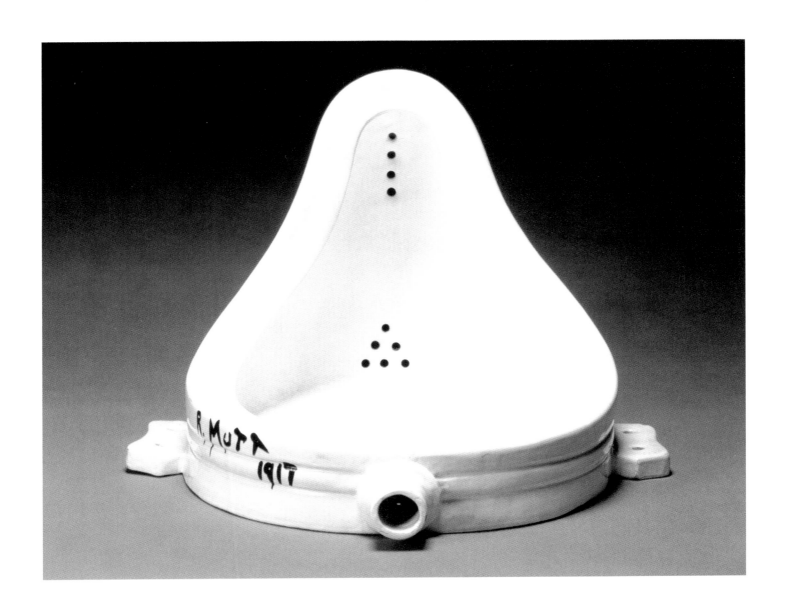

Marcel Duchamp, *Fountain*, October 1964 (replica of lost original 1917), edition produced by the Galleria Schwarz, Milan.

of authorship that the object appears to pose. Who is the real 'I' that stands behind the work's creation?

Since 1913, Duchamp had been experimenting with notions of originality, challenging the art world to accept as legitimate what he called 'readymades', or everyday commercial objects that he deemed, by situating them in a new cultural context, to be works of art. In the case of *Fountain*, Duchamp purchased from the J. L. Mott Iron Works Company in New York a new urinal which he sought to dislocate from its intended function by relabelling it a work of art. The assumed name he attached to the object – 'R. Mutt' – was intended, he later confessed, to be a fusion of the manufacturer's name and a 'funny' character from the famous cartoon strip 'Mutt and Jeff'.

Writing at the time of *Fountain*'s rejection from The Society of Independent Artists' exhibition, an anonymous contributor to the Dada periodical *Blind Man* defended the sculpture in terms that would help propel the work and the dilemmas it posed into popular imagination:

Mr Mutt's fountain is not immoral, that is absurd, no more than a bathtub is immoral. It is a fixture that you see every day in plumbers' shop windows.

Whether Mr Mutt with his own hands made the fountain has no importance. He CHOSE it. He took an ordinary article of life, placed it so that its useful significance disappeared under the new title and point of view — created a new thought for that object.

With a flick of his wrist, Duchamp had flushed traditional notions of artistic identity down the drain. The implications for how an artist perceived his or her role in making objects would be irreversible and far-reaching. With the 'I' of the artist now regarded as a piece that can be sacrificed without forfeiting the game, the observer is forced to change tactics and to entertain entirely new ways of seeing.

← Marcel Duchamp, *Nude Descending a Staircase (No. 2)*, 1912, oil on canvas, 147 × 89.2 cm (57⅞ × 35⅛ in.)

Years before *Fountain* would challenge observers to consider an object of mechanized production as a work of plausible aesthetic regard, Duchamp had already blurred the boundary between muscle and machine with the strange stride of *Nude Descending a Staircase*, which appears to equate the fluid flex of human motion with the syncopated pump of pistons.

→ Marcel Duchamp, *Bicycle Wheel*, 1951 (after lost original of 1913), metal wheel mounted on painted wood stool, 129.5 × 63.5 × 41.9 cm (51 × 25 × 16½ in.)

Though Duchamp's provocative *Fountain* is often cited as the artist's first 'readymade', or repurposed commodity reassigned the status of art object, he had in fact begun toying with the notion four years earlier with *Bicycle Wheel*. 'In 1913, I had the happy idea to fasten a bicycle wheel to a kitchen stool and watch it *turn*.' The implications of Duchamp's dislocation of objects continues to whirr in artistic imagination to this day.

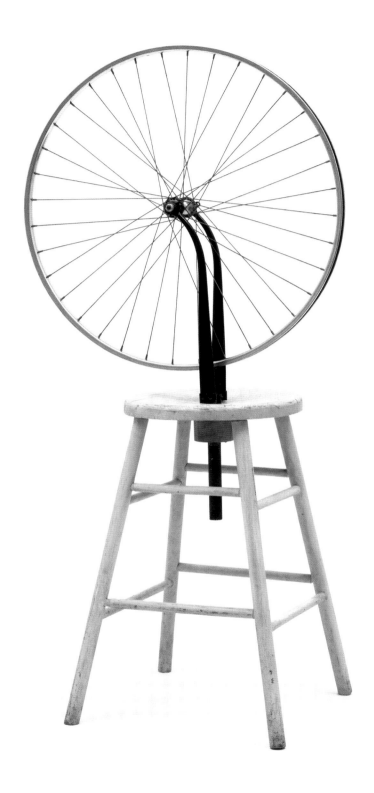

The most famous painting ever to emerge from America, Wood's heartland vision extends well beyond the humble horizons that appear to hem it in, to the undiscovered cosmos beyond.

Every great work of art has a twist. Grant Wood's cryptic double portrait *American Gothic*, frequently described as the most famous work of art in the United States, has two. Helixing in sync, the pair of seemingly unrelated eye-hooks, once revealed, corkscrew the eye into a consideration of distant cultural realms, far removed from the surface contexts of heartland hayforks and homespun aprons that dominate the painting's foreground.

Rivers of ink have been spilt by art historians endeavouring to detect and decrypt hidden meanings in a work that has held America transfixed ever since a panel of judges at the Art Institute of Chicago awarded it a $300 prize in 1930. Much of that effort has been spent scrutinizing the architecture of the wooden farmhouse that rises behind the pair who crowd the front of the work with blank, inscrutable expressions. According to local legend, the structure's 'pretentious' Rural Gothic style caught Wood's attention on a drive through Wapello County in his native Iowa shortly before the artist began work on his iconic painting.

Every embellishment in Wood's translation of the house's design into the fictional dwelling we see depicted in his work has been interrogated by critics – from the exaggeration of the roof's incline to Wood's fabrication of a red barn beside the house. Focus, too, has been drawn by those obsessed with comprehending the work's mysterious allure to the presumed relationship between the painting's central figures and whether Wood's intention is to celebrate or lampoon the Midwestern values they appear to embody. Modelled after the artist's sister Nan and his dentist, Dr Byron McKeeby, the prim duo were meticulously costumed for their roles as 'tintypes', or so Wood would later characterize them, 'from [his] old family album', before being inserted artificially against the backdrop of the so-called Dibble House (named after its first occupant, Charles Dibble, who lived there after its construction in 1881).

While some attention has been paid to the possible meaning of the fallen tress of hair that hangs loosely from Nan's prudish pinned-back coiffure (interpreted by some as a humanizing feature that softens an otherwise severe portrayal), what has gone utterly unnoticed is how that detail converses with another neglected element: the twisted stem of the weathervane that is bolted to the Dibble House roof at the very top of the painting. It is this rod that ineluctably leads our eye from the pointed apex of the

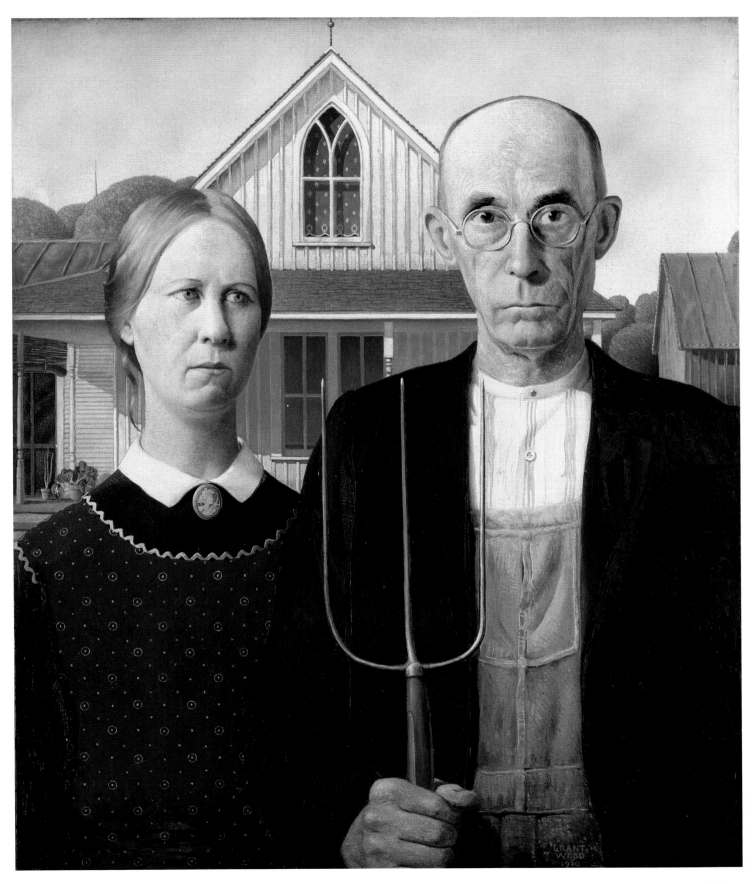

↖ Grant Wood, *American Gothic*, 1930,
oil on beaverboard, 78 × 65.3 cm
(30¾ × 25¾ in.)

👁 Detail of the twist of hair
in *American Gothic*, 1930

farmhouse to the universe beyond the painting. Spinning against the weathervane's slender tendrilled staff is a small gleaming blue sphere (or 'globe', to use the precise language of such meteorological instruments). Wood's curious cropping of the scene – a consequence of his elongation of the house's gable – has disconnected the globe from what we cannot see above it: the conventional ornament (probably a rooster) that would have capped off the weathervane.

Severed from its utilitarian function as part of the weathervane's rotating apparatus, the cerulean globe is suddenly transformed into a symbol of its own, like a freshly discovered planet hoisted in the heavens, as if forever rising and falling in the sky along its vertical axis. A few short months before Wood began work on *American Gothic*, the world was gripped by reports of a new planet swimming in our solar system, one that an eleven-year-old girl in Oxford, England, proposed should be christened 'Pluto' – the Roman name for the pitchfork-wielding Greek god of the underworld, Hades.

News of the exciting cosmic discovery and its fresh mythological identity was rapidly orbiting the world, igniting global interest in astronomy at precisely the instant that Wood began conceiving his work. 'SEE ANOTHER WORLD IN THE SKY' exclaimed the headline of *The Chicago Tribune*, as if speaking directly to Wood's imagination. Sliding down the weathervane's truncated axle into the heart of the painting, the observer's eye eventually finds itself skewered by the leftmost prong of the farmer's intimidating trident at the

dead-centre of the work, a visual trajectory that invisibly links the small blue planet and the enigmatic figure who dominates the painting. Suddenly, we are trapped in the gloom of a modern re-imagining of the classical underworld, summoned before its irascible ruler, Pluto, who glares at us accusingly as he grips his weapon. And who is this standing beside him, gazing vacantly into the distance, as if admonished to remain silent? The brooch pinned demurely to her chest makes it impossible to mistake her true identity: Proserpina, the goddess of grain and agriculture whom Pluto has abducted and raped.

Blurring the boundaries between art and life, Wood had given a brooch adorned with a portrait of Persephone (the name of Proserpina's Greek precursor) as a gift to his mother, Hattie, who in turn loaned it to Nan for her *American Gothic* wardrobe. Persephone's cameo appearance in Wood's painting makes implicit the violent relationship between the work's main characters. Where many observers of the painting have wondered whether the two are intended to be father and daughter, the preponderance of subtle clues points in a different direction: he is her captor. In light of their true identities, it is difficult not to interpret the fallen wisp of hair as evidence of Persephone's recent ravishing by Hades: the final twist in the tale.

👁 Detail of the rooftop weathervane with blue sphere in *American Gothic*, 1930

→ Thomas Hart Benton, *Persephone*, 1938–39, tempera with oil glazes on canvas, mounted on panel, 183.2 × 142.4 cm (72⅛ × 56⅛ in.)

Together with Grant Wood, Thomas Hart Benton was among the central figures of the movement known as American Regionalism. Benton's Regionalist reinvention of Persephone suggests just how significantly, if unexpectedly, the classical underworld figured in the imagination of rural America.

↓ Salvador Dalí, *The Persistence
of Memory*, 1931, oil on canvas,
24.1 × 33 cm (9½ × 13 in.)

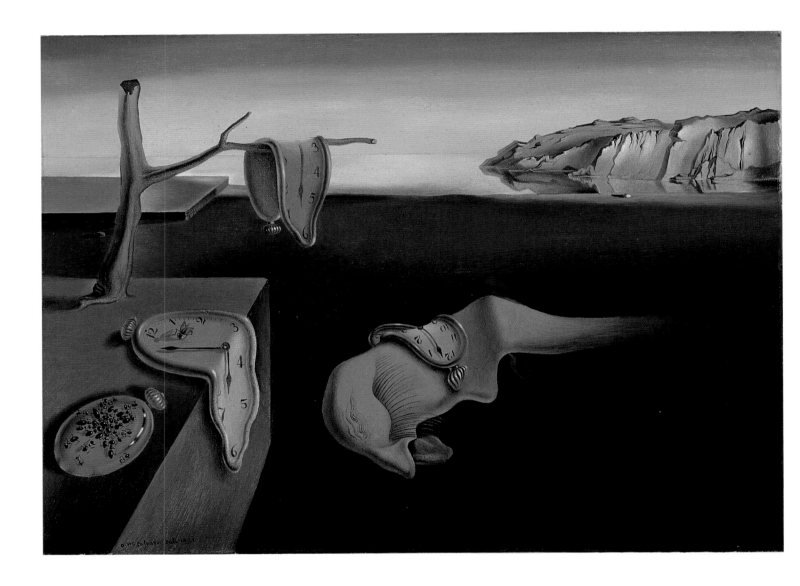

Dalí's inimitable depiction of liquified time is emblematic of an era obsessed with the unmapped realms of relativity and the subconscious. Look closer and it is also a haunting and haunted comment on the horrors of war.

Forget Einstein. Forget Freud. If you really want to understand what makes the melting watches in Salvador Dalí's *The Persistence of Memory* (1913) such a pungent symbol, we will need to leave the cupboards of science and psychoanalysis shut and rummage instead through a different kind of cultural larder. Historians and casual admirers of the famous painting have long assumed the liquescent chronometers in the work are embodiments of the new theories that were beginning to bend the world's mind. After all, the painting was created at the very moment that the revolutionary ideas of the German physicist and of the Austrian neurologist, respectively, were altering the way ordinary people contemplated such fundamental concepts as time, space and the unconscious mind. Yet Dalí himself remained coy about the nature of any such connections and insisted that there was more to the curious recipe than cutting-edge theories.

Without wishing to exclude from interpretations of his work Einstein's emerging concepts of relativity, or, as Freud would have it, the persistent impact of childhood memories on the adult self, Dalí suggested that it was something rather humbler – the sight of a hunk of melting cheese – that inspired him. 'Be persuaded', he insisted, referring to himself in the third-person, as he was wont to do in later years, 'that Salvador Dalí's famous limp watches are nothing but the tender, extravagant and solitary paranoiac-critical Camembert of time and space.' An incorrigible self-promoter of his own sophistication, Dalí is careful not to dismiss the possibility of hidden profundities vibrating below the surface of his work. The simultaneous nods to Freud (there in the word 'paranoiac') and to Einstein ('time and space') make certain that the mischievous artist can serve his image in a variety of ways.

It is also possible that Dalí's divulgence of Camembert as his cheese of choice is a kind of Freudian slip – a confession that reveals more about his unconscious intentions than he might have wished. First produced by a milkmaid from Normandy in 1791 (the same year that the royal family fled Paris in the early throes of the French Revolution), Camembert oozes with its own cultural connotations and has come to be closely associated with the very birth of the French Republic. Indeed, only three years before Dalí painted *The Persistence of Memory*, the former president of France, Alexandre Millerand, in dedicating a statue of the cheese's

creator, Marie Harel, in April 1928, 'elevated' Camembert 'to the status of national symbol', according to Pierre Boisard, author of *Camembert: A National Myth*. Camembert's prominence in French consciousness ripened further during the First World War, when it was a staple sent into the trenches to sustain troops defending the country's freedom.

By merging timepieces with a potent symbol of liberty, Dalí may have created an even more complex and enigmatic metaphor than critics have appreciated. Seen in such a context, the melting watches begin to appear less a celebration of pioneering scientific ideas and more a lament for something cherished, slipping away – the limp carcasses of a cultural ideal whose time has run out in an abandoned nowhere. The huddle of ants converging on the sole timepiece that is still intact only serves to amplify the sense of putrefaction and decay. That one of these compound symbols of time and freedom has collapsed lifelessly across the amorphous shape of what many critics contend is a distorted, washed-up self-portrait of the artist, in the centre of the painting, suggests a level of self-implication in the tragic demise of civilization we're witnessing.

Painted in the tense hiatus between the end of the First World War and the outset of the Spanish Civil War in 1936,

the painting pivots between conflicts. The image arguably belongs less to those works that speak to Dalí's fascination with science and the unconscious than to those, such as *Soft Construction with Boiled Beans (Premonition of Civil War)* (1936), that reveal his attitudes towards the destruction of lives and the imperilment of freedom. Perhaps *The Persistence of Memory*, created just before allegations of Dalí's attraction to fascism would find him expelled from the company of his fellow Surrealists, is a work that suppresses its own outrage at the atrocities the twentieth century had begun witnessing. The hobbled tree on the left of the painting, leafless and severed and able only to support the slumped weight of a Camembert chronometer, is a dead ringer for the gnarled crutch from which mutilated bodies droop in Plate 39 of Francisco Goya's *The Disasters of War* series – an image Dalí knew well and is thought to have echoed in *Soft Construction with Boiled Beans (Premonition of Civil War)*. The eye-hook tree, which simultaneously echoes and disguises Goya's fury at what human beings are capable of doing to one another, invests Dalí's painting with a level of political and humanitarian conscience it never admitted to having.

Grande hazaña! Con muertos!

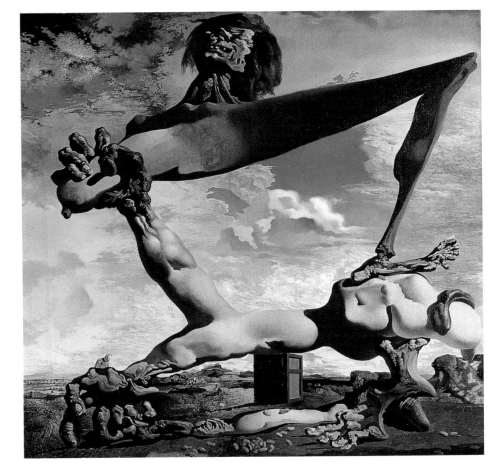

↑ Francisco Goya, Plate 39 from
The Disasters of War series, 1810
(published 1863), etching, lavis
and drypoint; plate 15.5 × 20.5 cm
(6⅛ × 8⅛ in.), sheet 25.1 × 34.3 cm
(9⅞ × 13½ in.)

→ Salvador Dalí, *Soft Construction
with Boiled Beans (Premonition of
Civil War)*, 1936, oil on canvas,
99.9 × 100 cm (39⁵⁄₁₆ × 39⅜ in.)

A brutal puzzle of intimate and enigmatic symbols, Picasso's immortal apotheosis of war altered forever how violence is chronicled by art.

Living in Paris during the Second World War, Pablo Picasso was frequently the target of harassment by Nazi soldiers, who occupied the French capital at that time. During one of the many inspections of the artist's studio, a Gestapo agent discovered a postcard reproduction of the painting *Guernica*, which Picasso had created for the Spanish Pavilion of the 1937 Paris International Exposition. Though only a few years old, the mural-size painting was already famous the world over as a symbol of protest against Nazism, and in particular Hitler's bombardment of a civilian Basque village which had killed over 1,600 people, injured thousands, and destroyed over seventy per cent of the homes and buildings. The officer waved the image in the painter's face and demanded of him, 'Did you do this?' 'No,' Picasso is said to have replied. 'You did.'

By turning the tables on his interrogator, Picasso left us with more than a defiant rejoinder. He offered a clue to understanding how to read his complicated work – how, in particular, the act of seeing operates in his enigmatic masterpiece. In Picasso's mind, perception of the painting and perception of the horror it evokes are inseparable. Looking, in other words, is not a one-way activity when it comes to *Guernica*. The painting stares back. However

intently we may scrutinize its surface in an effort to decode its complex symbols, the work returns our gaze with a penetrating power all its own.

The literal locus of this incessant staring is the large unblinking eye at the top of the work, just left of the canvas's centre – a menacing source of sinister illumination that Picasso intended as an allusion to the cubistic lantern that disturbs the night in Goya's *The Third of May 1808* (see p. 147). In the middle of the oversized eye, occupying the place of the pupil, is the only sign of technology in the work: a bare light bulb. The fact that the Spanish word for light bulb, *bombilla*, resembles *bomba* (the word for bomb) introduces the notion that the very act of looking unavoidably involves a level of violence. It is as though every time we engage with the canvas we unwittingly reignite its horrors by triggering, all over again, the violence visited on Guernica when the bombs fell from Nazi planes in April 1937. Simply by looking at the work, we're implicated in the devastation it depicts.

Radiating out from the eye-bomb, like vectors of exploding shrapnel, are a set of jagged lashes, or *latigazo* in Spanish – another cleverly chosen visual pun that carries with it meanings of 'shock' and 'whipping'. Comprised of a jumble

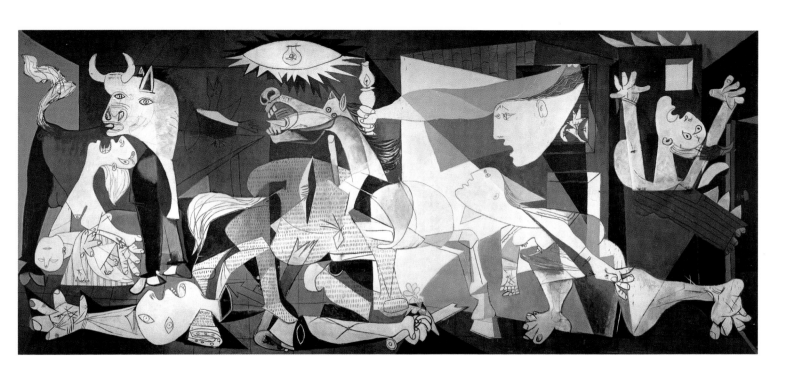

↑ Pablo Picasso, *Guernica*, 1937,
oil on canvas, 349.3 × 776.6 cm
(137½ × 305¾ in.)

Pablo Picasso, *Bull's Head*, 1942,
bicycle saddle and handlebars (leather
and metal), 33.5 × 43.5 × 19 cm
(13⅛ × 17⅛ × 7½ in.)

Formed simply by the unexpected
union of the handlebars and seat of
a dismantled bicycle, *Bull's Head* is at
once a found object and an intensely
intimate one, salvaged from the psyche
of an artist who frequently glimpsed
in the Minotaur (famously featured
in *Guernica*) some semblance of his
truest nature.

→ Picasso wearing a bull's mask
on the beach, 1968, photographed
by Gjon Mili

Detail of the eye, with a light bulb
in place of a pupil, in *Guernica*, 1937

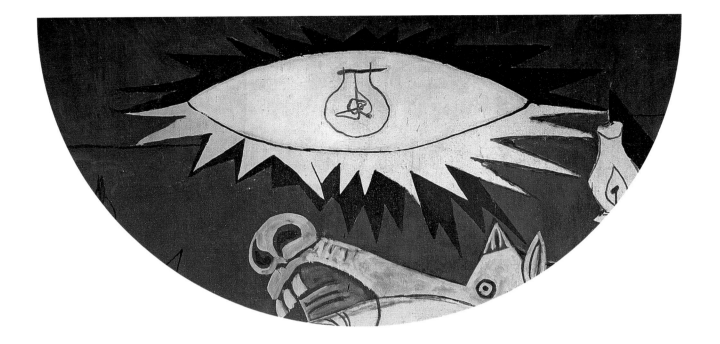

of small triangles, these angular lashes flare out from the exploding eye and point our attention to the insistence of that geometric shape in the work – a shape that at once holds the work together and blows it apart.

Hooked by the work's electric stare and the strobing shocks of its reverberating lashes, our eyes are hurled in a scatter of directions across the painting's surface. Not only are the eye's lashes echoed in the painting's shattered tongues and ears, their triangularity is also amplified in the three pyramidal groupings that dominate the work's structure. On the left, there's the pyramid comprised of the bull at the top, the wailing mother and lifeless child in the middle, and the dismembered soldier at the base. From there our eyes trace, in the centre of the painting, the tortured triangle that consists of the horse's wrenched body and the excruciating physique of the distended woman who strains towards the horse, dragging her crippled leg from the bottom right corner of the canvas. Lastly, our eyes follow the intersecting sides of an upside-down triangle on the right of the canvas, as they slip down the uplifted arms of a woman screaming beneath the flames of a burning house.

Though historians have busied themselves attempting to attach fixed meanings to the individual figures in the work, the painting has resisted decisive decoding. Whether, as some contend, the bull is intended as a stand-in for Picasso himself (he occasionally experimented with the mythological image of the half-man/half-bull Minotaur as a self-portrait), or whether it is intended to symbolize Spain – stoic in the face of fascist destruction – is a mystery unlikely ever to be solved. Likewise, to what extent the turmoil experienced by Picasso in his personal life during the period in which he created the picture (he was juggling three lovers at the time) invests the canvas with intimate agitations is impossible to measure. What is clear is that, as an anti-war icon, no picture in the history of art has ever waved itself more defiantly in the public's face and demanded from everyone who has ever stared into its anguished shatter of triangles and tear-shaped eyes, 'Did you do this?'

Cornell's enchanting tribute to the glory of an aging French dancer reveals the agility of a pioneering artist who dreamed outside the box by dreaming in it.

Joseph Cornell began constructing his signature 'shadow boxes' of assorted seashells and film stills, compasses and clay pipes, maps and laboratory vials in the early 1930s, around the time that the Austrian physicist Erwin Schrödinger was formulating his famous thought experiment involving an imaginary box containing a flask of poison, a clump of uranium and a cat. Cornell and Schrödinger never met, and there is no reason to think they were influenced by each other's work, yet the cultural coincidence of their curious contraptions is nevertheless intriguing. What motivated both was the desire to comprehend the mysteries that underlie existence. For Schrödinger, whose disquieting diorama was purely hypothetical, the arresting arrangement of incongruous ingredients was postulated to illustrate how two contrary conditions (the cat is concurrently both alive and dead) can theoretically coincide. A commitment to the merging of opposing perspectives on being –science and religion, mathematics and magic – is likewise what makes Cornell's ingenious gadgetry tick.

Although Cornell rarely travelled outside the New York area, where he shared a home with his widowed mother and his younger brother Robert, who suffered from cerebral palsy, his boxes served him and ably serve us as esoteric time-machines, shuttling us back and forth between the impinging present of Depression-era America and distant cultural pasts of which Cornell dreamt. Nowhere is such transport more poignantly engineered than in his portable museum *L'Égypte de Mlle Cléo de Mérode: cours élémentaire d'histoire naturelle*.

The work is dedicated to Cléopatra Diane de Mérode (1875–1966) – an aging French dancer of the Belle Époque who was once rumoured to have had an affair with King Leopold II of Belgium – and seeks to rekindle the enchantment of her fading celebrity. It provides the imagined ingredients of an alchemical experiment infusing Cléo's material existence with that of her Ancient Egyptian alter ego. Made of an oak box fitted with a dozen cork-stoppered bottles (filled variously with plastic tokens and costume pearls, sequins and miniature photographs of camels), the eccentric kit is reminiscent of a child's chemistry set and is a perfect example of the artist's concurrent fascinations with history and healing, medicine and magic, playfulness and the profound. 'Perhaps a definition of a box', Cornell once reflected, 'could be as a kind of "forgotten game", a philosophical toy of the Victorian era,

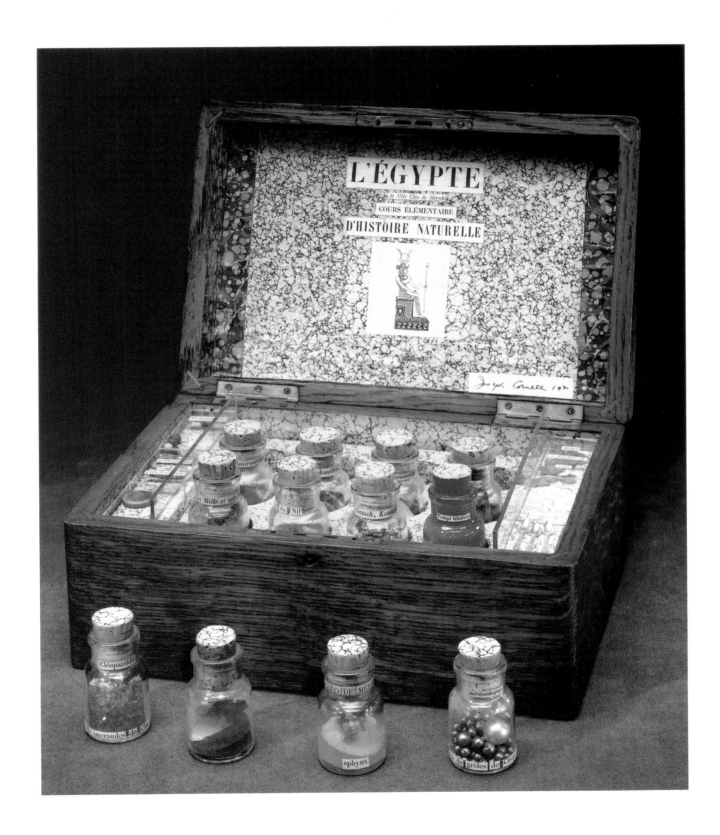

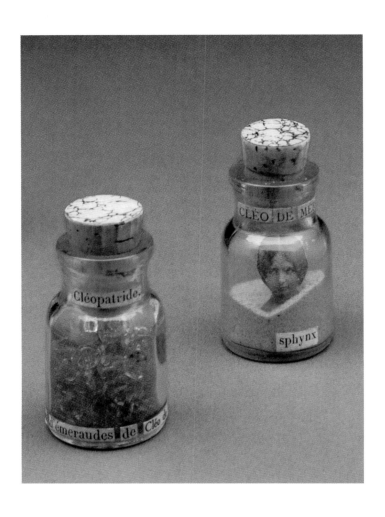

↖ Joseph Cornell, *L'Égypte de Mlle Cléo de Mérode: cours élémentaire d'histoire naturelle*, 1940, mixed media (including wood, paper, glass, sand, doll arm, wood ball, coin, mirror, cork, rock, plastic, thread, bone, rhinestones, sequins, beads, tulle, cut-outs, and glitter), 12.1 × 27.3 × 18.4 cm (4¾ × 10¾ × 7¼ in.)

← Detail of bottles in *L'Égypte de Mlle Cléo de Mérode: cours élémentaire d'histoire naturelle*, 1940

↓ Joseph Cornell, *Untitled*, 1930s, collage on paper, 12.9 × 20.5 cm (5⅛ × 8⅛ in.)

with poetic or magical "moving parts", achieving even slight measure of this poetry or magic.'

Among the many magical moving parts in *L'Égypte de Mlle Cléo de Mérode: cours élémentaire d'histoire naturelle* that invest the innocent machine with an air of childlike poetry is a hidden lower level, beneath the vials, on which a yellow ball, a German coin and the arm of a doll languish unburied on a coarse carpet of broken glass and sand – as if freshly washed up in some small corner of her subconscious. Meanwhile, flanking each side of the twelve-hole holster in which the glass bottles sit, is a narrow tray, or side compartment, in which are tucked away (on the left) a small assortment of coloured beads (mysteriously labelled 'preamble'), a small rock (called 'the pharaoh's stone'), and a token; while on the right we find three miniature metal spoons and a handful of red plastic rose petals, so classified.

The eye of anyone who has daydreamt through the bric-a-brac shop of Cornell's deliciously dishevelled imagination will snag on the last of these curios. In the artist's inimitable lexicon, roses often provide the key necessary to unlocking

sense. In an earlier, approximately 13 × 20 cm (5 × 8 in.) cut-and-paste collage by Cornell, which at first glance appears to depict nothing more than a seamstress's cluttered work station, it's the insertion of the head of an oversized rosebud beside a Singer sewing machine, precisely where one might expect to find a garment needing repair, that helps us decrypt the collage's meaning. The rose echoes a famous quotation from 1869 by the French poet Isidore Lucien Ducasse, the self-styled 'Comte de Lautréamont', who died at the age of 24. It is a phrase that expatriate Surrealists living in New York seized upon in the 1920s as a kind of motto for their vision: 'beautiful as the chance meeting on a dissecting-table of a sewing-machine and an umbrella'. By inserting a rose in place of the umbrella, Cornell signals his distance from the temperament of the Surrealists (several of whom, including Marcel Duchamp and Salvador Dalí, he would later come to know). That thornless rose – for centuries a symbol of mysticism and martyrdom, innocence and sacrifice – was a quiet assertion: Cornell's world was stitched together not by absurdity and clever whim, but by legends and romance.

The scatter of plastic rose petals in *L'Égypte de Mlle Cléo de Mérode: cours élémentaire d'histoire naturelle* suggests a further stripping back of the well-whittled symbol. Here, the rose is both breaking down and indestructible, just like Cléo de Mérode – just like you and I. In the strange Schrödinger arena of Cornell's enchanting box, life and history simultaneously converge and disperse, eternalize and evaporate.

*Like an esoteric Tarot card,
Kahlo's teasing self-portrait teems with
inscrutable symbols of her own intimate
invention – a sleight of mind that
ceaselessly trumps our imagination.*

The secret of great art is that it's secretive. It always keeps something up its sleeve, never disclosing its fullest meaning. Think of the works assembled in this book as a kind of stacked deck, or a clairvoyant's wicked pack of cards. Each image is as endlessly interpretable and re-interpretable as The Hanged Man or The Five of Swords. One by one, each work is laid before you here like an inscrutable Tarot, dealt by an unseen hand. To divine the ceaselessly shifting meaning of each work requires patience and a mystic's agility of mind. Consider, for instance, our next wildcard: an enigmatic poker-face of a painting that dares us to take it at face value.

At first glance, *Self-Portrait with Thorn Necklace and Hummingbird*, by the Mexican artist Frida Kahlo, is a chain-reaction of luckless portent – like a mirror smashed into thirteen pieces. One of nearly five dozen self-portraits created by Kahlo in her lifetime, the painting hurls at the observer a fistful of star-crossed charms: from the beady-eyed black cat (a traditional symbol of encroaching doom), whose arched spine bristles behind the artist's left shoulder, to the crown-of-thorns-like necklace that digs into Kahlo's skin. Invoking Christ's suffering, rather than his salvation,

the choker's abiding negativity is forever being cinched tighter still by the monkey on Kahlo's back.

Even ostensibly positive signs appear to have been given a foreboding twist in the painting. The eponymous hummingbird, for instance, which would normally carry with it connotations of good fortune, seems crucified here. Its stiffened outstretched wings dangle from the thorns that slowly garrot Kahlo like an albatross around her neck. Perched on the artist's head, a pair of butterflies (typically interpreted as symbolizing rebirth) appear poised for flight. But the upward trajectory of each is thwarted by a curious hybrid creature – part dragonfly, part flower – suspended in mid-swoop and blocking the butterflies' imagined lift-offs. Eerie folklore native to America warns that dragonflies are the 'Devil's needles' and that they demonically sew up the lips and eyes of children. Under such assault, the embattled butterflies are suddenly transformed from harbingers of hope into cruel embodiments of the unseen and unspoken anguish experienced by Kahlo after two of her pregnancies ended before birth.

On its face, Kahlo's painting would appear to be an ever-tightening noose of inescapable misfortune – a bad

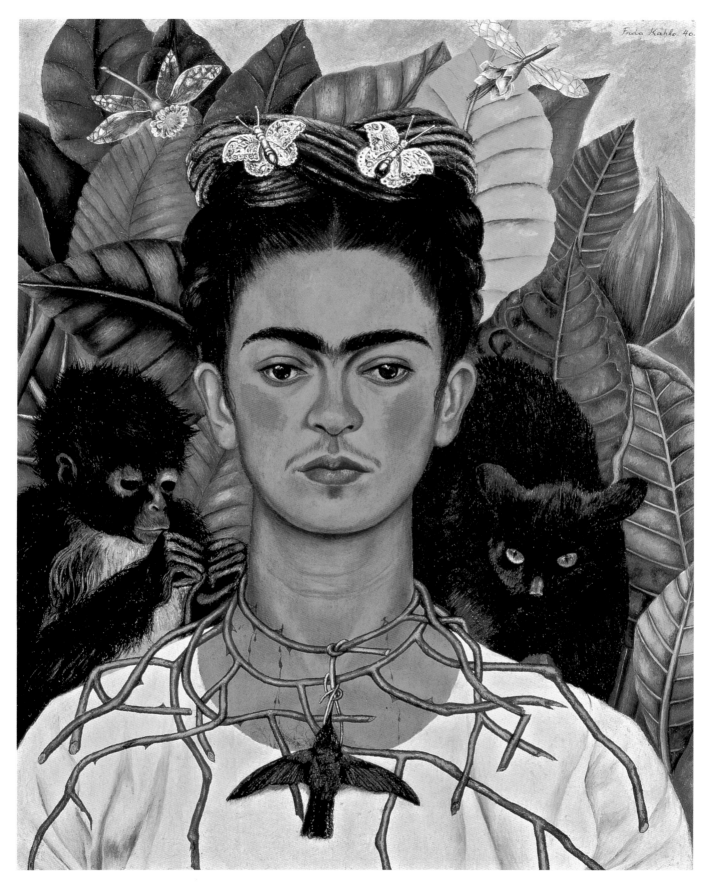

↖ Frida Kahlo, *Self-Portrait with Thorn Necklace and Hummingbird*, 1940, oil on canvas, 61.2 × 47 cm (24⅛ × 18½ in.)

👁 Detail of the headdress in *Self-Portrait with Thorn Necklace and Hummingbird*, 1940

moon rising. Look closer, however, and the artist unsettles the ominousness that threatens to overtake her work with a subtly insinuated symbol capable of transforming the canvas into an emblem of irrepressible fortitude and courage. In striking contrast to the discordant gaggle of cataclysmic auguries clamouring for regard all around her, a quietly composed token of restorative order presides over the scene in the form of a lemniscate (or infinity symbol) that weaves itself harmoniously above Kahlo's head like a geometric halo. Fashioned here from purple cloth (thereby echoing countless medieval representations of the Virgin Mary) and woven into the artist's hair so that she and it become one, the symbol interjects into the portrait an air of mathematical calm and indivisible order.

The very presence of the lemniscate counterbalances the chaos of competing superstitions that wrestle for the upper hand in Kahlo's work. But rather than dispelling the supernatural from her painting, the symbol doubles-down on its underlying mysticism, trumping the other omens that orbit the artist's countenance by coolly playing the ace the artist has kept up her sleeve: her own indomitable strength. By hiding in plain view the sinuous swerve of the lemniscate levitating on butterfly wings above her, Kahlo invites observers to blur into one her painting and the well-known depiction of 'Strength' in Tarot – the eighth card in the so-called 'Major Arcana' suit of the esoteric deck.

Originally entitled 'Fortitude' in fifteenth-century versions of Tarot, the 'Strength' card features a woman, draped with flowers, calmly controlling a lion while above her head floats an infinity symbol.

Tarot served as a significant inspiration to Kahlo's contemporaries, especially the French artist and founder of Surrealism, André Breton, whom Kahlo met in 1938, two years before she painted her *Self-Portrait*, and who admired Kahlo's work as being intrinsically in accord with his own imagination. In Kahlo's painting, the mark of strength that is denoted by the infinity symbol serves as a crucial slipknot that links the realms of reality with those of pure imagination and hermetic belief. Though Breton was keen to claim her as a disciple of his *-ism*, Kahlo steadfastly held to the conviction that her work played by its own rules. 'I really don't know', she once confided, 'if my paintings are surrealistic or not, but I do know they are the most honest expression of myself, never taking into consideration the judgments or prejudices of anyone.'

Neither a diversion from the struggles of this world nor a repudiation of spiritual mystery, Kahlo's work offers itself as a semi-permeable membrane between two dispositions, between two universes. By keeping its sympathies close to its chest, the painting knows that 'the cards are no good that you're holding', as Bob Dylan sings in 'Series of Dreams', 'unless they're from another world'.

→ Óscar Domínguez, *Freud, Mage de rêve – Étoile*, March 1941, sketch for the Marseille card deck published 1943, ink, pencil and gouache, 27.1 × 17 cm (10⅝ × 6¾ in.)

The same year that Frida Kahlo created her self-portrait with its echo of Tarot tropes, a group of Surrealists, including Óscar Domínguez, Max Ernst, André Masson and the movement's founder André Breton (who believed Kahlo's imagination was in sync with theirs), began designing their own pack of Tarot cards.

↓ Jackson Pollock, *One: Number 31,*
1950, oil and enamel paint on canvas,
269.5 x 530.8 cm (106⅛ × 208⅞ in.)

The chaotic rhythms of Pollock's canvas are more carefully calibrated than they initially seem. Composed from a polyphony of angles, the painting offers a multi-perspective, fly-on-the-fly glimpse into the frenetic techniques of the artist's imagination.

The greatest works of art stop the eyes of an age in their tracks. They fossilize the era's perception of the world the way amberous resin oozes over the ancient antennae of extinct insects. Re-encountered by subsequent generations, such works are gazed into as time-polished lenses – lucent capsules of how we used to see. No work embodies the petrifying power of art more enthrallingly than the American Abstract Expressionist Jackson Pollock's 1950 sprawling primordial tarpit of a painting, *One: Number 31*.

Nearly 2.75 metres (9 ft) tall and 5.5 metres (18 ft) wide, the work flares out from its chaotic surface in choppy tussles of primeval energies flailing for discernible form. Thin whorls of black enamel flung calligraphically at the canvas in wristy loops wrestle for legibility with webby squirts of white liquidized bone. The result is a work that's neither written nor drawn, brushed nor sculpted – a work out of which one could imagine once crawled forth not words themselves, not shapes, but the primal impulse for expression. Representing nothing, the work surges to represent everything. Instinctively, our eyes insist that this isn't a painting at all but the clotted bandwidths of something huge: an expanding cosmos groaning into life.

And then you see it, a small hummock of blue crust in the right corner of the canvas, no bigger than a fingernail, suspended beside a skein of pulsing white: the still-intact, pigment-frozen body of a fly, eternally shellacked into art. Suddenly, a work of shuddering and unrelenting abstraction, seemingly attuned to antediluvian rhythms of galactic upheaval, wads itself into a tight clump of unflinching reality and intimate feeling. Our perception of the work instantly zooms to a palpable pinpoint and then shatters into the complex pixellation of the insect's strange compound eye.

The creature's vibrant rigidity on the surface of Pollock's painting speaks volumes about the pace and frenzy of the artist's manic 'drip' technique. Infamously difficult to nab, a fly possesses the advantage of perceiving the world around it in panoramic slo-mo. Its mosaic vision slices potential assaults down to fractions of a millisecond, giving the fly's reflexes time to react and scurry. The flick that paralysed the insect must have been discharged at lightning speed, a likelihood corroborated by photos and films of the artist at work taken around the time that *One: Number 31* was created.

The fly trapped in the right-hand corner of *One: Number 31*, 1950

→ Detail of *One: Number 31*, 1950

Stretching his canvas across the floor, rather than propping it upright against a wall, enabled Pollock to run circles around his art. Circumnavigating the full perimeter of his work, the artist swooped its surface from every angle the way a fly bombards a picnic table. Now armed with a crusted brush, its bristles hardened from disuse, now wielding a trowel, a stick, a knife or a turkey baster, Pollock flipped paint straight from its can as he danced hypnotically around his work like an arsonist scattering petrol on the floor of the warehouse he's about to torch. 'When I am *in* my painting,' Pollock once explained, 'I'm not aware of what I'm doing... I have no fear of making changes, destroying the image, etc., because the painting has a life of its own.'

And, in the case of *One: Number 31*, it has a death of its own, too. The mortal sacrifice of the fly to Pollock's work is key to understanding the painting's urgency. While artists have long inserted depictions of the insect into their works as *memento mori* – whether perching infectiously on a crust of bread in a still life, or loitering on the coarsening fuzz of peach beginning to perish, the tangibility and literality of Pollock's preserved specimen constitutes a categorical shift in the tradition. Where Salvador Dalí, nineteen years earlier, poised a fly on the clock-face that droops on the left-hand side of his *Persistence of Memory* (see p. 206), as a legible symbol of life's fleetingness (a point amplified by the insect's strangely human-shaped shadow), Pollock melts metaphor into fact by alchemizing a literal death into the persistence of art.

In Pollock's painting, the fly at once gets in the way of the work's vision and encompasses it. No longer a mere metaphor, or a signpost of something else, the fly becomes a corporeal vestige of the artist's former presence 'in' his painting – a relic of his freneticism that forever watches over the space. Simultaneously mortal and mystical, the fly is the very incarnation of that which troubled the sight of the American poet Emily Dickinson, who eerily imagined the distended instant of her own death in her poem 'I heard a Fly buzz - when I died'. 'And then it was', Dickinson wrote, 'There interposed a Fly'. In Dickinson's poem, as in Pollock's painting, the 'Blue - uncertain - stumbling Buzz' of the interloping fly suspends the transition from the world of the living to the world of the dead. The fly snags the soul's eye, freezing it on a threshold between two levels of being – 'Between the light - and me'.

↑ Ambrosius Bosschaert the Younger,
Dead Frog with Flies, 1630, oil on
copper, 12.5 × 17.5 cm (4⅞ × 6⅞ in.)

The invocation of flies as agents of
decay in Western still lifes was
amplified unsettlingly by the Dutch
Golden Age painter Ambrosius
Bosschaert the Younger in *Dead Frog
with Flies*, where the balance is
disturbingly tipped in the direction
of appalling putrescence. The literality
of a dead fly trapped on the surface
of Jackson Pollock's *One: Number 31*
challenges observers to distinguish
between representation and reality.

*An emblem of angst for a war-weary
world, Bacon's howling pontiff is a work
of frightful ambivalence – one that
pulls viewers in by pushing them away.*

Reflecting upon a work of art involves a powerful paradox. As a psychological activity, reflection requires a merging of the see-er and the seen, as the reflecting self dissolves into the meaning of the object under contemplation. Conversely, physical reflection, when it occurs on the glossy surface of a glazed work, can result in an optical obstacle, one that distracts the eye as it struggles to disentangle the image of the looker from the image being looked at.

Reflection, in other words, is something at once to be encouraged and strenuously avoided. Unless, that is, you are the Irish artist Francis Bacon, who strove to unite in his paintings the retinal awkwardness of physical reflection on the one hand with the virtues of its meditative counterpart on the other. In Bacon's contrary imagination, what hooks the eye most in a work is the eye itself, looking back. No work captures the profundities of that ricochet of staring more boldly or alarmingly than Bacon's unsettling modern icon, *Study after Velázquez's Portrait of Pope Innocent X*. Though Bacon steadfastly avoided visiting the seventeenth-century masterpiece in the flesh when he had opportunities to do so, he perversely hoarded reproductions of the work whenever he came across them in books and magazines,

bewitched by what he believed to be the penetrative power of the subject's unsettling stare.

What truly captivates the observer's eye in Bacon's haunting reinvention of Velázquez's portrait is not the strange cocooning of the papal subject behind a series of diaphanous barricades – the translucent curtain that gauzily pleats the work's surface and the existential scaffolding of the surreal geometric box that pens the pope in – but the howling countenance whose bespectacled stare feels much closer to us than those insistent partitions might imply. More than any other single detail, it is the pope's round and oversized glasses that draw the observer into the work's horrified and horrifying orbit. Their intervention into Velázquez's portrait is multi-purpose and deepens the work's resonance both aesthetically and personally.

On more than one occasion Bacon explained that his *Study* was not intended as a strict reinterpretation of Velázquez's portrait, but a complex fusion of that painting with a still from the 1925 silent film *Battleship Potemkin* by the Soviet director Sergei Eisenstein. In the famous Odessa staircase scene, which Bacon says transfixed him, a bespectacled nurse is shot through the eye. The assault forces her to lose control of

a baby carriage, which breaks loose and barrels uncontrollably down the steep stone steps as she screams silently. The merging of culturally unconnected images – Pope Innocent X and a traumatized Soviet nurse – was central to Bacon's imagination. If we squint through the backward focus of the lenses that Bacon has perched surreally on his subject's nose, another figure can be glimpsed in the telescoping vision: that of Jessie Lightfoot, Bacon's own deeply adored nanny.

In the complex backstory of Bacon's work, Lightfoot figures significantly as another bespectacled visual antecedent whom biographers have noted bore more than a serviceable resemblance to Eisenstein's tragic nurse and who died shortly before Bacon created his painting. The horror expressed by the screaming pope is a compound echo of the pain Eisenstein's nurse felt at losing control of the infant in her care, as well as that which Bacon too may have experienced in facing the world without his childhood companion.

Aesthetically, the pope's glasses are a reflective paradox: they add a further layer of distance between the subject and the viewer, while, at the same time, succeed in drawing us into the disjointed narrative they signal. Without the humanizing 'eye-hook' of the glasses, the work risks seeming irredeemably estranged to the observer. The palpability of Bacon's decision to lock his subject's eyes behind spectacles was reinforced in the work's display by the artist's insistence on framing the canvas behind glass – a frequent dimension of his paintings that he felt was crucial to their effect. 'The glass', Bacon once explained, 'helps to unify the picture. I like

the distance between what has been done and the onlooker that the glass creates; I like the removal of the object as far as possible.'

Locked behind glass, Bacon's work is suspended, aesthetically, between impulsion and repulsion as it simultaneously impels and repels the observer's gaze. Such artistic ambivalence would have a profound effect on the imaginations of his creative descendants, especially the Young British Artists of the 1990s. The shark's sopping roar in Damien Hirst's *The Physical Impossibility of Death in the Mind of Someone Living*, the poster-beast for the YBA vision, not only amplified the mute yawp of Bacon's scream for a new generation, it exaggerated still further the complicating role of glass, as a reflective device. By forcing visitors, in effect, to dry-swim around the display case in which the shark was suspended, mimicking the motion of the rapacious fish, Hirst turned looking into an act of predation, thus taking Bacon's devilish devolution of humanity into yelping primitivity one step further.

→ Still of the screaming nurse from the film *Battleship Potemkin*, directed by Sergei Eisenstein (1925)

↓ Damien Hirst, *The Physical Impossibility of Death in the Mind of Someone Living*, 1991, glass, painted steel, silicone, monofilament, shark and formaldehyde solution, 217 × 542 × 180 cm (85½ × 213⅜ × 70⅞ in.)

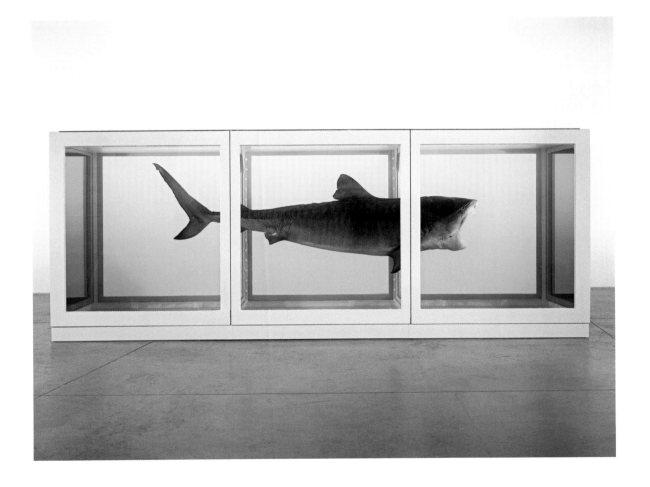

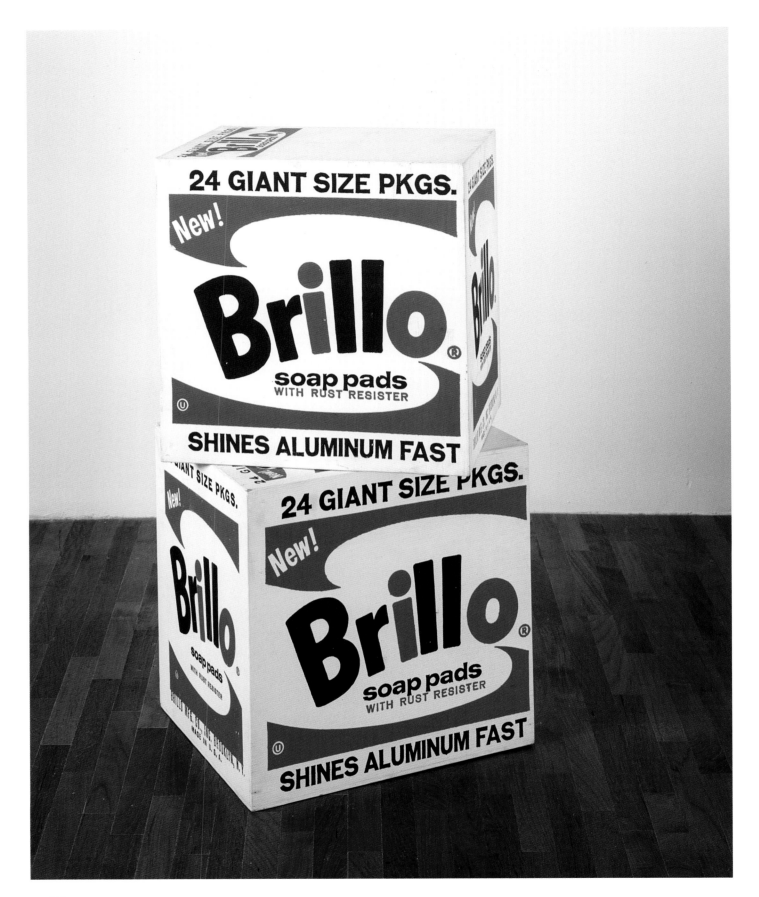

Warhol's daring work, dithering dangerously between facsimile and farce, challenges the sensibility of our eyes to a staring contest. But who'll blink first remains anyone's guess.

Is it, or isn't it? That's the question that every guest attending the opening of Andy Warhol's exhibition at the Stable Gallery in New York in 1964 found themselves asking, as they stared in dumbfounded perplexity at each identically stencilled cube that comprised the artist's installation *Brillo Boxes*. Is it filled with soap-infused steel pads, or isn't it? Is this the actual bulk packaging of a domestic cleaning product that has merely been shifted from the warehouse of a supermarket to an art gallery? Or has the artist fabricated a convincing facsimile, daring collectors to deny the piece as a bona fide *objet d'art*?

The power, if power it might be called, of Warhol's *Brillo Boxes* is their ability to freeze us at a level of scrutiny that precedes and forestalls any meaningful aesthetic interrogation of the work as an actual material object – a work of art. Warhol's work pushes our eyes away and forces us into an intellectual disposition that has been, but should not be, confused with artistic appreciation. They shut down what the Romantic poet Wordsworth called 'the tyranny of the eye' and leave observers with little choice but to adopt instead an alternative, philosophical perspective – one where the concept of concept trumps palpable proof of artistic achievement. Inspection is thwarted into introspection.

Fully aware that we, the observers of the piece, require first, before we expend any energy on assessing merit, reassurance that the work is really a work, the work teases us out of one kind of thinking into another. We need to know whether the broader label 'art' that envelops the piece (on the sign of the gallery in which the object is being exhibited, or in a book, like this one, where it is being reproduced) is deceiving us about its status, or if the label on the piece, announcing itself as a disposable commercial product, is being mischievously disingenuous instead. We need to know if we're being conned – if the cat inside of Schrödinger's box is alive or dead.

A direct descendant of Duchamp's urinal (see p. 199), which adroitly dislocated itself from any pretence of actual utility by shifting its posture slightly and flashing a signature, Warhol's *Brillo Boxes* assume a more hermetic stance – sealing within themselves the mystery of their own truth and daring us to be confident of our own powers of discrimination. Their plausibility as products makes them impossible as art. Here, the eye-hook we crave to give us retinal traction has slipped

↖ ⟨👁⟩ Andy Warhol, *Brillo Boxes*, 1964, synthetic polymer paint and silkscreen ink on wood, 43.3 × 43.2 × 36.5 cm (17⅛ × 17 × 14 in.)

→ Andy Warhol, Untitled from *Campbell's Soup I*, 1968, one from a portfolio of ten screenprints, each approx. 81 × 48 cm (31⅞ × 18⅞ in.); *Campbell's Soup Cans* first exhibited 1962

Crucial to Andy Warhol's eventual creation of *Brillo Boxes* was the making, two years earlier, of a series of thirty-two soup-can canvases resembling retail advertisements for the product. From there, it was an easy step from replicating a mere representation of a commercial object as a work of art to replicating the object itself.

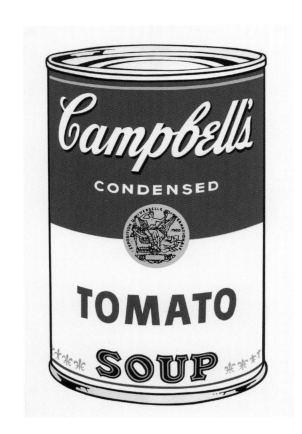

out of sight and concealed itself in the unknown of the box's invisible cavity. Is it, or isn't it?

It would be imprecise to say that our judgment of the piece has been suspended: we have not been able to proceed to any such level of discernment. What has been suspended is meaningful thought, if not the thought of meaning. The implosive nothingness that Warhol's *Brillo Boxes* represent has become the vacuous void in which a big bang of banging on about what art is and isn't has issued in the last half century. Arthur Danto, the legendary art critic, was among those who visited the Stable Gallery in 1964. The experience inspired the young philosopher to justify Warhol's work in an aesthetic tradition that, he felt, was woefully under-prepared to accommodate its significance.

Believing he had witnessed a turning point in cultural history, Danto set about redefining what art is, in light of the introduction into the history of image-making of Warhol's *Brillo Boxes*. 'To see something as art', Danto concluded in his epoch-defining essay, published in the scholarly periodical *Journal of Philosophy*, 'requires something the eye cannot descry – an atmosphere of artistic theory, a knowledge of the history of art: an artworld.' With that single permissive

sentence, the eye was suddenly off the hook. All previous priorities in the history of seeing had been scrubbed by Warhol's *Brillo Boxes*. No longer obliged to discern, discriminate or descry, the eye was permitted to turn inside itself and contemplate the meditative space where works of art install themselves inside our minds, rather than the contours of the work itself.

Though Warhol may have insisted his concerns differed significantly from those of his more painterly contemporaries ('I like boring things,' he once admitted, 'all the great things that the Abstract Expressionists tried so hard not to notice at all'), the dark abyss that yawns inside his *Brillo Boxes* is merely the logical extension, the realization, of a blankness that was first mapped half a century earlier by Kazimir Malevich's *Black Square*. With Danto's essay, which sanctions thinking outside art as equivalent to appreciating it, the cat was well and truly out of the box. From now on, detractors of Warhol's work, who believed his boxes represented the throwing in of the proverbial towel, were left to have kittens about the direction of things to come.

↑ Kazimir Malevich, *Black Square,*
1915, oil on canvas, 79.5 × 79.5 cm
(31¼ × 31¼ in.)

A rampart of reverberating rhythm,
Scully's bulwark of a painting echoes back
the soul of outmoded Minimalism
with a bold new music in it.

Great art is fretful. It strings us along and plucks at the soul. It pulses out from its core in imperceptible waves, wearing away the world around it. Finely tuned, great art calibrates our experience of being in the universe and measures the invisible vibrations of life against its silent demarcations of tone and semitone. Few works in the past half century have projected the majesty of art's philosophical fretfulness as powerfully as Sean Scully's *Backs and Fronts* – a colossal multi-panel work that imposes an impenetrable soundingboard between the artist and the outside world. Stretching an enormous 6 metres (20 ft) wide and rising, at the apex of its parapets, to a height of nearly 2.5 metres (8 ft), the punchy work echoes above its weight – its top edge bouncing boldly like the spectral audio display of a throbbing stereo system.

As a declaration of artistic intent, *Backs and Fronts* is in many ways Scully's manifesto painting – a pugilistic proclamation that helped abstraction jab a way out of the box it had found itself in by the late 1970s. The British artist Gillian Wearing has hailed *Backs and Fronts* as 'the work that broke the logjam of minimalist painting'. Comprised of eleven separate panels of varying dimensions and proportions of stripes, the work absorbs the anonymizing skyline and cityscape of New York, where Scully moved in 1975, leaving behind his native Ireland and his early life and training as an artist in England. At the same time, the painting offers itself as a magnified projection of individuals standing together in unbreakable solidarity – as if marching in unison like a crowd of protesters, or a Sondheim street gang of syncopating rhythm about to burst into belligerent song.

'*Backs and Fronts* started out as *Four Musicians*', Scully said in 2016, attesting to the unmistakeable musicality of the work,

as an homage to my friend Pablo Picasso, who painted *Three Musicians*. I didn't think that three panels or figures were enough for my paintings – so I decided to call it 'Four Musicians'. It stayed that way, with the first four panels on the left locked together side by side. Then, however, I slowly added more panels, then more panels ... as if more and more musicians were joining our already successful band. To make it even better, it became seven musicians, nine musicians, then eleven musicians. And finally, after its long journey, it was renamed 'Backs and Fronts'.

↑ Sean Scully, *Backs and Fronts*,
1981, oil on linen and canvas,
243.8 × 609.6 cm (96 × 240 in.)

↑ Pablo Picasso, *Three Musicians*,
1921, oil on canvas, 201 × 223 cm
(79⅛ × 87¾ in.)

Detail of the 'fret' in the seventh panel of *Backs and Fronts*, 1981

Where Picasso's work, in faithful Cubist fashion, boldly breaks physical form down to a shuffle of shapes and a tight score of texture and tone, Scully strips things down further still, leaving nothing but a retinal ricochet of pure rhythm – not a rhythm distilled from the imagined music thrumming from the trio of instruments, but the rhythm of exponentially expanding bodies absorbing those sounds. *Backs and Fronts* is a magnified projection of an ecstatic self.

Despite its strenuous efforts to transcend its own physicality into an immateriality of pulses analogous to the patterns of sound, the work nevertheless knows itself as a palpable construction – the product of a craftsman's careful carpentry. Though the ear of the eye may succumb to the unheard melodies and seductive rhythms of *Backs and Fronts* – the logic of whose precise arrangement of retinal notes defies proving – our stare inevitably finds itself plucking at a particular string in the work's complex weaving. Hypnotized by the insistent verticality and horizontality of each constituent panel, our gaze suddenly jams on an *unexpected riff in the seventh panel – the widest in the* work, and the one whose alternating strings of light and dark brown pluck in perfect sync with the two tones of the guitar neck that reverberates from the centre of Picasso's *Three Musicians*.

There, a third of the way down the long length of Scully's poly-string panel, is a slight seam or ghostly joint – a faint fret that runs horizontally against the grain, evidence of the man-made nature of the painting. Far from breaking the melodious spell of the work, that subtle fret – the only such hem in all of the panels – ensures that the entire octave of Scully's composition is divisible into a perfect twelve, not eleven, semitones. That fret, which our eyes ineluctably find themselves strumming, plucks the work out of its unreal aspiration to something other than it and we are: bodily echoes of a mute music our awkward soul squints to hear.

*Richter's playfully paradoxical likeness,
which slyly resists its audience's eyes
by aligning its stare with theirs, pushes
the potential of portraiture to the very edge.*

What happens if a portrait denies its own existence? What are we left with when a work of art – by definition an object of expression – refuses to express itself? The answer is *Betty*, one of the most intriguing paintings in contemporary art. The creation of German artist Gerhard Richter, *Betty* sees things differently than any portrait before it. Or, to be more precise, we don't know what *Betty* sees. Wrenched around dramatically so that her point of view both merges with and obstructs ours, the subject's invisible eyes are forever lost in the grey blankness that looms nebulously behind her. Whether that smoky emptiness is literal (an expanse of dusky wall in the distance) or figurative (the moody manifestation of a tenebrous mind) is a quandary that invests Richter's canvas with a foreboding mystique.

The sitter's awkward posture, perverse for a portrait, ensures that she is never comfortably the straightforward focus of our gaze. Her prominence in the composition keeps us from ever glimpsing what, exactly, preoccupies her, while at the same time makes certain that, paradoxically, she is never not the focal point of our looking. The painting, one eventually concedes, is neither really about this psychologically absented subject, nor about anything else.

Unlike Caspar David Friedrich's famous *Wanderer Above the Sea Fog*, which shares with us something of the subject's elevated panoramic scope, Richter's deceptively detailed and photographically explicit painting teases us into and out of vision. Whatever (or whoever) it is, beyond the vanishing points of the frame, that has made Betty turn around – distracting her from the proper attentiveness that one expects from a sitter – is as elusive and unknowable as she is. Denied access to the key coordinates of a conventional portrait (facial features and some sense of the artist's finesse with physiognomy), we are left forever on the periphery of a mysterious interaction, never knowing what role we were meant to play in the drama.

Working from a photograph that he had taken eleven years earlier, when his daughter was a young girl, Richter created his famous portrait in 1988. Scholars have since determined that the diffuse grey that pulsates behind Betty is likely another of Richter's works from an early abstract series of his so-called 'monochromes' – paintings that prioritize feeling over looking; the tactility of applied pigment over the retinal discernibility of form. Within the conflicted consciousness of *Betty*, therefore, Richter

↖ Gerhard Richter, *Betty*, 1988, oil on canvas, 102 × 72 cm (40⅛ × 28⅜ in.)

👁 Detail of the red hood in *Betty*, 1988

→ Caspar David Friedrich, *Wanderer Above the Sea Fog*, c. 1817, oil on canvas, 94.8 × 74.8 cm (37⅜ × 29⅜ in.)

has managed to merge onto a single surface, however obliquely, two radically distinct modes in which he had been working for the past two decades: photorealism up front and abstraction in the distance. In that light, the backwards swivel of the subject can be interpreted as one aspect of the artist's consciousness looking over its shoulder at the sudden encroachment of another, as the painting traps itself in an endless compression of introspection.

That this curious confrontation of selves should be visually ventriloquized through the vantage of a child, Betty, is especially fascinating. Richter's own upbringing was itself brutally riven. Just a boy when his hometown of Dresden was all but annihilated by Allied bombardment during the Second World War, Richter spent his post-war adolescence in Soviet-controlled East Germany, where he was forced to swap one nationalistic allegiance for another; one socio-political perspective for its polar opposite. The fact that, years later, he should find himself drawn simultaneously to the antithetical ideologies of photorealism and those of abstraction becomes somewhat less surprising in this context. He was hardwired for extreme ambivalence.

But what is it about *Betty*'s averted vision that connects so powerfully with the imaginations of audiences, even when her eyes refuse to connect with theirs? A survey of artists, gallery owners and museum curators conducted by *Frieze* magazine in 2001 found that only a silkscreen by Andy Warhol was considered more desirable than Richter's *Betty* as a work to take home and hang on the living room wall. Tied with Richter's canvas in second place was Pieter Bruegel the Elder's *Hunters in the Snow* – an enchanting scene whose grim, fairy-tale-like ambiance may, by sideways glance, offer a clue to *Betty*'s own appeal. Placed alongside Bruegel's wintry scene, the eye-hook red hood that droops from Betty's nape is rumpled with folkloric possibility.

In 1939, when Richter was himself around the age that his daughter is in his painting, a repugnant reinterpretation of classic fairytales was filmed and distributed by the National Socialist Party. It featured a propagandized and anti-Semitic re-imagining of 'Little Red Riding Hood' in which a Nazi rescues the helpless girl from a Jew in wolf's clothing. Whether or not Richter was ever aware of that grotesque adaptation and was reacting against it, Betty with her little red hood has the look of someone looking over her shoulder in startlement, if not fear – as if wary of her own guardianship. Perhaps the appeal of Richter's inscrutable portrait is its unflinching post-Holocaust acknowledgment that, from now on, in history's mysterious forest of dark intentions, we're all a little antsy – that we never really know who or what it is we're facing.

At once terrifying and intimate,
Bourgeois's towering tribute
to her dead mother relies for
its power on the artist's willingness
to risk self-annihilation.

A great work of art draws us, as if by invisible filaments, into its web of meaning. As a metaphor for the maker, the making and the made, the spider is as rich and resplendent as the silken weave it spins. Seized upon by artists and writers since ancient times as an irresistible symbol of frightful beauty, the arachnid was blown out of all proportion in 1999 by the French artist Louise Bourgeois in a monumental steel and marble work titled *Maman* (or 'Mummy'). Mincing gingerly as if on tip-toes, the giant spindly legs of Bourgeois's enormous spider sculpture, which towers 9 metres (30 ft) in the air, throws into dizzying disarray an observer's sense of scale. Installed in 2000 at London's Tate Modern as part of the artist's exhibition of works in the museum's Turbine Hall (Bourgeois was the first artist invited to show in the large-scale venue in a legendary series sponsored by Unilever), the sculpture's contradictory size and elegance, fragility and dominion, frightfulness and allure, defied fathoming.

Bourgeois, who was 88 years old at the time the work was erected, had been fascinated since childhood with the symbolism of spiders. Aware of the intimidating nature of her overwhelming sculpture, she embedded within its awesome armature a seductive detail capable of luring the eye and stride of visitors into its perilous ambit. Under the gnarled abdomen of the spider, hoisted high into the air like a medieval mosaic under a church's dome, seventeen grey and white marbles have been suspended behind a metal mesh. Symbolizing unhatched eggs, the natal sac is anything but an incidental decoration. Indeed, it is the very key to understanding the sculpture's unexpectedly intimate meaning – the eye-hook that entangles us.

Bourgeois's career-long obsession with spiders, which motivated countless drawings and sculptures from the 1940s onwards, is tightly bound up with the memory of the artist's mother – a tapestry weaver who died when the artist was in her early twenties. 'The Spider', Bourgeois has explained, 'is an ode to my mother.'

She was my best friend. Like a spider, my mother was a weaver. My family was in the business of tapestry restoration, and my mother was in charge of the workshop. Like spiders, my mother was very clever. Spiders are friendly presences that eat mosquitoes. We know that mosquitoes spread diseases and are therefore unwanted. So, spiders are helpful and protective, just like my mother.

243

By envisioning the spider as suspended in pregnancy – her eggs forever frozen in their pre-hatched state, wrapped in an eternally protective embrace – Bourgeois has spun back time to a moment before the painful losses of motherhood and daughterhood. Bourgeois's decision to display the suspended eggs behind a metal mesh accentuates their meaning when understood within the broader context of her art. An ongoing series of sculptures begun in the late 1980s and collectively entitled 'Cells' emerged concurrently with Bourgeois's fascination with the spider in the last decades of her life. Consisting, typically, of wire enclosures of varying sizes that are filled with an array of both very personal as well as found objects, the artist's 'Cells' at once exclude observers as well as entice intrusive gazing at their uncanny inventory. In one such work, *Cell (Choisy)* (1993), the slanted blade of a rusty guillotine hovers ominously over an encaged model of the artist's childhood home in the Parisian suburb of Choisy-Le-Roi – the home where she recuperated after her father rescued her from a river where she had tried to drown herself after learning of her mother's death.

Among the earliest works in the series, *Cell (Eyes and Mirrors)*, created between 1989 and 1993, is comprised of a large woven-iron-mesh cube, reinforced by iron bars, into which the artist has installed a pair of black marble spheres resembling enormous pupils. Over the enmeshed marbles an ovoid mirror, which juts out through a kind of sun-roof in the ceiling of the cube, swivels on hinges. Alongside the marbles, an assortment of additional mirrors has been positioned, enhancing the implication that to reflect is to be imprisoned. Seen alongside such earlier works, *Maman*'s encaged eggs suddenly begin to feel loaded with intense, if inchoate, meaning. Implicit in the levitating marbles is the artist's own imagined erasure from existence: a selfless sacrifice she's prepared to contemplate in order to weave into being the mother, and friend, she so profoundly misses. Never before in art has the entwined vision of self-negation and love loomed so enchantingly or so large.

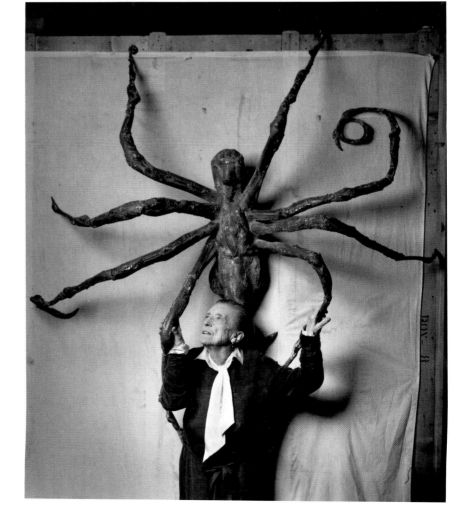

↑ Louise Bourgeois, *Spider*, c. 1948 (alternately titled *Pas de Géant* [An Apparatus]), soft ground etching and engraving on paper; plate 15.1 × 8 cm (5⅞ × 3⅛ in.), sheet 25 × 16.6 cm (9⅞ × 6½ in.)

→ Louise Bourgeois with *Spider IV*, photographed by Peter Bellamy in 1996

*After centuries of absorbing
our scrutinizing gaze, a work of art
finally stares back and, in
doing so, brings the entire history
of image-making full circle.*

Our survey of definitive works of art began with the surprise excavation in 2008 of an object whose discovery changed forever our understanding of the origins of image-making: the prehistoric ivory statuette known as the Venus of Hohle Fels. The eerie genius of the seminal artist who carved the object forty millennia ago (whose strange and estranging instinct was to replace the head and stare of the depicted figure with a utilitarian eye-hook, making the object wearable) helped bore the aperture through which all subsequent art has been, in these pages, glimpsed and measured. Deprived of its gaze, the prototypical artwork has, in a sense, served as a metaphor for the entire story of art to date: a restless search to restore sight to works that have withstood the one-way assault of ceaseless seeing.

In 2010, after tens of thousands of years of being stared at, art stared back. It did so in the form of one of the most famous works of the age: an extraordinary feat of performance stamina by the Belgrade-born artist Marina Abramović entitled *The Artist is Present*. For 736 and a half hours, Abramović sat in the Metropolitan Museum of Art in New York, gazing expressionlessly into the eyes of any visitor who volunteered to take the seat opposite her. Sounds simple? The intensity of the experience, by most accounts, was emotionally overwhelming. Support groups sprang up for 'survivors' of her stare. It was as if the passion, scrutiny and indifference that every observer of a work of art has ever exerted on an object had reached breaking point and penetrated the event horizon that once separated subject and object.

A groundbreaking veteran of performance art, admired for her endurance, Abramović is no stranger to the physical and psychological demands of putting oneself on display not merely as an exhibiting artist, but as the art itself. In an attempt to determine how much self-abuse an audience was prepared to witness before intervening, Abramović famously tortured herself naked on a block of ice for one of her early works and went so far as to gouge geometric shapes into her stomach with a knife. Yet, in a sense, *The Artist is Present* was even more extreme and went further still. By whittling herself down to nothing more than a refined reflex – a pair of pupils and a stare, Abramović courageously isolated the very essence of art's eye-hook: seeing itself.

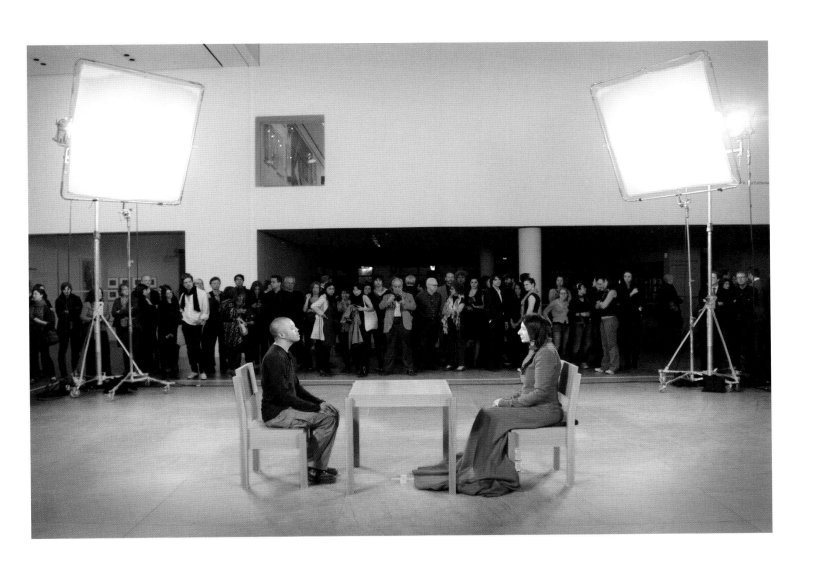

Marina Abramović,
The Artist is Present, performance
(3 months), Museum of
Modern Art, New York, 2010

Sources and Further Reading

Selected General Sources

Baudelaire, C., *The Painter of Modern Life and Other Essays*, trans. and ed. J. Mayne, London, 2012

Bell, J., *Mirror of the World: A New History of Art*, London, 2010

Berenson, B., *The Italian Painters of the Renaissance: With 400 Illustrations*, London, 1956

Berger, J., *Ways of Seeing*, London, 1972

Clark, T. J., *Image of the People: Gustave Courbet and the 1848 Revolution*, Princeton, 2004

Gage, J., *Colour and Culture: Practice and Meaning from Antiquity to Abstraction*, London, 1993

Gombrich, E. H., and R. Woodfield, *The Essential Gombrich: Selected Writings on Art and Culture*, London, 1996

—, *The Story of Art*, London, 2016

Greenberg, C., *Art and Culture: Critical Essays*, Boston, 2006

Honour, H., and J. Fleming, *A World History of Art*, London, 2016

Hughes, R., *The Shock of the New: Art and the Century of Change*, London, 1992

Krauss, R. E., *The Originality of the Avant-Garde and Other Modernist Myths*, Cambridge, MA, 1999

Panofsky, E., *Renaissance and Renascences in Western Art*, Stockholm, 1960

Rideal, L., *How to Read Paintings: A Crash Course in Meaning and Method*, London, 2014

Schapiro, M., *Word and Image*, Leyden, 1972

Vasari, G., *Lives of the Artists*, selected lives trans. by G. Bull, 2 vols, London, 1965 & 1987

Welch, E., *Art in Renaissance Italy 1350–1500*, Oxford, 2000

Introduction

Hughes, R., *Nothing If Not Critical: Selected Essays on Art and Artists*, New York, 1992, pp. 145–8

Insoll, T., *The Oxford Handbook of Prehistoric Figurines*, Oxford, 2017

Jansen, L., H. Luijten, and N. Bakker (eds), *Vincent van Gogh – The Letters: The Complete Illustrated and Annotated Edition*, London, 2010

01
Ashurbanipal Hunting Lions (*c.* 645–635 BC)

Barnett, R. D., and A. Lorenzini, *Assyrian Sculpture in the British Museum*, Toronto, 1975

Caygill, M., *Treasures of the British Museum*, London, 2009

Strommenger, E., and M. Hirmer, *5000 Years of the Art of Mesopotamia*, New York, 1964

02
Parthenon Sculptures (*c.* 444 BC)

Browning, R., C. Hitchens, and G. Binns, *Imperial Spoils: The Curious Case of the Elgin Marbles*, New York, 1988

Connelly, J. B., 'Parthenon and Parthenoi: A Mythological Interpretation of the Parthenon Frieze', in *American Journal of Archaeology*, vol. 100, no. 1, 1996, pp. 53–80

Jenkins, I., I. Kerslake, and D. Hubbard, *The Parthenon Sculptures*, Cambridge, MA, 2007

03
Terracotta Army of the First Qin Emperor (*c.* 210 BC)

Kesner, Ladislav, 'Face as Artifact in Early Chinese Art', in *RES: Anthropology and Aesthetics*, no. 51, 2007, pp. 33–56

Ledderose, L., *Ten Thousand Things: Module and Mass Production in Chinese Art*, Princeton, 2000

Portal, J., *The First Emperor: China's Terracotta Army*, Cambridge, MA, 2007

04
Villa of the Mysteries murals (*c.* 60–50 BC)

Gazda, E. K. (ed.), *The Villa of the Mysteries in Pompeii: Ancient Ritual, Modern Muse*, Ann Arbor, 2000

Pappalardo, U., and L. Romano. *The Splendor of Roman Wall Painting*, Los Angeles, 2009

05
Laocoön and his Sons (*c.* 27 BC–AD 68)

Beard, M., 'Arms and the Man: The Restoration and Reinvention of Classical Sculpture', in *Times Literary Supplement*, 2 February 2001

Richter, S., *Laocoon's Body and the Aesthetics of Pain: Winckelmann, Lessing, Herder, Moritz, Goethe*, Detroit, 1992

06
Trajan's Column, Apollodorus of Damascus (AD 113)

Claridge, A., 'Hadrian's Column of Trajan', in *Journal of Roman Archaeology*, vol. 6, 1993, pp. 5–22

Hunter, F., 'The Carnyx in Iron Age Europe', in *The Antiquaries Journal*, vol. 81, 2001, pp. 77–108

07
The Book of Kells (*c.* AD 800)

Meehan, B., *The Book of Kells: An Illustrated Introduction to the Manuscript in Trinity College, Dublin*, London, 2014

Pulliam, H., *Word and Image in the Book of Kells*, Dublin, 2006

08
Travellers among Mountains and Streams, Fan K'uan (*c.* 1000)

Ebrey, P. B., *The Cambridge Illustrated History of China*, Cambridge, 1999

Paine, R. T., and A. C. Soper, *The Art and Architecture of Japan*, New Haven, 1981

09
Bayeux Tapestry (*c.* 1077 or after)

Bloch, R. H., *A Needle in the Right Hand of God: The Norman Conquest of 1066 and the Making and Meaning of the Bayeux Tapestry*, New York, 2006

Hicks, C., *The Life Story of a Masterpiece*, London, 2007

10
The Universal Man, Hildegard of Bingen (1165)

Bingen, H. of, *Selected Writings*, trans. M. Atherton, London, 2001

Dale, T. E. A., 'Monsters, Corporeal Deformities, and Phantasms in the Cloister of St-Michel-de-Cuxa', in *The Art Bulletin*, vol. 83, no. 3, 2001, pp. 402–36

11
The Expulsion from the Garden of Eden, Masaccio (*c.* 1427)

Ahl, D. C., *The Cambridge Companion to Masaccio,* Cambridge, 2002

Post, J. F. S., 'Footloose in Paradise: Masaccio, Milton, and Renaissance Realism', in *Huntington Library Quarterly*, vol. 69, no. 3, 2006, pp. 403–24

12
Ghent Altarpiece, Jan van Eyck (1430–32)

Isaac, E., 'The Citron in the Mediterranean: A Study in Religious Influences', in *Economic Geography*, vol. 35, no. 1, 1959, pp. 71–8

Schmidt, P., *The Adoration of the Lamb*, Leuven, 2005

13
The Descent from the Cross, Rogier van der Weyden (*c.* 1435)

Crombie, L., *Archery and Crossbow Guilds in Medieval Flanders, 1300–1500*, Woodbridge, 2016

Klein, J., and G. Perry, *Grayson Perry*, London, 2013

Powell, A., 'The Errant Image: Rogier van der Weyden's "Deposition from the Cross" and Its Copies', in *Art History*, vol. 29, no. 4, 2006, pp. 540–62

14
The Annunciation, Fra Angelico (*c.* 1438–47)

Singer, F., 'Richard Hamilton's "The Annunciation"', in *Print Quarterly*, vol. 25, no. 3, 2008, pp. 267–77

Spencer, J. R., 'Spatial Imagery of the Annunciation in Fifteenth Century Florence', in *The Art Bulletin*, vol. 37, no. 4, 1955, pp. 273–80

15
The Lamentation over the Dead Christ, Andrea Mantegna (c. 1480)
Eisler, C., 'Mantegna's Meditation on the Sacrifice of Christ: His Synoptic Savior', in *Artibus et Historiae*, vol. 27, no. 53, 2006, pp. 9–22

'The Genius of Andrea Mantegna', in *The Metropolitan Museum of Art Bulletin*, vol. 67, no. 2, 2009, pp. 4–64

16
The Birth of Venus, Sandro Botticelli (c. 1482–85)
Barolsky, P., 'Looking at Venus: A Brief History of Erotic Art', in *Arion: A Journal of Humanities and the Classics*, vol. 7, no. 2, 1999, pp. 93–117

Clark, K., *The Nude: A Study in Ideal Form*, New York, 1959

Mack, C. R., 'Botticelli's Venus: Antique Allusions and Medicean Propaganda', in *Explorations in Renaissance Culture*, vol. 28, no. 1, 2002, pp. 1–31

17
Mona Lisa, Leonardo da Vinci (c. 1503–6)
Hales, D., *Mona Lisa: A Life Discovered*, New York, 2015

Kemp, M., and G. Pallanti, *Mona Lisa: The People and the Painting*, Oxford, 2017

18
The Garden of Earthly Delights, Hieronymus Bosch (1505–10)
Glum, P., 'Divine Judgment in Bosch's Garden of Earthly Delights', in *The Art Bulletin*, vol. 58, no. 1, 1976, pp. 45–54

Gombrich, E. H., 'Bosch's "Garden of Earthly Delights": A Progress Report', in *Journal of the Warburg and Courtauld Institutes*, vol. 32, 1969, pp. 162–70

19
Sistine Chapel ceiling frescoes, Michelangelo (1508–12)
Grovier K., 'Secret Harmony: Mozart, Michelangelo, and the Miserere Mei', in *The Times Literary Supplement*, 8 June 2012, pp. 14–15

King, R., *Michelangelo and the Pope's Ceiling*, London, 2014

20
The School of Athens, Raphael (1510–11)
Bell, D. O., 'New Identifications in Raphael's School of Athens', in *The Art Bulletin*, vol. 77, no. 4, 1995, pp. 639–46

Jones, R., and N. Penny, *Raphael*, New Haven, 1991

21
Isenheim Altarpiece, Matthias Grünewald (1512–16)
Burkhard, A., 'The Isenheim Altar', in *Speculum*, vol. 9, no. 1, 1934, p. 57

Hayum, A., 'The Meaning and Function of the Isenheim Altarpiece: The Hospital Context Revisited', in *The Art Bulletin*, vol. 59, no. 4, 1977, pp. 501–17

22
Bacchus and Ariadne, Titian (1520–23)
Hope C., and Jaffé, D., *Titian*, London, 2003

Wethey, H. E., *The Paintings of Titian*, London, 1975

23
Self-Portrait, Catharina van Hemessen (1548)
Borzello, F., *Seeing Ourselves: Women's Self-Portraits*, London, 2016

Jones, S. F., *Van Eyck to Gossaert: Towards a Northern Renaissance*, London, 2011

24
Crucifixion, Tintoretto (1565–87)
Mills, C., *The Travels of Theodore Ducas, in Various Countries in Europe, at the Revival of Letters and Art, Edited by Charles Mills,* Part the First, Italy, London: printed for Longman, Hurst, Rees, Orme, and Brown, 1822

Valcanover, F., T. Pignatti, and R. E, Wolf, *Tintoretto*, New York, 1985

25
The Supper at Emmaus, Caravaggio (1601)
Cassani, S., and M. Sapio, *Caravaggio: The Final Years*, Naples, 2005

Graham-Dixon, A., *Caravaggio: A Life Sacred and Profane*, New York, 2012

26
The Ecstasy of St Teresa, Gian Lorenzo Bernini (1647–52)
Schama, S., *The Power of Art*, London, 2009

Warma, S., 'Ecstasy and Vision: Two Concepts Connected with Bernini's Teresa', in *The Art Bulletin*, vol. 66, no. 3, 1984, pp. 508–11

27
Las Meninas, Diego Velázquez (1656)
Alpers, S., *The Vexations of Art: Velázquez and Others*, New Haven, 2007

Cumming, L., *The Vanishing Man: In Pursuit of Velázquez*, London, 2017

Hamann, B. E., 'The Mirrors of Las Meninas: Cochineal, Silver, and Clay', in *The Art Bulletin*, vol. 92, no. 1/2, 2010, pp. 6–35

28
Girl with a Pearl Earring, Johannes Vermeer (c. 1665)
Cibelli, D. H., 'Girl with a Pearl Earring: Painting, Reality, Fiction', in *The Journal of Popular Culture*, 2004, 37: 583–92

Liedtke, W. A., M. C. Plomp, and A. Rüger, *Vermeer and the Delft School*, exh. cat., New York, 2001

29
Self-Portrait with Two Circles, Rembrandt van Rijn (c. 1665–69)
Porter, J. C., 'Rembrandt and his Circles: Self Portrait at Kenwood House', in Fleischer, R. E., et al, *The Age of Rembrandt: Studies in Seventeenth-Century Dutch Painting*, Philadelphia, 1988, pp. 188–213

White, C., Q. Buvelot, E. van de Wetering, V. Manuth, and M. de Winkel, *Rembrandt by Himself*, exh. cat., London, 1999

30
An Experiment on a Bird in the Air Pump, Joseph Wright of Derby (1768)
Egerton, J., *Wright of Derby*, London, 1990

Uglow, J., *The Lunar Men: The Friends Who Made the Future, 1730–1810*, London, 2002

31
The Nightmare, Henry Fuseli (1781)
Grovier, K., '"She is mine and I am hers!" Henry Fuseli, Voyeurism, and the Dark Side of the Canvas', in *Times Literary Supplement*, 10 March 2006, pp. 16–17

Myrone, M., C. Frayling, M. Warner, and M. Heard, *Gothic Nightmares: Fuseli, Blake and the Romantic Imagination*, London, 2006

32
The Third of May 1808, Francisco Goya (1814)
Grovier, K., 'Eating out of his hands', in *The Art Newspaper*, 20 November 2015

Hughes, R., *Goya*, New York, 2004

33
The Hay Wain, John Constable (1821)
Reynolds, G., *Constable's England*, New York, 2013

Rosenthal, M., *Constable: The Painter and his Landscape*, New Haven, 1989

34
Rain, Steam, and Speed – The Great Western Railway, J. M. W. Turner (1844)
Concannon, A., B. Livesley, S. Smiles, and D. Brown, *Late Turner: Painting Set Free*, London, 2014

Grovier, K., 'From the infinite to the infinitesimal', in *Times Literary Supplement*, 8 October 2014

35
Arrangement in Grey and Black No. 1 (Portrait of the Artist's Mother), James Abbott McNeill Whistler (1871)
Allen, S., *From Realism to Symbolism: Whistler and his World*, New York, 1971

MacDonald, M. F., and P. de Montfort, *An American in London: Whistler and the Thames*, London, 2014

36
The Thinker, Auguste Rodin (1880–1904)
Elsen, A. E., *Rodin's Gates of Hell*, Minneapolis, 1960
Masson, R., V. Mattiussi, and D. Dusinberre, *Rodin*, Paris, 2015

37
A Bar at the Folies-Bergère, Édouard Manet (1882)
De Duve, T., and B. Holmes, 'How Manet's "A Bar at the Folies-Bergère" is Constructed', in *Critical Inquiry*, vol. 25, no. 1, 1998, pp. 136–68
Iskin, R. E., 'Selling, Seduction, and Soliciting the Eye: Manet's Bar at the Folies-Bergère', in *The Art Bulletin*, vol. 77, no. 1, 1995, pp. 25–44

38
Bathers at Asnières, Georges Seurat (1884)
Homer, W. I., *Seurat and the Science of Painting*, Cambridge, MA, 1978
Leighton, J., and R. Thomson, *Seurat and the Bathers*, London, 1997

39
The Scream, Edvard Munch (1893)
Heller, R., *Edvard Munch: The Scream*, New York, 1973
Prideaux, S., *Edvard Munch: Behind the Scream*, Cumberland, 2014

40
The Large Bathers, Paul Cézanne (1900–6)
Cézanne, P., and M. L. Krumrine, *Paul Cézanne: The Bathers*, exh. cat., New York, 1990
Fry, R., *Cézanne: A Study of his Development*, London, 1927
Reff, T., and W. S. Rubin, *Cézanne: The Late Work*, London, 1978

41
Group IV, No. 7, Adulthood, Hilma af Klint (1907)
Almqvist, K., and L. Belfrage, *Hilma af Klint: The Art of Seeing the Invisible*, Stockholm, 2015
Enderby, E., M. Blanchflower, and M. Larner, *Hilma af Klint: Painting the Unseen*, London, 2016

42
The Kiss, Gustav Klimt (1907)
Natter, T. G., and G. Frodl, *Klimt's Women*, Cologne, 2000
Néret, G., *Gustav Klimt, 1862–1918: The World in Female Form*, Cologne, 2015

43
Dance, Henri Matisse (1909–10)
Flam, J., *Matisse on Art*, Berkeley, 2003
Kostenevich, A., 'Matisse and Shchukin: A Collector's Choice', in *Art Institute of Chicago Museum Studies*, vol. 16, no. 1, 1990, pp. 27–92

44
Water Lilies, Claude Monet (1914–26)
King, R., *Mad Enchantment: Claude Monet and the Painting of the Water Lilies*, London, 2016
Temkin, A., and N. Lawrence, *Claude Monet: Water Lilies*, New York, 2009

45
Fountain, Marcel Duchamp (1917)
Grovier, K., 'The urinal that changed how we think', BBC Culture online, 11 April 2017
Kilroy, R., *Marcel Duchamp's Fountain: One Hundred Years Later*, Cham, 2018

46
American Gothic, Grant Wood (1930)
Grovier, K., 'Fallen from the heavens', in *Times Literary Supplement*, 31 March 2017, pp. 20–21
Tripp Evans, R., *Grant Wood: A Life*, New York, 2010

47
The Persistence of Memory, Salvador Dalí (1931)
Gibson, I., and M. Raeburn, *Salvador Dalí: The Early Years*, New York, 1994
Grenier, C., and D. Radzinowicz, *Salvador Dalí: The Making of an Artist*, Paris, 2012

48
Guernica, Pablo Picasso (1937)
Arnheim, R., *The Genesis of a Painting: Picasso's Guernica*, Berkeley, 2012
Clark, T. J., *Picasso and Truth: From Cubism to Guernica*, Princeton, 2013
Van Hensbergen, G., *Guernica: The Biography of a Twentieth-Century Icon*, London, 2005

49
L'Égypte de Mlle Cléo de Mérode: cours élémentaire d'histoire naturelle, Joseph Cornell (1940)
Grovier, K., 'Shadow boxing with Joseph Cornell', in *The Art Newspaper*, 27 August 2015
Hartigan, L. R., S. Lea, and J. Sharp, *Joseph Cornell: Wanderlust*, exh. cat., London, 2015

50
Self-Portrait with Thorn Necklace and Hummingbird, Frida Kahlo (1940)
Drucker, M., *Frida Kahlo*, Albuquerque, 1999
Udall, S. R., 'Frida Kahlo's Mexican Body: History, Identity, and Artistic Aspiration', in *Woman's Art Journal*, vol. 24, no. 2, 2003, pp. 10–14

51
One: Number 31, Jackson Pollock (1950)
Karmel, P. (ed.), *Jackson Pollock: Interviews, Articles, and Reviews*, New York, 1999
Rampley, M., 'Identity and Difference: Jackson Pollock and the Ideology of the Drip', in *Oxford Art Journal*, vol. 19, no. 2, 1996, pp. 83–94

52
Study after Velázquez's Portrait of Pope Innocent X, Francis Bacon (1953)
Davies, H., *Francis Bacon: The Papal Portraits of 1953*, Aldershot, 2002
Peppiatt, M., *Francis Bacon in the 1950s*, New Haven, 2008

53
Brillo Boxes, Andy Warhol (1964)
Danto, A. C., *Andy Warhol*, New Haven, 2010
—, *Beyond the Brillo Box: The Visual Arts in Post-Historical Perspective*, Berkeley, 2008

54
Backs and Fronts, Sean Scully (1981)
Grovier, K., *Sean Scully / Facing East*, St Petersburg, 2017
Scully, S., *Inner: The Collected Writings and Selected Interviews of Sean Scully*, ed. K. Grovier, Berlin, 2016

55
Betty, Gerhard Richter (1988)
Melville, S., 'Betty's Turn', in *RES: Anthropology and Aesthetics*, no. 53/54, 2008, pp. 31–46
Storr, R., *Gerhard Richter: Forty Years of Painting*, New York, 2004

56
Maman, Louise Bourgeois (1999)
Morris, F., P. Herkenhoff, and M.-L. Bernadac, *Louise Bourgeois*, New York, 2008
Warner, M., and F. Morris, *Louise Bourgeois*, exh. cat., London, 2000

57
The Artist is Present, Marina Abramović (2010)
Abramović, M., K. Biesenbach, and M. Christian, *Marina Abramović: The Artist is Present*, exh. cat., New York, 2010
Abramović, M., and H. U. Obrist, *Marina Abramović*, Cologne, 2010

Picture Credits

2 Alte Pinakothek, Munich. Photo akg-images

9 Museum of Modern Art, New York. Acquired through the Lillie P. Bliss Bequest (472.1941)/Scala, Florence

10 The Metropolitan Museum of Art, New York. H. O. Havemeyer Collection, Bequest of Mrs. H. O. Havemeyer, 1929 (29.100.131)

11 Photo Hilde Jensen. © University of Tübingen

14, 16 The Trustees of the British Museum, London

17 Collection Kröller-Müller Museum. Detail, installation view at MASS MoCA, North Adams, 2004. Photo Kevin Kennefick, courtesy MASS MoCA

18 The Trustees of the British Museum, London

20 British Museum, London. Photo Erin Babnik/Alamy Stock Photo

21 Photo Tim Graham/Getty Images

23, 24b Photo efired/123RF

24a © the artist

25 DV Travel/Alamy Stock Photo

26 Photo Adam Eastland/Alamy Stock Photo

28 Villa of the Mysteries, Pompeii

29 Giovanni Caselli

31 Vatican Museums, Vatican City. Nick Fielding/Alamy Stock Photo

32 © Richard Deacon. Courtesy Lisson Gallery

33 Vatican Museums, Vatican City. Exotica/Alamy Stock Photo

35 Ingram Publishing/Diomedia

36 B. O'Kane/Alamy Stock Photo

37 Trajan's Column, Rome

38, 41 Trinity College Dublin (MS 58, f. 34r)

40a British Library, London (Cotton MS Nero D.IV)

40b © Matthew Barney. Courtesy the artist and Gladstone Gallery, New York and Brussels

43, 45 National Palace Museum, Taipei. Pictures From History/ Bridgeman Images

44 Kunstmuseum Basel, with contributions from the Government of the Canton of Basel-Stadt, the Education department of Basel-Stadt, the company CIBA AG, the company J. R. Geigy AG, the

company Sandoz AG and acquired from the masterpiece fund, 1955 (G 1955.12)

46–7, 49a Bayeux Museum, France

48–9 Courtesy the artist and Victoria Miro Gallery. © Grayson Perry

50 Biblioteca Statale, Lucca, Italy

52 Rupertsberger Codex des Liber Scivias, Hildegard Abbey, Eibingen

53 Gallerie dell'Accademia, Venice

55, 57 Brancacci Chapel, Santa Maria del Carmine, Florence/Bridgeman Images

56a Brancacci Chapel, Santa Maria del Carmine, Florence

56b © the artist. Courtesy the artist and Wilkinson Gallery, London

58, 60 St Bavo's Cathedral, Ghent. Photo Scala, Florence

61 St Bavo's Cathedral, Ghent. Photo akg-images

63, 65 Museo Nacional del Prado, Madrid/Bridgeman Images

64 Museo Nacional del Prado, Madrid. SuperStock/Diomedia

67, 68r Museo di San Marco, Florence/Bridgeman Images

68l Galleria Nazionale dell'Umbria, Perugia

69 © R. Hamilton. All Rights Reserved, DACS 2018

71 Pinacoteca di Brera, Milan

72a Pinacoteca di Brera, Milan. Photo Scala, Florence – courtesy of the Ministero Beni e Att. Culturali e del Turismo

72b Scrovegni Chapel, Padua

73 Stefan T. Edlis Collection. Courtesy Anthony d'Offay, London and Hauser & Wirth. © Ron Mueck

74, 76, 78 Uffizi, Florence

77 Royal Collection Trust. Her Majesty Queen Elizabeth II, 2018/Bridgeman Images

79 Tate, London. © Rineke Dijkstra. Courtesy the artist and Marian Goodman Gallery

81, 82 Musée du Louvre, Paris. Photo RMN-Grand Palais (musée du Louvre)/Michel Urtado

83a © Association Marcel Duchamp/ADAGP, Paris and DACS, London 2018

83b Private Collection. © Robert Rauschenberg Foundation/DACS, London/VAGA, New York 2018

84, 86a Museo Nacional del Prado, Madrid

86b Palais des Beaux-Arts de Lille

87 Museo Nacional del Prado, Madrid. The Print Collector/Alamy Stock Photo

88 Museum Mayer van den Bergh, Antwerp

89 Tate, London. © Salvador Dali, Fundació Gala-Salvador Dalí, DACS 2018

90, 93 Vatican Museums and Galleries, Vatican City

92 Vatican Museums and Galleries, Vatican City/Bridgeman Images

94 Apostolic Palace, Vatican City. Photo Scala, Florence

97a Apostolic Palace, Vatican City

97b Church of Santa Maria delle Grazie, Milan

99, 101, 102 Musée Unterlinden, Colmar, France

100 Musée Unterlinden, Colmar, France. Photo Scala, Florence

105, 107 National Gallery, London

106 Tate, London. Presented by the executors of the estate of David Wilkie, 1993. © Frank Auerbach, courtesy Marlborough Fine Art

109, 110ar Kunstmuseum Basel, donation of Prof. J.J. Bachofen-Burckhardt Foundation 2015 (1361)

110al Alte Pinakothek, Munich. Photo akg-images

110b Courtesy the artist and Metro Pictures, New York

113 Sala dell'Albergo, Scuola Grande di San Rocco, Venice. Cameraphoto/ Scala, Florence

114l Musée du Louvre, Paris

114r Art Gallery and Museum, Kelvingrove, Glasgow, Scotland. © CSG CIC Glasgow Museums Collection/Bridgeman Images

115 Sala dell'Albergo, Scuola Grande di San Rocco, Venice

117, 118 National Gallery, London

119a Musée du Louvre, Paris

119b Pinacoteca di Brera, Milan

120, 124 Chiesa della Vittoria, Rome

122 Chiesa della Vittoria, Rome. Photo DeAgostini/Getty Images

123 Staatliches Museum, Schwerin

125l Courtesy Kevin Francis Gray Studio. Photo Tara Moore

125r Galleria Borghese, Rome

127, 129 Museo Nacional del Prado, Madrid

128 National Gallery, London

131, 133 Mauritshuis, The Hague

132 National Gallery of Art, Washington, D.C. Andrew W. Mellon Collection (1937.1.53)

135, 137 The Iveagh Bequest, Kenwood House, London

136 Rijksmuseum, Amsterdam

139, 141 National Gallery, London. Photo culture-images/Topfoto

140a Private Collection. Photographed at the 'BP Spotlight: Joseph Wright of Derby', Tate Britain, London, 30 March 2016. Photo Guy Bell/REX/Shutterstock

140b National Gallery of Victoria, Melbourne. Presented through The Art Foundation of Victoria by Mrs. Michael Hawker (née Patricia Synnot), Founder Benefactor, 1980 (E1-1980)

142, 144, 145 Detroit Institute of Arts. Founders Society Purchase with funds from Mr. and Mrs. Bert L. Smokler and Mr. and Mrs. Lawrence A. Fleischman/Bridgeman Images

147, 148 Museo Nacional del Prado, Madrid. GL Archive/Alamy

149, 150, 152 National Gallery, London

153 Courtesy the artist and Ronchini Gallery, London

155, 157 National Gallery, London

156 Tate, London

159, 161 Musée d'Orsay, Paris

160 The Metropolitan Museum of Art, New York. Gift of Susan Dwight Bliss, 1967 (67.630.59)

163, 164 Ny Carlsberg Glyptotek, Copenhagen. Photo Prisma Archivo/ Alamy

165a Bibliothèque nationale de France, Paris

165b The Philadelphia Museum of Art. Bequest of Jules E. Mastbaum, 1929 (F1929-7-50)/Photo Dist. RMN-Grand Palais/image Philadelphia Museum of Art

166, 168 The Samuel Courtauld Trust, The Courtauld Gallery, London

169 Christie's Images, London/Scala, Florence. © Succession Picasso/DACS, London 2018

171, 173 National Gallery, London

172 Art Institute of Chicago. Helen Birch Bartlett Memorial Collection (1926.224)

175, 176l National Gallery, Oslo, Norway

Index

About the Author

Kelly Grovier is a poet, cultural critic and historian. He is a columnist and feature-writer for BBC Culture and a regular contributor to the *Times Literary Supplement*. His writing on art has appeared in numerous publications, including the *Observer*, the *Sunday Times* and *Wired*. Educated at the University of California, Los Angeles, and at the University of Oxford, he is co-founder of the international scholarly journal *European Romantic Review*, as well as the author of the best-selling *100 Works of Art That Will Define Our Age* (2013) and *Art Since 1989* (2015).

Acknowledgments

This book could not have been written without the encouragement, kindness and patience of Thames & Hudson's Editorial Director, Roger Thorp, to whom I am extremely grateful. My extended thanks, too, to his wonderful team – to Amber Husain, Poppy David, Maria Ranauro, Jenny Wilson, Lisa Ifsits and Ginny Liggitt – for all they have done to bring the book so beautifully to life. Without friendship, conversation and coffee, the ideas that fill this book would never have been brewed: my warmest thanks to Mark Alexander, Matthew Anderson, Tiffany Atkinson, Erica Bolton, Michael Caines, Paul Carter-Robinson, Marilina Cesario, Edith Devaney, Sara Faith, Darragh Hogan, Midge Gillies, John Kennedy, Jacky Klein, Rebecca Laurence, Christopher Le Brun, Fiona Macdonald, Paul McGarrity, Anthony Mosawi, Pac Pobric, Jem Poster, Mark Robinson, Seán Rocks, Sean Scully, Liliane Tomasko, Anna Vaux and Ben Wright. This book is dedicated to my wife, Sinéad, for her tremendous love and support, and to our son, Caspar, who, every day, teaches us new ways of seeing.

Kelly Grovier